D1292878

SHOP DRAWINGS
OF
SHAKER FURNITURE
WOODENWARE
IRONWARE
AND
TINWARE

MEASURED DRAWINGS
BY
EJNER HANDBERG

THE BERKSHIRE TRAVELLER PRESS
Stockbridge, Massachusetts

Shop Drawings of Shaker Furniture
and Woodenware — Volume I
by Ejner Handberg
LC# 73-83797
Copyright 1973 by
Ejner P. Handberg
ISBN No. 0-912944-09-9

Shop Drawings of Shaker Furniture
and Woodenware, Vol. II
by Ejner Handberg
Photographs by Jane McWhorter
LC# 73-83797
Copyright © 1975 by
Ejner P. Handberg
ISBN No. 0-912944-29-3

Shop Drawings of Shaker Iron and Tinware
by Ejner Handberg

PHOTOGRAPH CREDITS:
The following photographs are reprinted through the courtesy of The
Andrews Shaker Collection: Door Latch, from New Lebanon, N.Y., p. 77;
The Andrews Living Room at Shaker Farm, Richmond, Mass., photo by
Tom Yee, p. 83; Tea Pot, initialed BC, p. 81. The following photographs
are reprinted through the courtesy of The Henry Francis du Pont Winter-
thur Museum, The Edward Deming Andrews Memorial Shaker Collection:
Kitchen, Church Family, Niskeyuna, N.Y., p. 81; Shaker Sisters Preparing
Maple Sugar Cakes, p. 85. All other photographs by Ejner Handberg.

Copyright © 1976 by Ejner P. Handberg
ISBN #0-912944-36-6
Library of Congress #76-12896

All rights reserved.
Printed in the United States of America.

FOREWORD

This is not an attempt to write a book about the Shakers and their furniture. There are already excellent books which serve that purpose. I refer especially to those by Dr. and Mrs. Edward Deming Andrews. Rather, this is a collection of measured drawings made to scale and with dimensions and details accurately copied from Shaker pieces which have been in my shop for restoration or reproduction. These drawings and patterns have been accumulated over a period of many years of interest in the woodwork of the New England and New York State Shakers.

Ejner P. Handberg

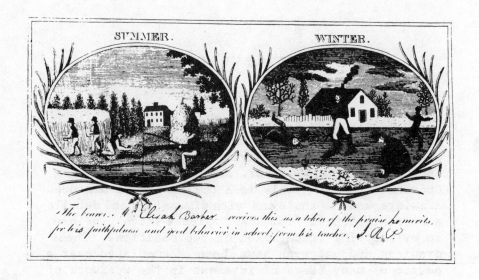

SHAKER REWARD OF MERIT

This Shaker reward of Merit was given to a young Shaker
School boy of Hancock, Massachusetts during the nineteenth
century. The drawings depict Shakers at work and play during
two seasons.

It reads as follows:

*The bearer Mr. Elijah Barker receives this as a token of the
praise he merits. For his faithfulness and good behavier in
schools from his teacher. S.A.P.*

Courtesy of the Edward Deming Andrews Memorial Shaker
Library, Winterthur, Museum, Winterthur, Delaware.

Reward of Merit

In the Shaker Manner

To Ejner Handberg

From Faith Andrews

Pittsfield, Mass. May 1, 1972

An expression of thanks for
your understanding and
appreciation of Shaker furniture.

Collectors of this furniture are
indeed fortunate to know of your
work and have benefited by your
advice and help.

When a restored piece leaves
your shop to take its place in
the "world" one is reminded
of the virtues of the early Be-
lievers. Honesty, simplicity and
humility were their guiding
principles. When these are
adapted by an artisan today
we approach perfection in
workmanship.

F. A.

NOTES TO THE CRAFTSMAN OR COLLECTOR

White pine was the most common wood used for furniture like cupboards, chests of drawers, benches, woodboxes and many other items.

Bedposts, chairposts and all parts requiring strength were usually made of hard maple or yellow birch.

Maple, birch and cherry were used for legs on trestle tables, drop leaf tables and stands. The tops were often pine. Square legs are tapered on the inner surfaces only.

Sometimes candlestands, work stands and sewing stands were made entirely of cherry, maple or birch. The legs are dovetailed to the shaft and the grain should run as nearly parellel to the general direction of the leg as possible. A thin metal plate should be fastened to the underside of the shaft and extend about three quarters of an inch along the base of each leg with a screw or nail put in the leg to keep them from spreading.

Parts for chairs and stools were mostly hard maple with an occasional chair made of curly or bird's-eye maple. Birch, cherry and butternut were used less often.

Oval boxes and carriers were nearly always made of maple. The bottoms and covers were fitted with quarter-sawn, edge-grain pine which is less apt to cup or warp than flat-grained boards. First the "fingers" or "lappers" are cut on the maple bands, then they are steamed and wrapped around an oval form and the fingers fastened with small copper or iron rivets (tacks). After they are dry and sanded the pine disks are fitted into the bottom and cover and fastened with small square copper or iron brads.

In New York State and New England, the woods used for the many different small pieces of cabinet work and woodenware were white pine, maple, cherry, yellow birch, butternut and native walnut. They were often finished with a coat of thin paint, or stained and varnished, or sometimes left with a natural finish.

CONTENTS

PART I
FURNITURE AND WOODENWARE

PART II
FURNITURE AND WOODENWARE

XI

PART III
WROUGHT IRON

CAST IRON

TINWARE

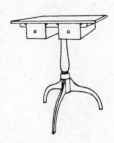

SHOP DRAWINGS
OF
SHAKER FURNITURE
AND
WOODENWARE

PART I

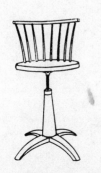

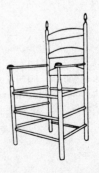

LC# 73-83797
Copyright 1973 by
Ejner P. Handberg
ISBN No. 0-912944-09-9

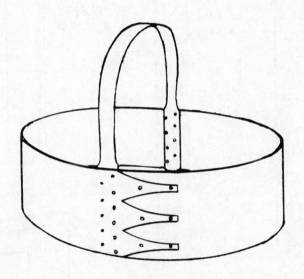

" THAT WHICH HAS IN ITSELF THE HIGHEST USE
POSSESSES THE GREATEST BEAUTY"

PINE CUPBOARD.

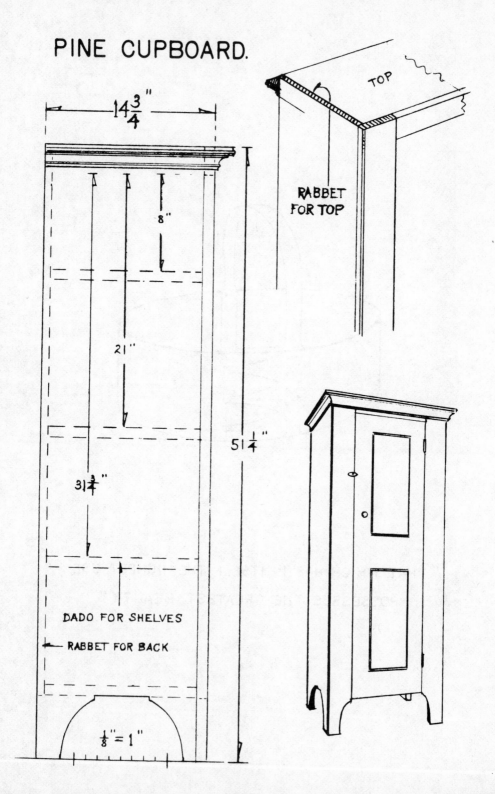

14¾"

8"

21"

51¼"

31¾"

DADO FOR SHELVES

RABBET FOR BACK

⅛" = 1"

TOP

RABBET FOR TOP

4

PINE CUPBOARD.

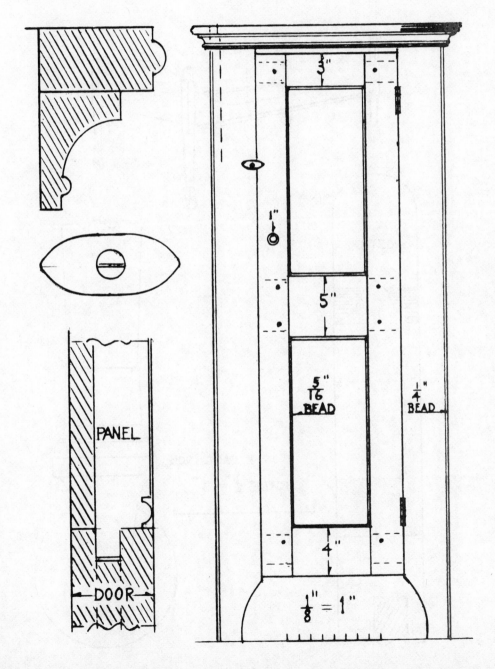

3"

1"

5"

5/16" BEAD

1/4" BEAD

4"

1/8" = 1"

PANEL

DOOR

5

BED
MAPLE AND WHITEWOOD

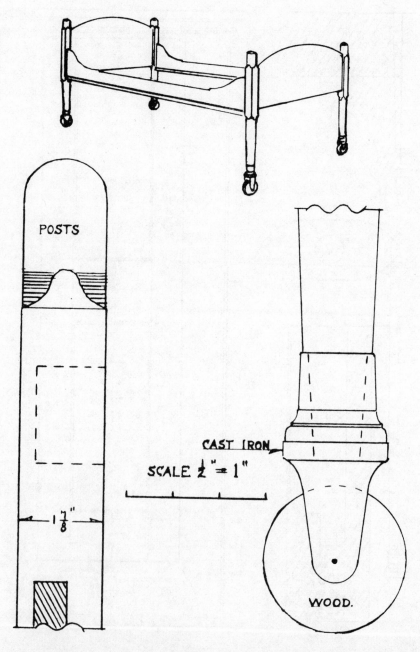

POSTS

CAST IRON

SCALE $\frac{1}{2}$" = 1"

$1\frac{7}{8}$"

WOOD.

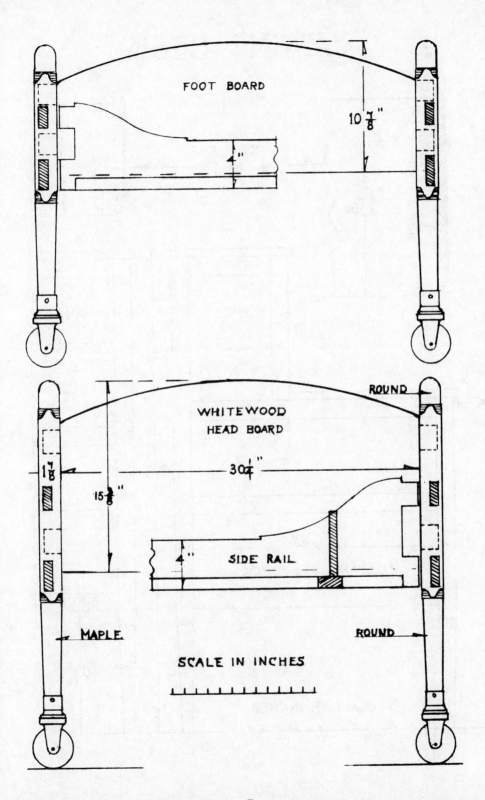

FOOT BOARD

$10 \frac{7}{8}$"

4"

WHITEWOOD
HEAD BOARD

ROUND

$30 \frac{1}{4}$"

$1 \frac{7}{8}$"

$15 \frac{5}{8}$"

SIDE RAIL

4"

MAPLE

ROUND

SCALE IN INCHES

SEWING DESK

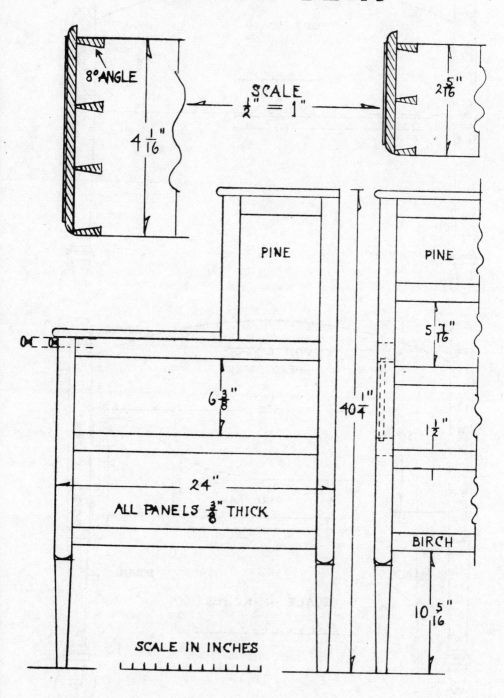

8°ANGLE

SCALE
½" = 1"

$4\frac{1}{16}$"

$2\frac{5}{16}$"

PINE

PINE

$5\frac{7}{16}$"

$6\frac{3}{8}$"

$40\frac{1}{4}$"

$1\frac{1}{2}$"

24"

ALL PANELS $\frac{3}{8}$" THICK

BIRCH

$10\frac{5}{16}$"

SCALE IN INCHES

SEWING DESK

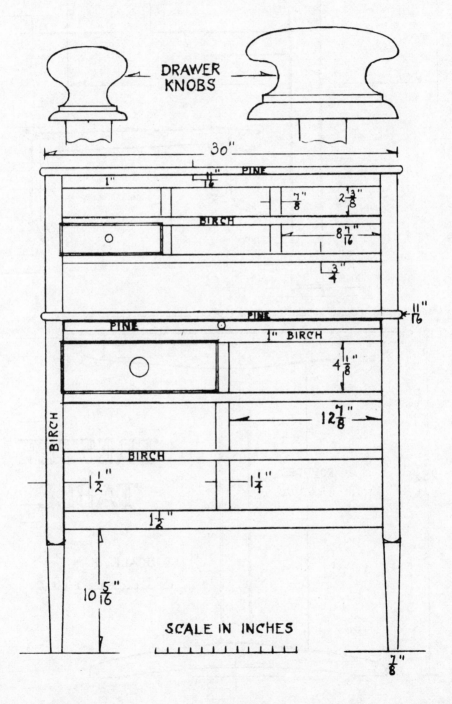

DRAWER KNOBS

30"

PINE

1"

1/16"

7/8"

2 3/8"

BIRCH

8 7/16"

3/4"

PINE PINE 11/16"

PINE 1" BIRCH

4 1/8"

12 7/8"

BIRCH

BIRCH

1 1/2" 1 1/4"

1 1/2"

10 5/16"

7/8"

SCALE IN INCHES

9

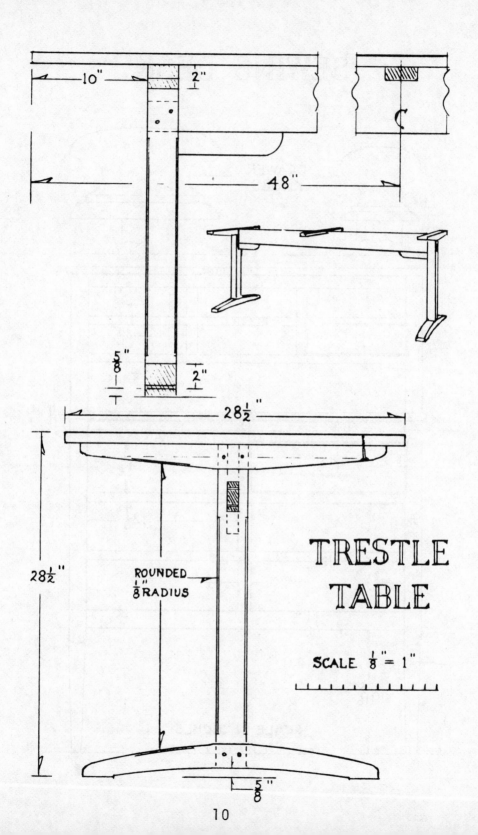

10" 2"

48"

5⁄8" 2"

28½"

28½"

ROUNDED
⅛" RADIUS

TRESTLE
TABLE

SCALE ⅛" = 1"

5⁄8"

TRESTLE TABLE

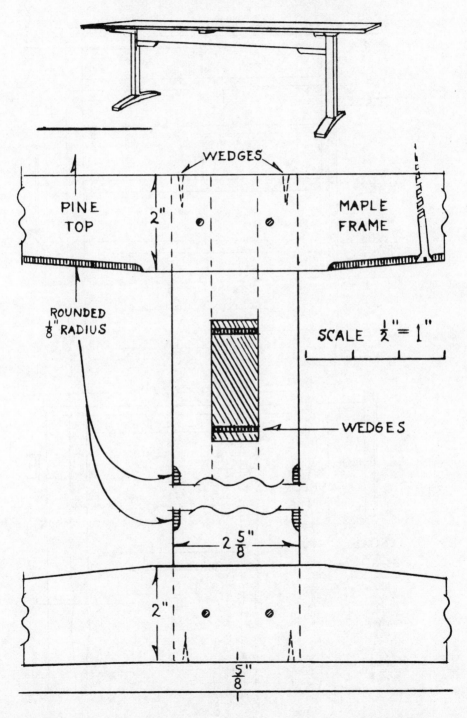

WEDGES

PINE TOP

2"

MAPLE FRAME

ROUNDED ⅛" RADIUS

SCALE ½" = 1"

WEDGES

2 ⅝"

2"

⅝"

SEWING TABLE.

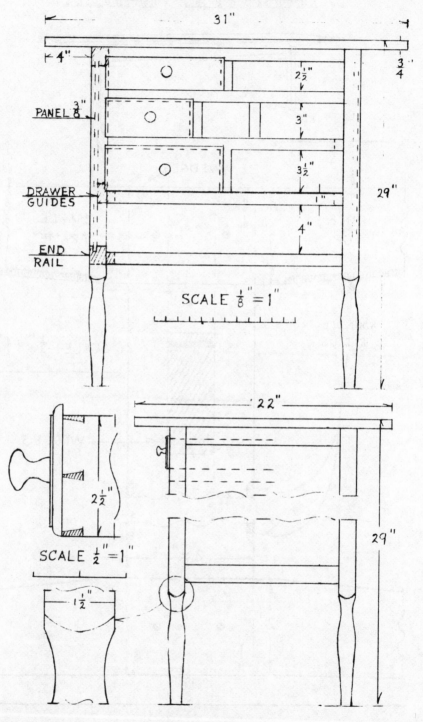

31"

4"

3/4"

PANEL 3/8"

2 1/2"

3"

DRAWER
GUIDES

3 1/2"

1"

29"

END
RAIL

4"

SCALE 1/8" = 1"

2 1/2"

22"

SCALE 1/2" = 1"

29"

1 1/2"

WORK TABLE.

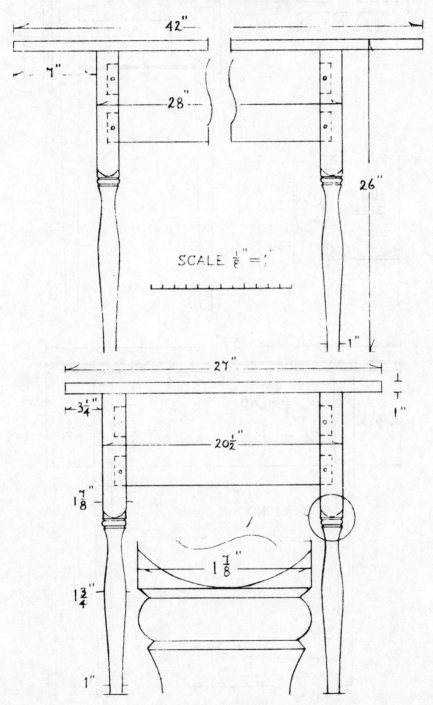

42"

7"

28"

26"

1"

SCALE $\frac{1}{8}$" = 1"

27"

$3\frac{1}{4}$"

1"

$20\frac{1}{2}$"

$1\frac{7}{8}$"

$1\frac{7}{8}$"

$1\frac{3}{4}$"

1"

DROP-LEAF TABLE.

CHERRY

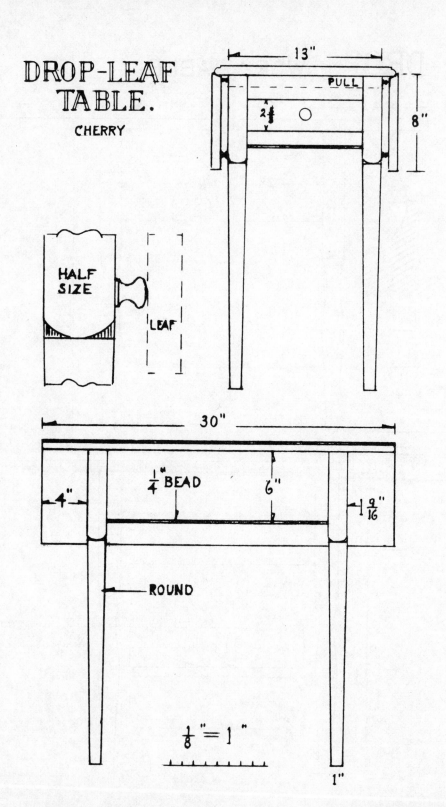

13"

PULL

2⅛

8"

HALF SIZE

LEAF

30"

¼" BEAD

6"

4"

9/16"

ROUND

⅛" = 1"

1"

DROP-LEAF
TABLE

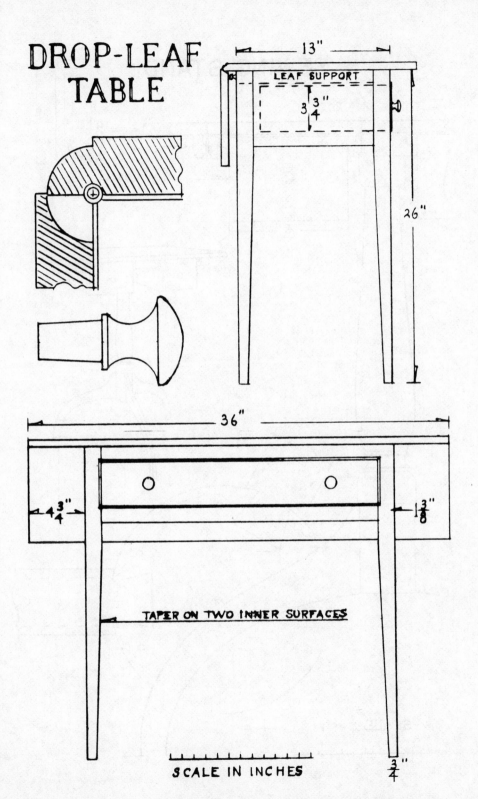

LEAF SUPPORT

13"

$3\frac{3}{4}$"

26"

36"

$4\frac{3}{4}$"

$1\frac{3}{8}$"

TAPER ON TWO INNER SURFACES

SCALE IN INCHES

$\frac{3}{4}$"

SEWING STAND.

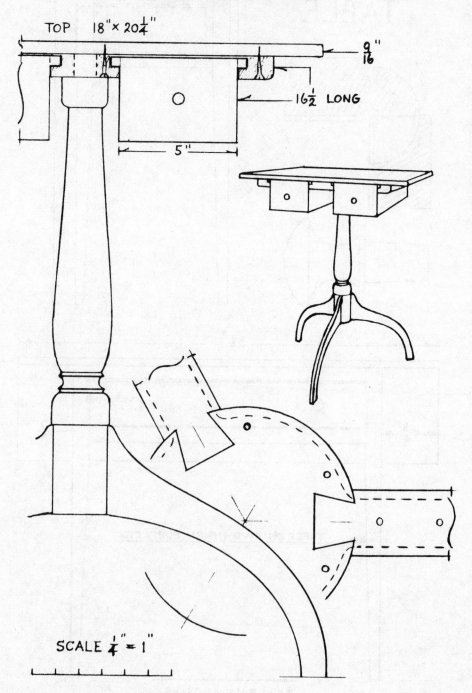

TOP 18" × 20¼"

$\frac{9}{16}$"

16½ LONG

5"

SCALE ¼" = 1"

16

WORKSTAND.

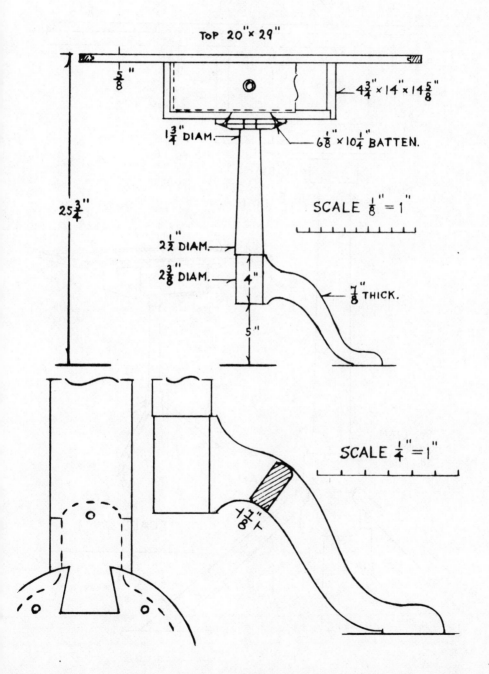

TOP 20" × 29"

$\frac{5}{8}$"

$4\frac{3}{4}$" × 14" × $14\frac{5}{8}$"

$1\frac{3}{4}$" DIAM.

$6\frac{1}{8}$" × $10\frac{1}{4}$" BATTEN.

$25\frac{3}{4}$"

SCALE $\frac{1}{8}$" = 1"

$2\frac{1}{2}$" DIAM.

$2\frac{3}{8}$" DIAM.

4"

$\frac{7}{8}$" THICK.

5"

SCALE $\frac{1}{4}$" = 1"

$\frac{7}{8}$"

PEG-LEG STAND.

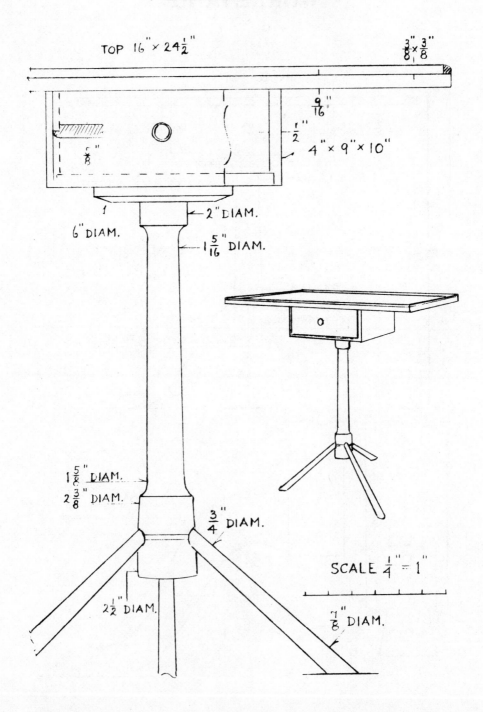

TOP 16" × 24½"

$\frac{3}{8}$" × $\frac{3}{8}$"

$\frac{9}{16}$"

$\frac{1}{2}$"

4" × 9" × 10"

$\frac{5}{8}$"

2" DIAM.

6" DIAM.

1$\frac{5}{16}$" DIAM.

1$\frac{5}{16}$" DIAM.

2$\frac{3}{8}$" DIAM.

$\frac{3}{4}$" DIAM.

2$\frac{1}{2}$" DIAM.

SCALE $\frac{1}{4}$" = 1"

$\frac{7}{8}$" DIAM.

18

CANDLESTAND.

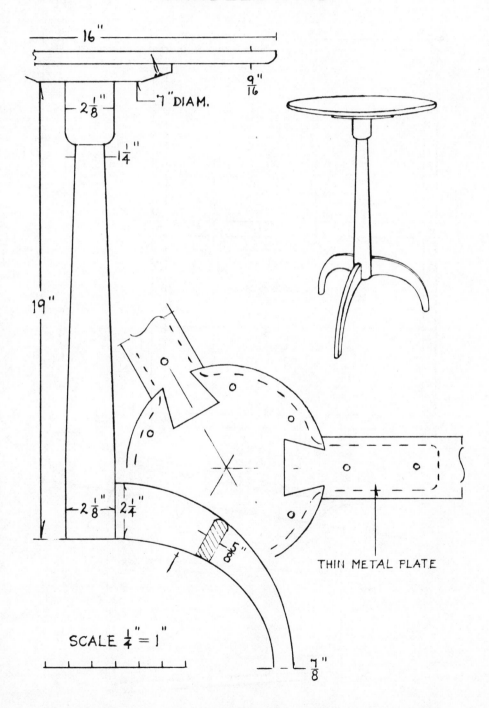

16"

$\frac{9}{16}$"

2$\frac{1}{8}$"

7" DIAM.

1$\frac{1}{4}$"

19"

2$\frac{1}{8}$" 2$\frac{1}{4}$"

$\frac{5}{8}$"

THIN METAL PLATE

SCALE $\frac{1}{4}$" = 1"

$\frac{7}{8}$"

TOWEL RACK.

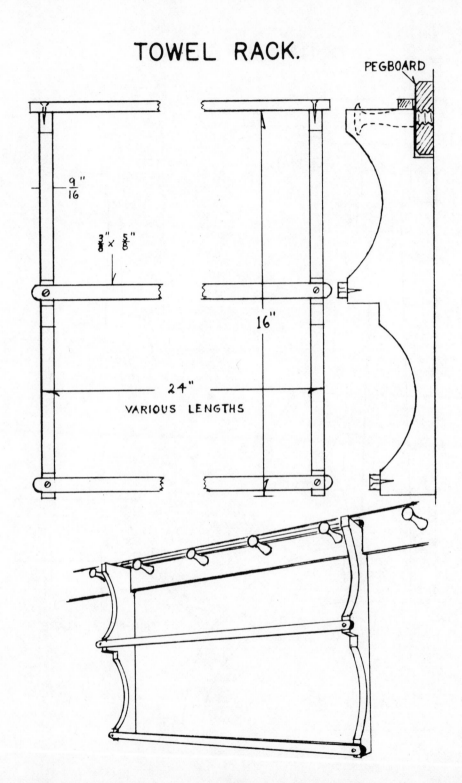

PEGBOARD

$\frac{9"}{16}$

$\frac{3"}{8} \times \frac{5"}{8}$

16"

24"
VARIOUS LENGTHS

PINE TOWEL RACK.

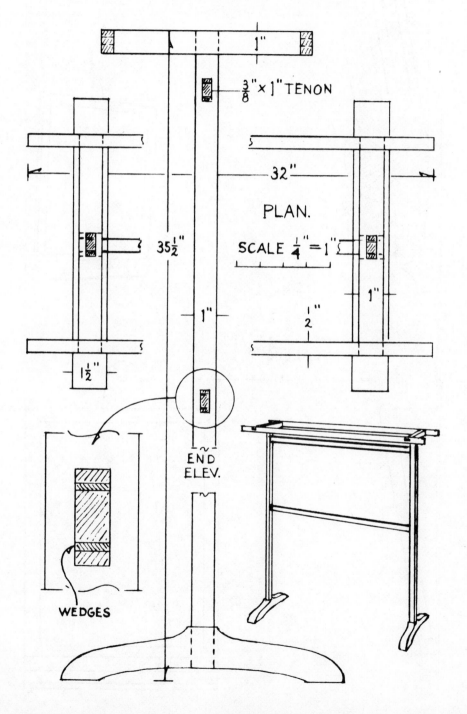

1"

$\frac{3}{8}$" x 1" TENON

32"

PLAN.

SCALE $\frac{1}{4}$" = 1"

$35\frac{1}{2}$"

1"

$\frac{1}{2}$"

$1\frac{1}{2}$"

END
ELEV.

WEDGES

1"

LOOKING GLASS.

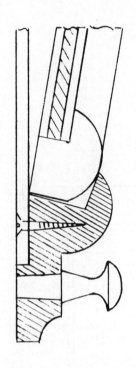

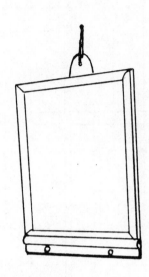

SCALE $\frac{3}{16}$" = 1"

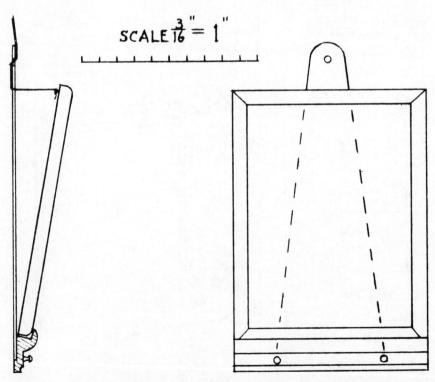

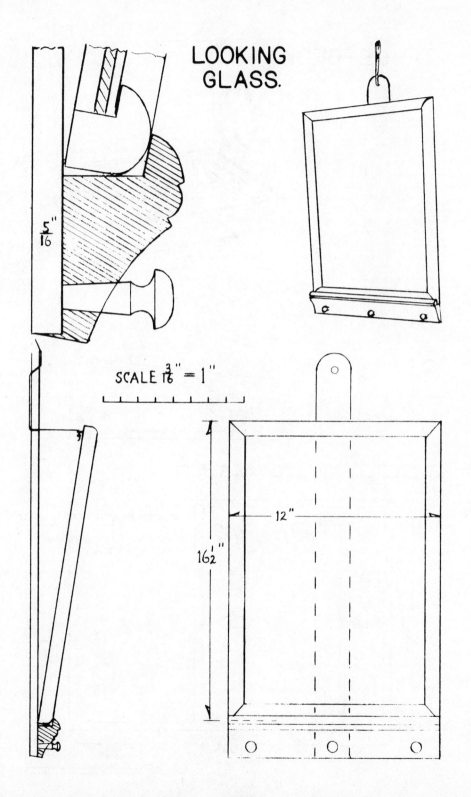

LOOKING GLASS.

$\frac{5}{16}$"

SCALE $\frac{3}{16}$" = 1"

12"

16$\frac{1}{2}$"

23

TABLE -DESK.

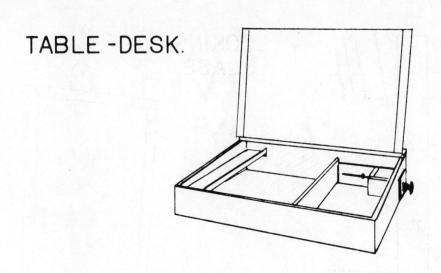

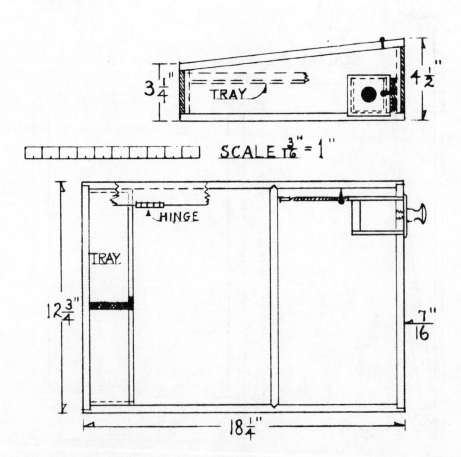

$3\frac{1}{4}$" TRAY $4\frac{1}{2}$"

SCALE $\frac{3}{16}$" = 1"

HINGE

TRAY

$12\frac{3}{4}$"

$\frac{7}{16}$"

$18\frac{1}{4}$"

24

TABLE -DESK.
CHERRY AND PINE

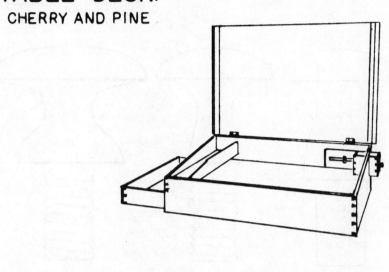

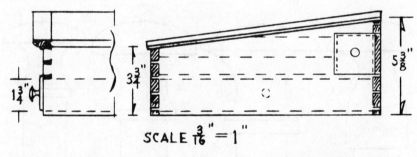

SCALE $\frac{3}{16}'' = 1''$

$3\frac{3}{4}''$

$5\frac{3}{8}''$

$1\frac{3}{4}''$

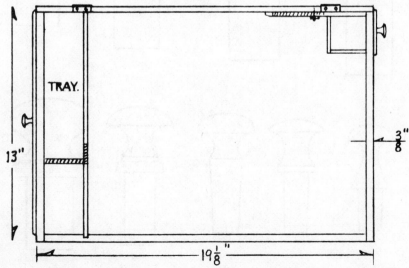

TRAY.

13"

$\frac{3}{8}''$

$19\frac{1}{8}''$

KNOBS AND PULLS.

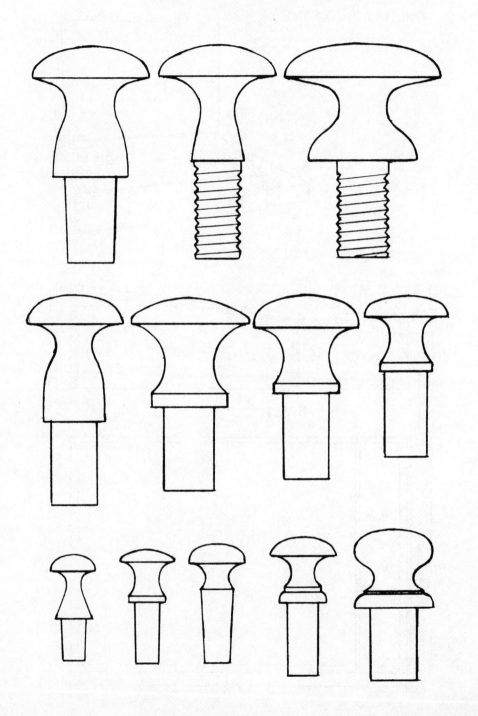

WALL-PEGS.

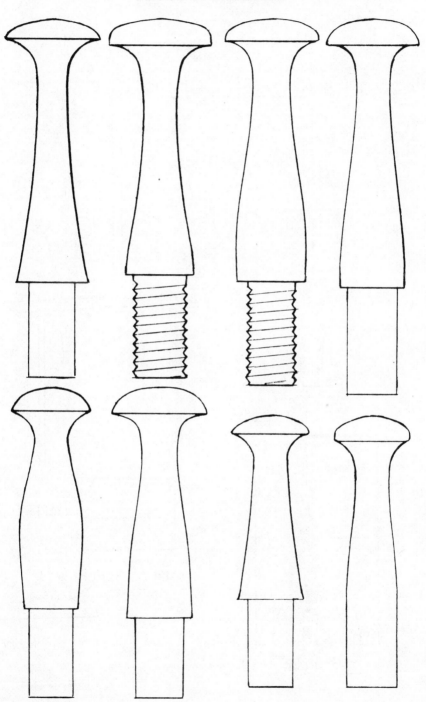

SMALL BENCH.

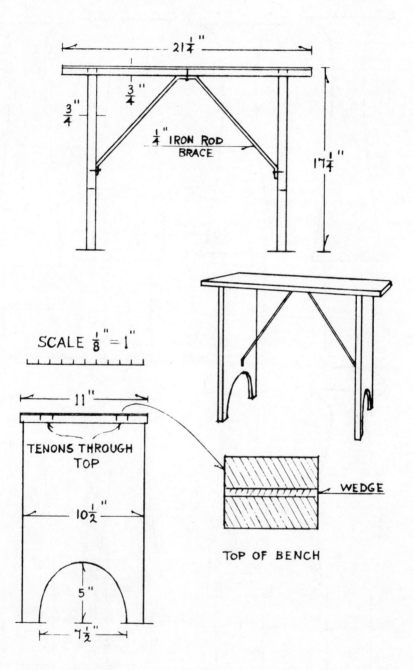

21¼"

¾"

¾"

17¼"

¼" IRON ROD BRACE

SCALE ⅛" = 1"

11"

TENONS THROUGH TOP

10½"

5"

7½"

WEDGE

TOP OF BENCH

PINE BENCH.

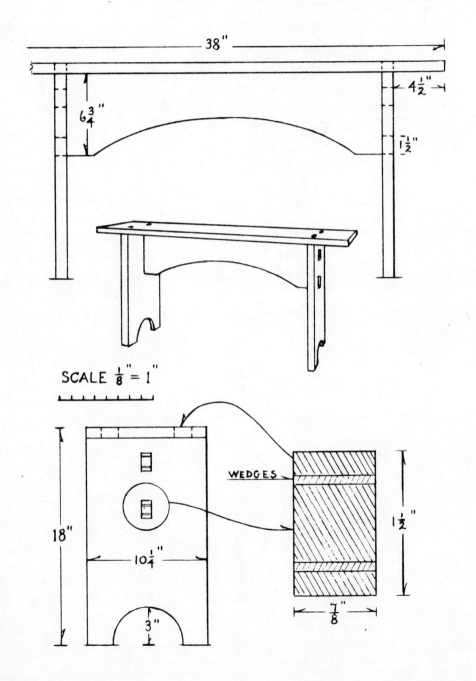

SCALE $\frac{1}{8}'' = 1''$

WEDGES

FOOT BENCHES.

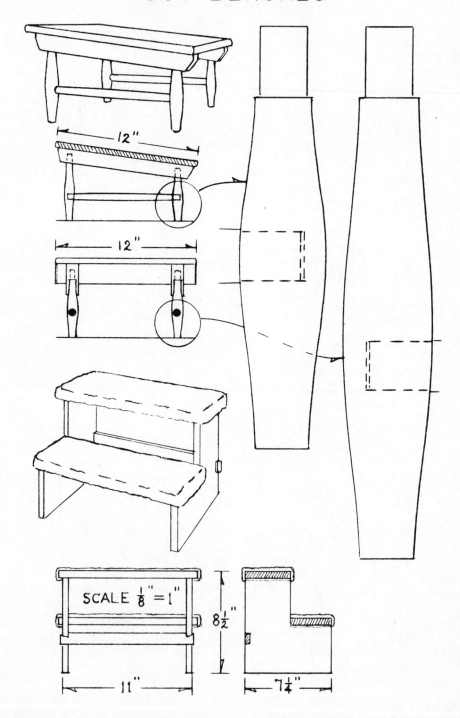

12"

12"

SCALE $\frac{1}{8}$" = 1"

$8\frac{1}{2}$"

11"

$7\frac{1}{4}$"

FOOTSTOOLS.

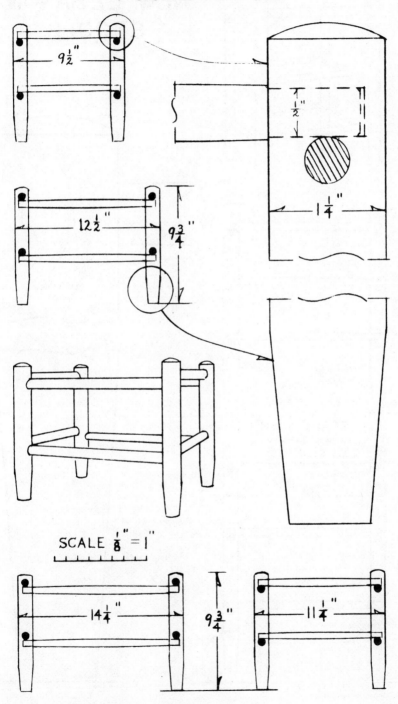

SCALE $\frac{1}{8}$" = 1"

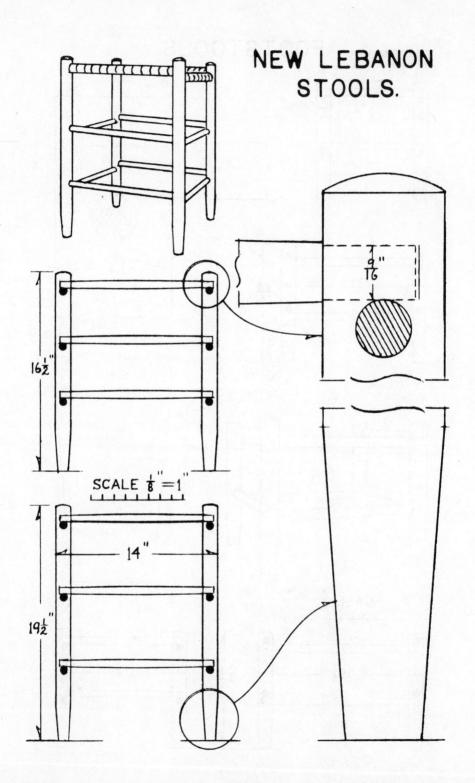

NEW LEBANON STOOLS.

SCALE $\frac{1}{8}" = 1"$

$16\frac{1}{2}"$

$19\frac{1}{2}"$

14"

$\frac{9}{16}"$

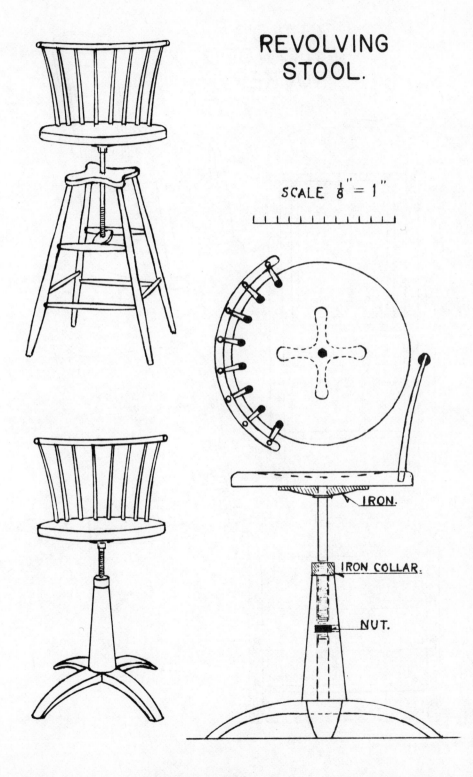

REVOLVING STOOL.

SCALE $\frac{1"}{8} = 1"$

IRON.

IRON COLLAR.

NUT.

CHILD'S
BENT-WOOD
ROCKER.

$29\frac{3}{4}$"

$12\frac{1}{2}$"

$\frac{1}{8}$" = 1"

$16\frac{1}{4}$"

BENT-WOOD
CHAIR.

38½"

⅛" = 1"

20¼"

CHILD'S CHAIR.

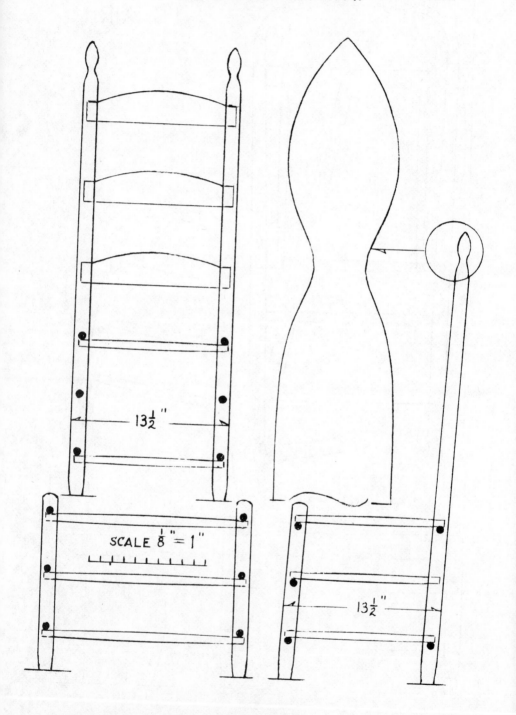

$13\frac{1}{2}$"

SCALE $\frac{1}{8}$" = 1"

$13\frac{1}{2}$"

CHILD'S CHAIR.

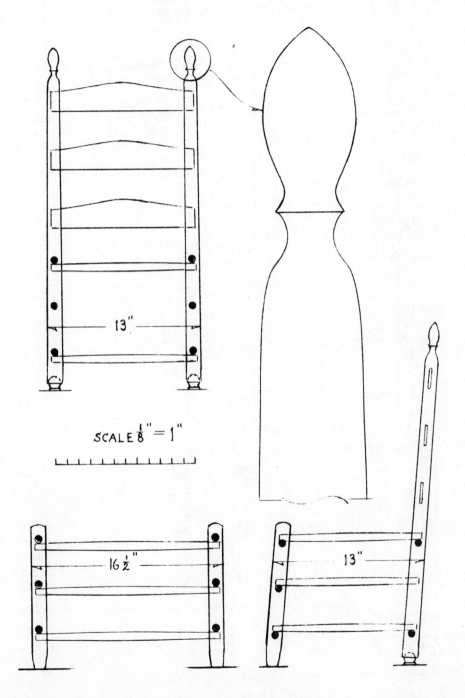

13"

SCALE ⅛" = 1"

16½"

13"

TWO-SLAT
DINING CHAIR.

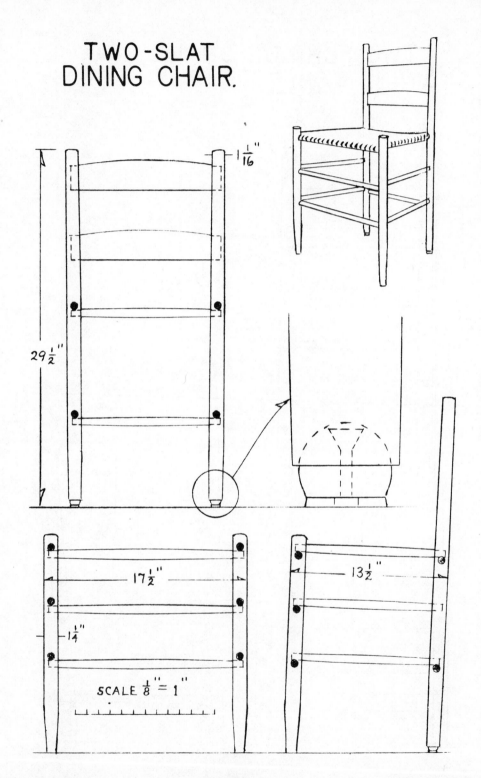

$1\frac{1}{16}''$

$29\frac{1}{2}''$

$17\frac{1}{2}''$

$1\frac{1}{4}''$

$13\frac{1}{2}''$

SCALE $\frac{1}{8}'' = 1''$

TWO-SLAT
DINING CHAIR

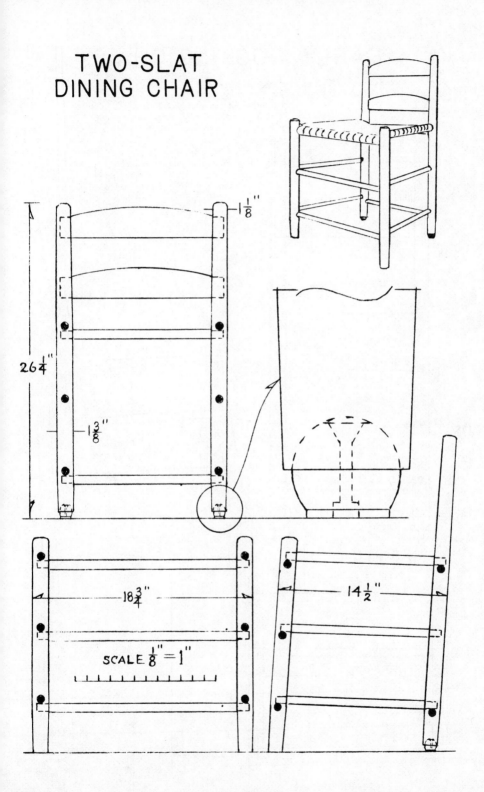

$26\frac{1}{4}$"

$1\frac{1}{8}$"

$1\frac{3}{8}$"

$18\frac{3}{4}$"

$14\frac{1}{2}$"

SCALE $\frac{1}{8}$" $=1$"

EARLY ROCKING CHAIR.

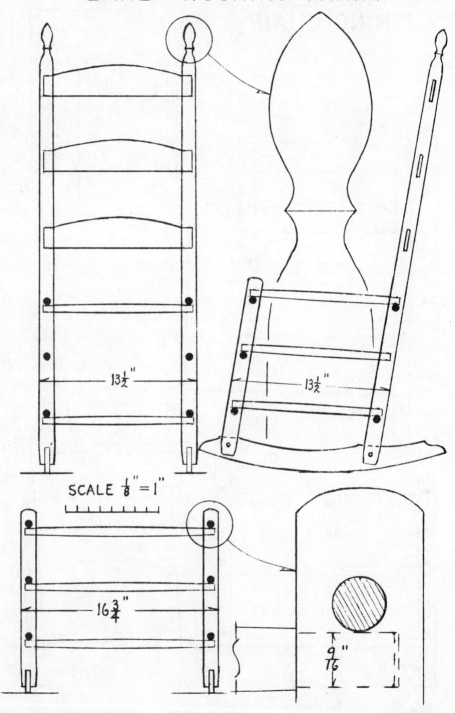

$13\frac{1}{2}"$

$13\frac{1}{2}"$

SCALE $\frac{1}{8}" = 1"$

$16\frac{3}{4}"$

$\frac{9}{16}"$

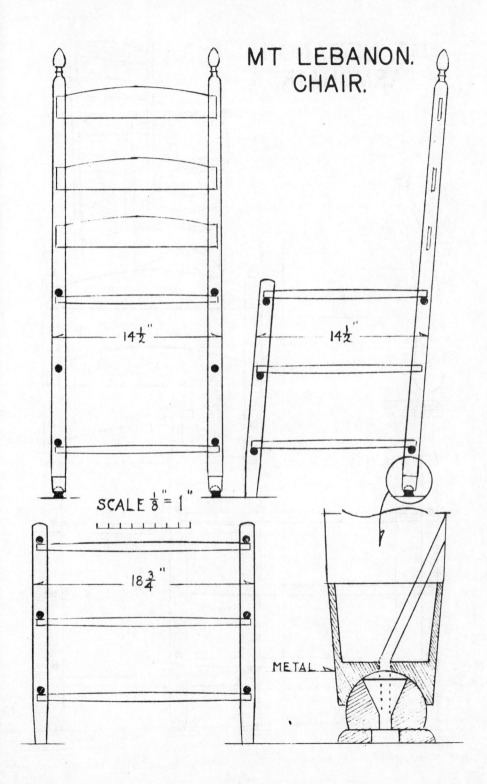

MT LEBANON. CHAIR.

14½"

14½"

SCALE ⅛" = 1"

18¾"

METAL

MT. LEBANON
ARMCHAIR.

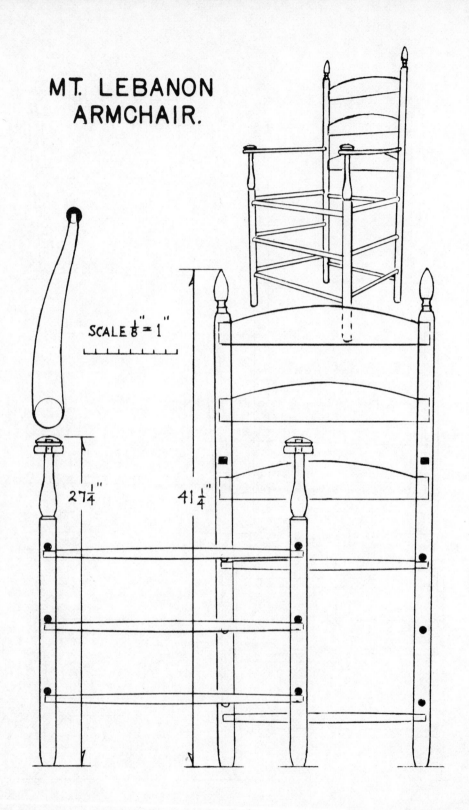

SCALE ⅛" = 1"

27¼"

41¼"

42

MT. LEBANON ARMCHAIR.

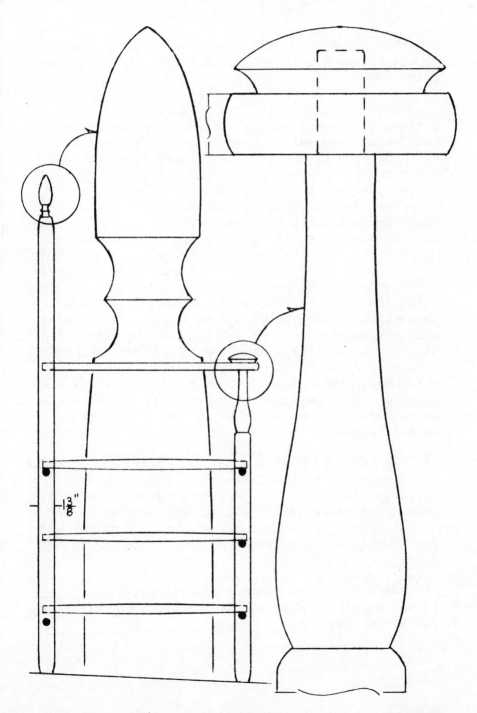

$1\frac{3}{8}"$

MT. LEBANON CHAIRS.

The following quotations and the descriptions on the Plates are taken from a Shaker chair catalog dated 1876.

" . . . a description and a representation of the different sizes of chairs and foot benches which we manufacture and sell. We would also call attention of the public to the fact that there is no other chair manufactory which is owned and operated by the Shakers, except the one which is now in operation and owned and operated by the Society of Shakers, at Mount Lebanon, Columbia, county, N. Y. We deem it a duty we owe the public to enlighten them in this matter, owing to the fact that there are now several manufacturers of chairs who have made and introduced into market an imitation of our own styles of chairs, which they sell for Shakers' Chairs, and which are unquestionably bought by the public generally under the impression that they are the real genuine article, made by the Shakers at their establishment in Mount Lebanon, N. Y. Of all the imitations of our chairs which have come under our observation, there is none which we would be willing to accept as our workmanship, nor would we be willing to stake our reputation on their merits.

"The increasing demand for our chairs has prompted us to increase the facilities for producing and improving them. We have spared no expense or labor in our endeavors to produce an article that cannot be surpassed in any respect, and which combines all the advantages of durability, simplicity and lightness.

"The bars across the top of back posts are intended for cushions, but will be furnished to order without additional cost.

"Many of our friends who see the Shakers' chairs
for the first time may be led to suppose that the
chair business is a new thing for the Shakers to
engage in. This is not the fact, however, and may
surprise even some of the oldest manufacturers to
learn that the Shakers were pioneers in the business
after the establishment of the independence of the
country.

"The principles as well as the rules of the Soci-
ety forbid the trustees or any of their assistants
doing business on the credit system, either in the
purchase or sale of merchandise, or making bargains
or contracts. This we consider good policy, and a
safe way of doing business, checking speculative or
dishonest propensities, and averting financial panics
and disasters. We sell with the understanding that
all bills are to be cash.

"Look for our trade-mark before purchasing - no
chair is genuine without it. Our trade-mark is a
gold transfer, and is designed to be ornamental; but,
if objectionable to purchasers, it can be easily
removed without defacing the furniture in the least,
by wetting a sponge or piece of cotton cloth with
AQUA AMMONIA, and rubbing it until it is loosened."

The Shakers' Slat Back Chairs, with Rockers.

WORSTED LACE SEATS.

Showing a Comparison of Sizes.

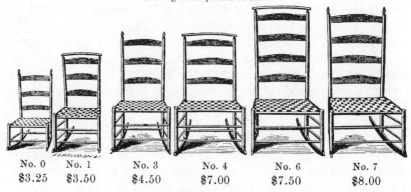

No. 0	No. 1	No. 3	No. 4	No. 6	No. 7
$3.25	$3.50	$4.50	$7.00	$7.50	$8.00

The Shakers' Web Back Chairs, With Rockers.

WORSTED LACE SEATS AND BACKS.

Showing a Comparison of Sizes.

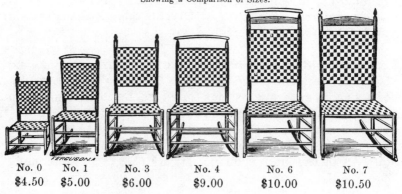

No. 0	No. 1	No. 3	No. 4	No. 6	No. 7
$4.50	$5.00	$6.00	$9.00	$10.00	$10.50

THE SHAKERS' UPHOLSTERED CHAIRS.

WITHOUT ARMS.

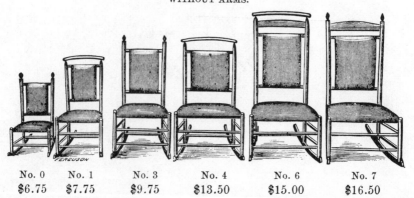

No. 0	No. 1	No. 3	No. 4	No. 6	No. 7
$6.75	$7.75	$9.75	$13.50	$15.00	$16.50

46

The Shakers' Slat Back Chairs, with Arms and Rockers.

WORSTED LACE SEATS.

Showing a Comparison of Sizes.

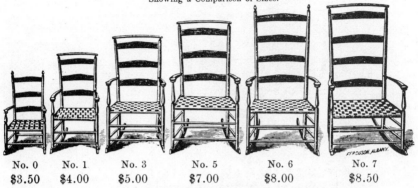

No. 0	No. 1	No. 3	No. 5	No. 6	No. 7
$3.50	$4.00	$5.00	$7.00	$8.00	$8.50

The Shakers' Web Back Chairs, with Arms and Rockers.

WORSTED LACE SEATS AND BACKS.

Showing a Comparison of Sizes.

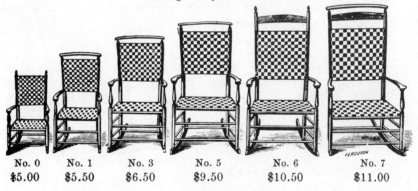

No. 0	No. 1	No. 3	No. 5	No. 6	No. 7
$5.00	$5.50	$6.50	$9.50	$10.50	$11.00

THE SHAKERS' UPHOLSTERED CHAIRS.

WITH ARMS AND ROCKERS.

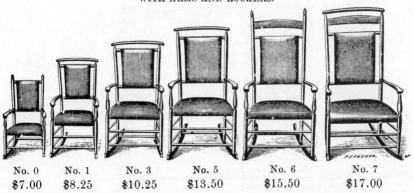

No. 0	No. 1	No. 3	No. 5	No. 6	No. 7
$7.00	$8.25	$10.25	$13.50	$15.50	$17.00

MT. LEBANON CHAIR NO. 7.

"This is our largest chair, and
on the top of the back posts is a
bar which we attach to all the chairs
which are designed for cushions.

"We have this chair with or with-
out rockers or arms.

"Remember that all chairs are
imitations which are not made and
sold by the Society of Shakers,
Mount Lebanon, N. Y. Don't let any
outside party sell you the imitation
or spurious chairs which may bear
the name of Shaker chair."

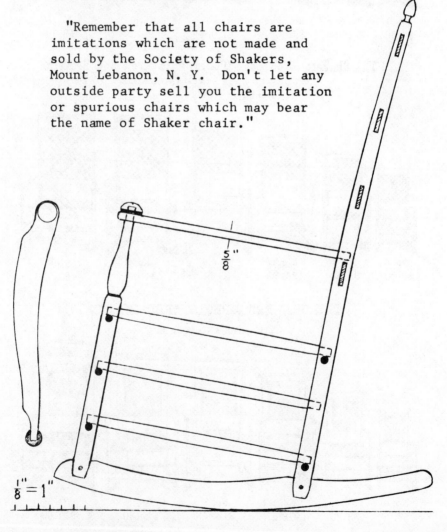

$\frac{5}{8}$"

$\frac{1}{8}" = 1"$

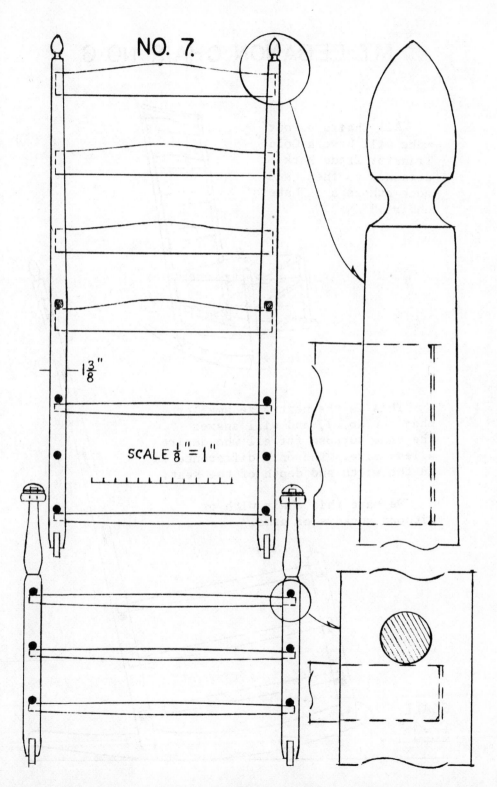

NO. 7.

$1\frac{3}{8}$"

SCALE $\frac{1}{8}$" = 1"

MT. LEBANON CHAIR NO. 6.

"All Chairs of our
make will have a Gold
Transfer Trade Mark
attached to them, and
none others are Shakers'
Chairs."

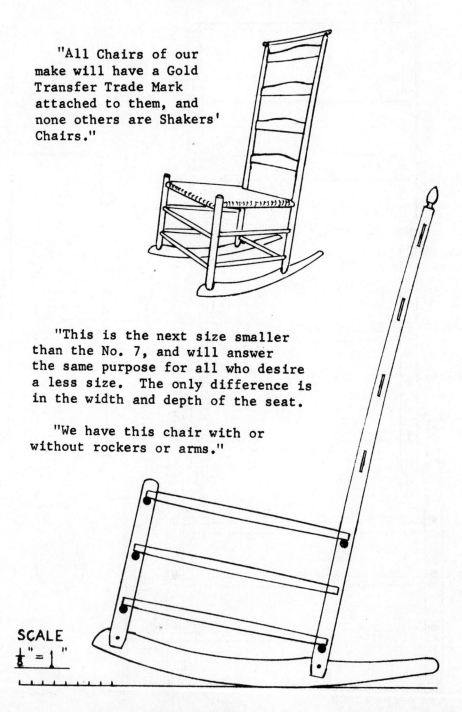

"This is the next size smaller
than the No. 7, and will answer
the same purpose for all who desire
a less size. The only difference is
in the width and depth of the seat.

"We have this chair with or
without rockers or arms."

SCALE
¼" = 1"

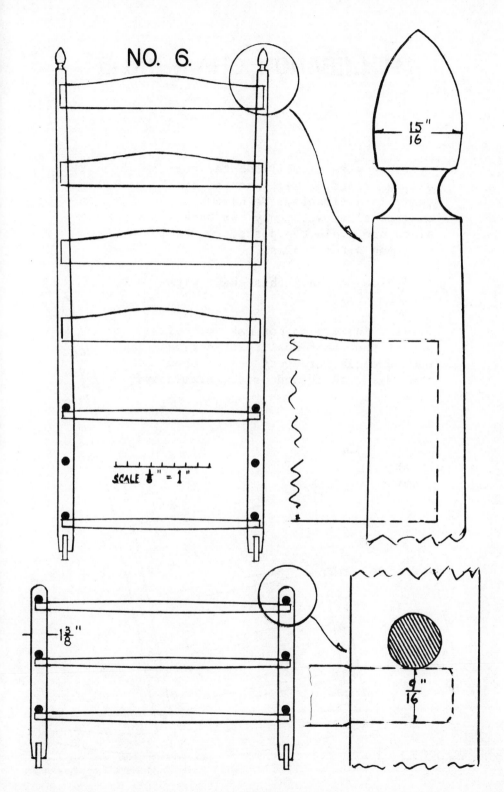

NO. 6.

SCALE $\frac{1}{8}$" = 1"

$\frac{15}{16}$"

$1\frac{3}{8}$"

$\frac{9}{16}$"

MT. LEBANON CHAIR NO. 5.

"This size is well adapted for dining or office use, when an arm chair is desirable. We have a smaller size, with only two back slats and plain top posts, for table use, and without arms.

"We do not have this chair without the arms.

"The Shakers do not make or sell any of the cheap quality of chairs, but we claim for every one of them the same quality and price invariably."

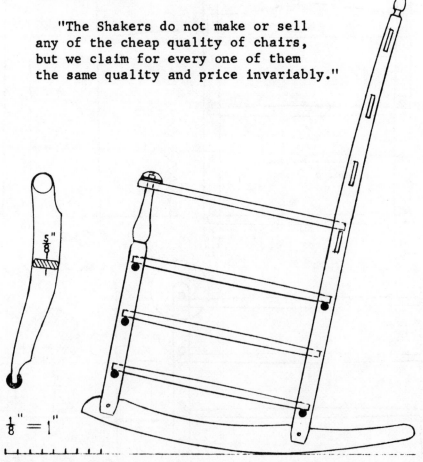

$\frac{1}{8}'' = 1''$

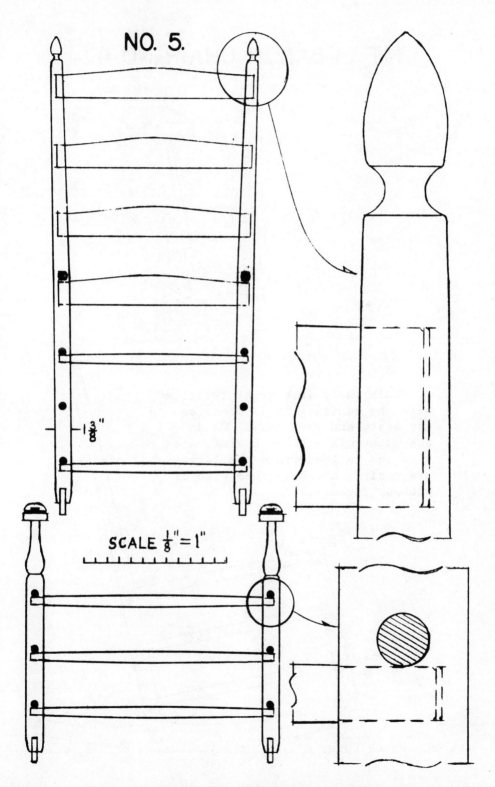

NO. 5.

$1\frac{3}{8}$"

SCALE $\frac{1}{8}$" = 1"

MT. LEBANON CHAIR NO. 4.

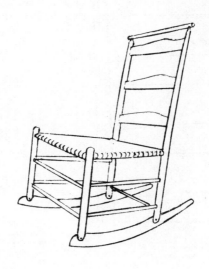

"This chair is a great favorite
with the ladies. It is broad on
the seat, and very easy. We do
not make this size with arms, and
the back is lower than the large
arm chairs, but have them with or
without rockers."

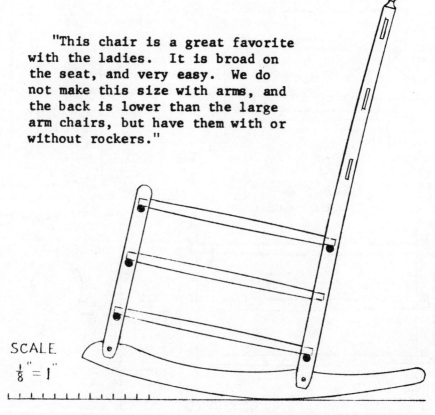

SCALE
$\frac{1}{8}'' = 1''$

MT. LEBANON CHAIR NO. 4.

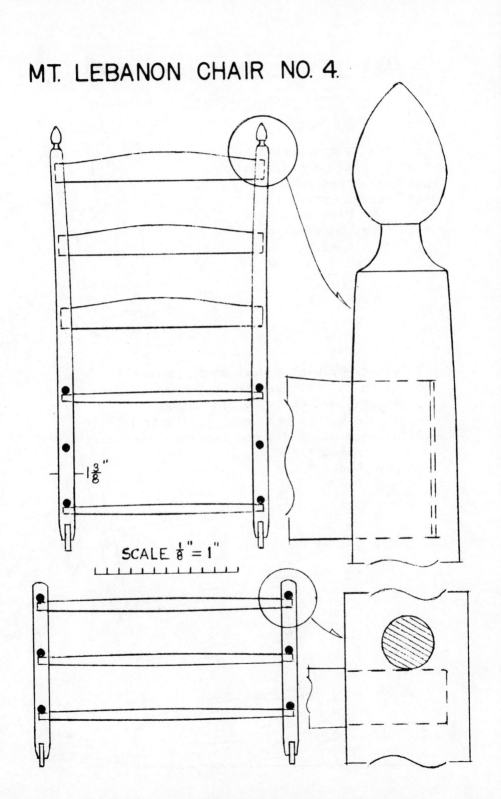

SCALE $\frac{1}{8}" = 1"$

$1\frac{3}{8}"$

MT. LEBANON CHAIR NO. 3.

"This is a favorite
sewing chair, and for all
general purposes about
the chamber and sitting
room. We have this size
with arms, rockers, or
without either."

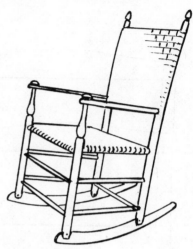

"Those who want a very comfortable
chair, and do not want to expend enough
for a cushioned chair, would do well
to get one with a web back. It is both
comfortable and neat, and requires only
a trifling additional cost more than
the slat backs."

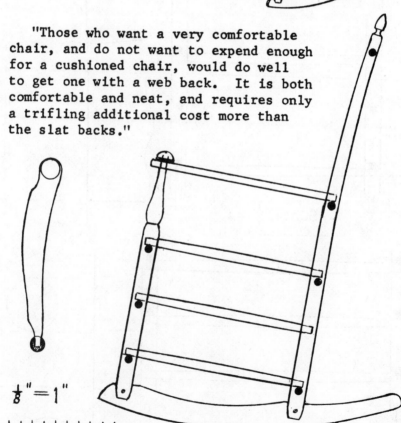

$\frac{1}{8}" = 1"$

MT. LEBANON CHAIR NO. 3.

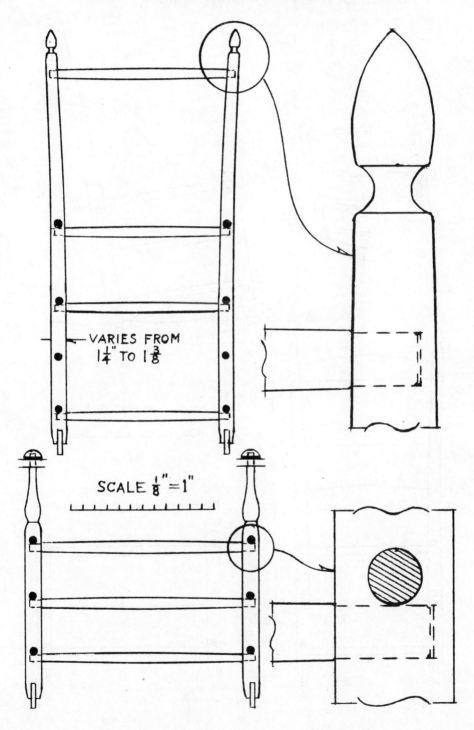

VARIES FROM 1¼" TO 1⅜

SCALE ⅛" = 1"

MT. LEBANON CHAIR NO. I.

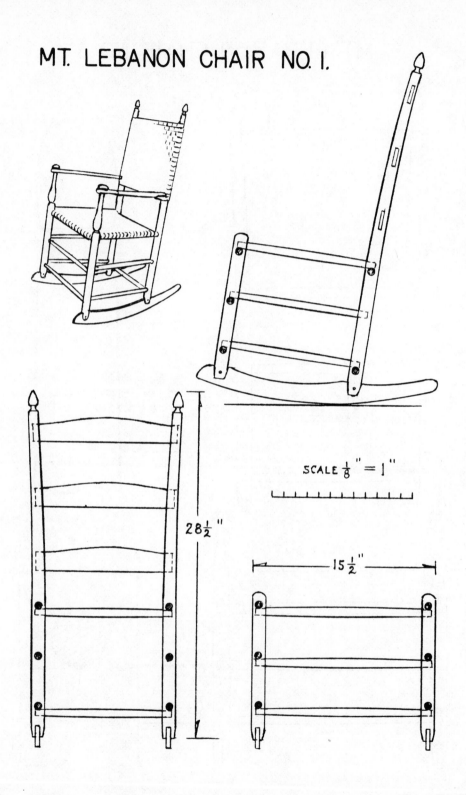

SCALE $\frac{1}{8}$" = 1"

$28\frac{1}{2}$"

$15\frac{1}{2}$"

MT. LEBANON CHAIR NO. I.

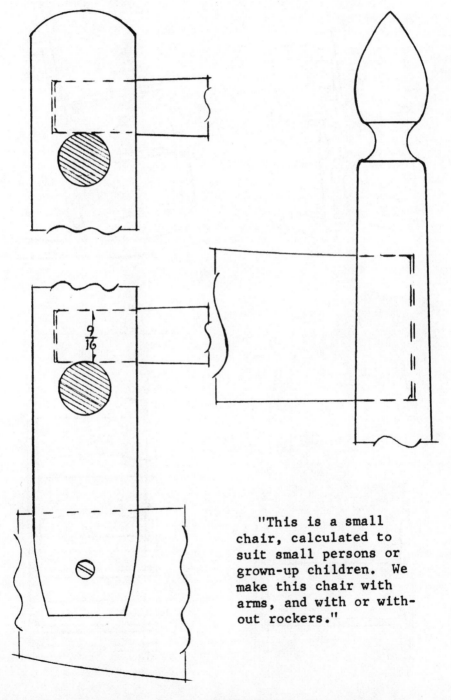

$\frac{9}{16}$

"This is a small chair, calculated to suit small persons or grown-up children. We make this chair with arms, and with or without rockers."

MT. LEBANON CHAIR NO. O.

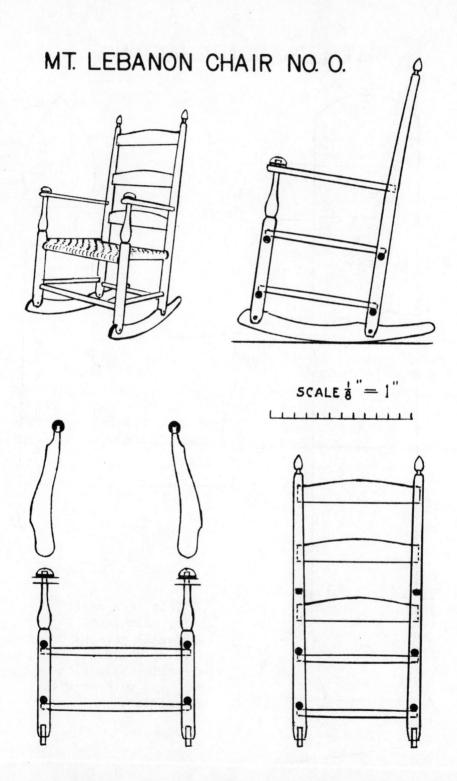

SCALE $\frac{1}{8}$" = 1"

MT. LEBANON CHAIR NO. O.

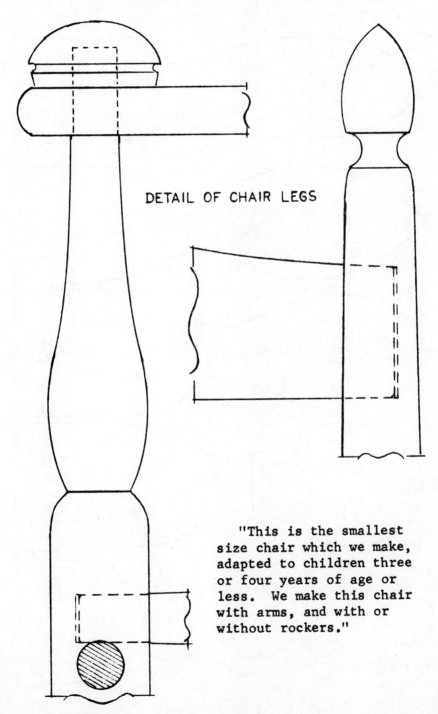

DETAIL OF CHAIR LEGS

"This is the smallest size chair which we make, adapted to children three or four years of age or less. We make this chair with arms, and with or without rockers."

CHAIR FINIALS.

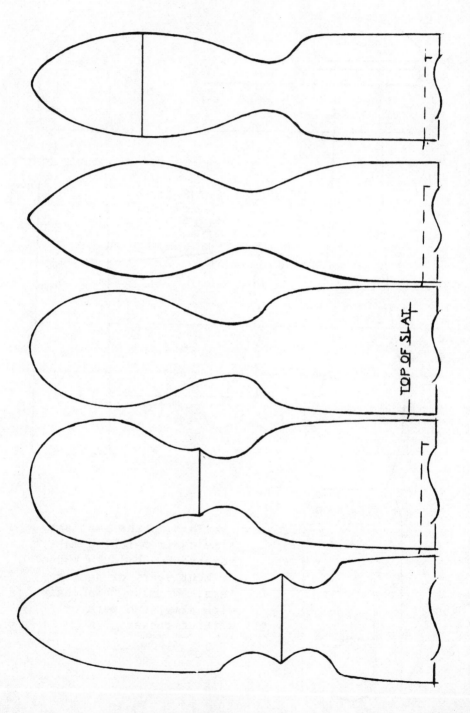

TOP OF SLAT

CHAIR FINIALS.

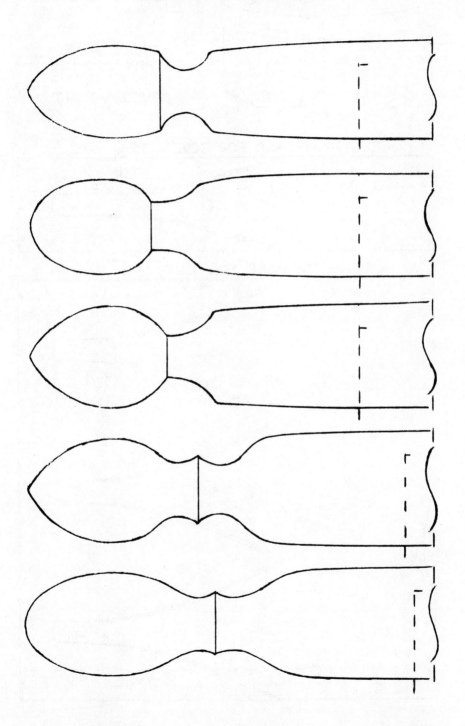

OVAL BOX.

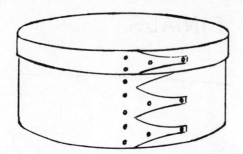

INSIDE MEAS.
OF BOX $7\frac{1}{2}"\times 10\frac{7}{8}"$

COVER TO FIT

LENGTH OF BAND FOR COVER $35\frac{7}{8}"$

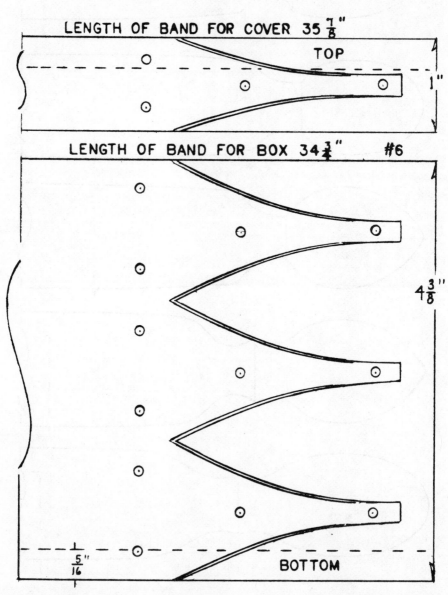

TOP

1"

LENGTH OF BAND FOR BOX $34\frac{3}{4}"$ #6

$4\frac{3}{8}"$

$\frac{5}{16}"$

BOTTOM

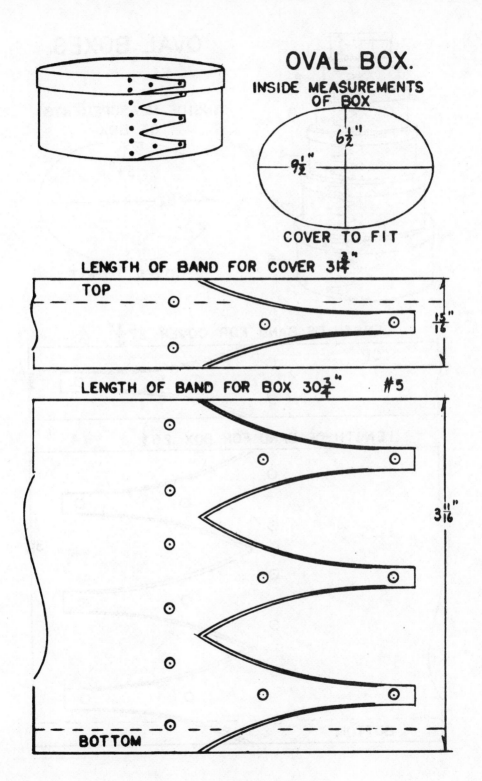

OVAL BOX.

INSIDE MEASUREMENTS OF BOX

6½"

9½"

COVER TO FIT

LENGTH OF BAND FOR COVER 31¾"

TOP

15/16"

LENGTH OF BAND FOR BOX 30¾" #5

3 11/16"

BOTTOM

OVAL BOXES.

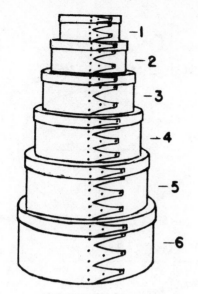

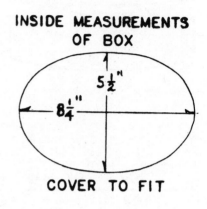

INSIDE MEASUREMENTS OF BOX

$5\frac{1}{2}"$

$8\frac{1}{4}"$

COVER TO FIT

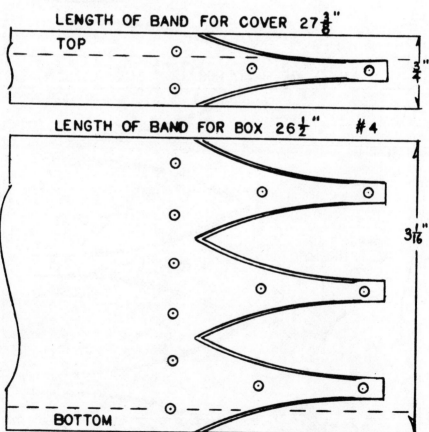

LENGTH OF BAND FOR COVER $27\frac{3}{8}"$

TOP

$\frac{3}{4}"$

LENGTH OF BAND FOR BOX $26\frac{1}{2}"$ #4

$3\frac{1}{16}"$

BOTTOM

OVAL BOXES.

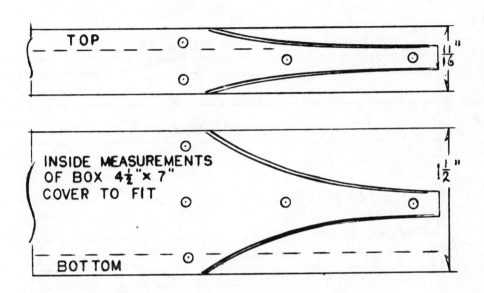

TOP

INSIDE MEASUREMENTS
OF BOX 4½"× 7"
COVER TO FIT

BOTTOM

$\frac{11}{16}$"

$1\frac{1}{2}$"

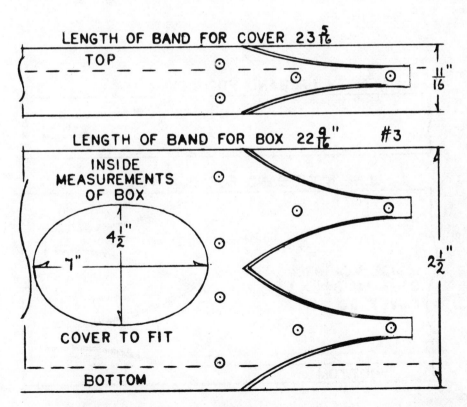

LENGTH OF BAND FOR COVER 23$\frac{5}{16}$

TOP

$\frac{11}{16}$"

LENGTH OF BAND FOR BOX 22$\frac{9}{16}$" #3

INSIDE
MEASUREMENTS
OF BOX

4½"

7"

COVER TO FIT

BOTTOM

$2\frac{1}{2}$"

OVAL BOXES.

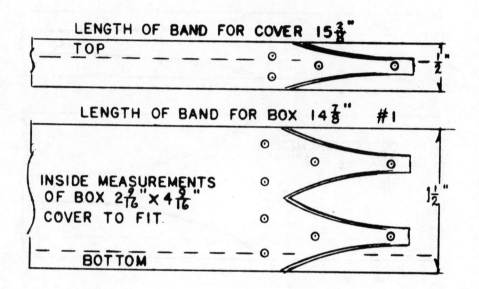

LENGTH OF BAND FOR COVER $15\frac{3}{8}''$

TOP

$\frac{1}{2}''$

LENGTH OF BAND FOR BOX $14\frac{7}{8}''$ #1

INSIDE MEASUREMENTS
OF BOX $2\frac{9}{16}'' \times 4\frac{9}{16}''$
COVER TO FIT.

BOTTOM

$1\frac{1}{2}''$

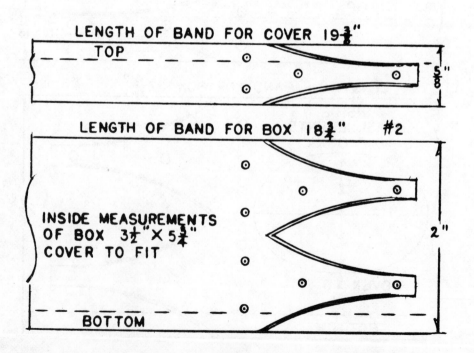

LENGTH OF BAND FOR COVER $19\frac{3}{8}''$

TOP

$\frac{5}{8}''$

LENGTH OF BAND FOR BOX $18\frac{3}{4}''$ #2

INSIDE MEASUREMENTS
OF BOX $3\frac{1}{2}'' \times 5\frac{3}{4}''$
COVER TO FIT

BOTTOM

$2''$

SEWING BOX.

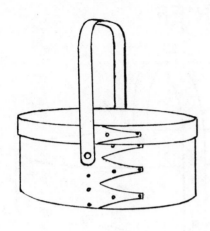

INSIDE MEASUREMENTS OF BOX

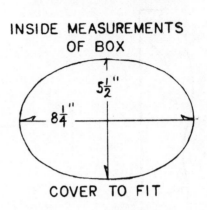

$5\frac{1}{2}''$

$8\frac{1}{4}''$

COVER TO FIT

LENGTH OF BAND FOR COVER $27\frac{3}{8}''$

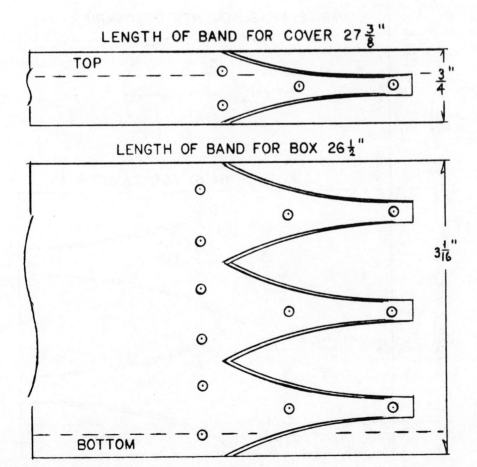

TOP

$\frac{3}{4}''$

LENGTH OF BAND FOR BOX $26\frac{1}{2}''$

$3\frac{1}{16}''$

BOTTOM

CARRIER.

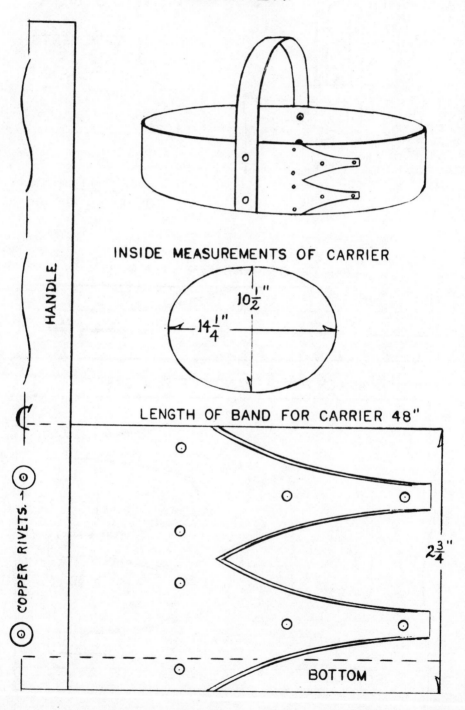

HANDLE

INSIDE MEASUREMENTS OF CARRIER

$10\frac{1}{2}''$

$14\frac{1}{4}''$

LENGTH OF BAND FOR CARRIER 48"

COPPER RIVETS.

$2\frac{3}{4}''$

BOTTOM

CARRIERS.

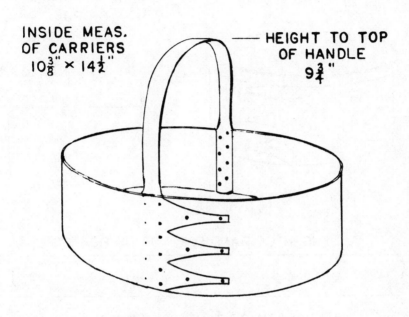

INSIDE MEAS.
OF CARRIERS
$10\frac{3}{8}" \times 14\frac{1}{2}"$

HEIGHT TO TOP
OF HANDLE
$9\frac{3}{4}"$

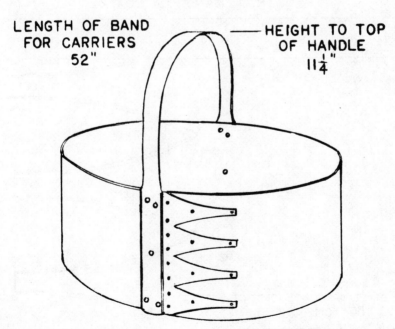

LENGTH OF BAND
FOR CARRIERS
52"

HEIGHT TO TOP
OF HANDLE
$11\frac{1}{4}"$

SPITTOON OR "SPIT-BOX"

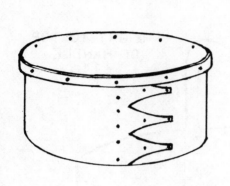

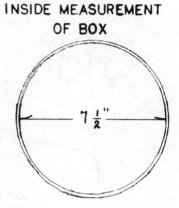

INSIDE MEASUREMENT
OF BOX

7 $\frac{1}{2}$"

LENGTH OF BAND FOR TOP OF BOX 28"

LENGTH OF BAND FOR BOX 32"

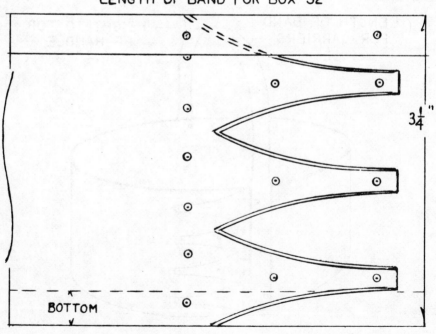

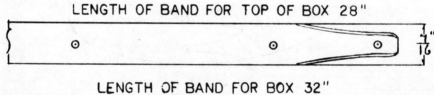

$\frac{1}{16}$"

3 $\frac{1}{4}$"

BOTTOM

PINE TRAY 9" × 15"

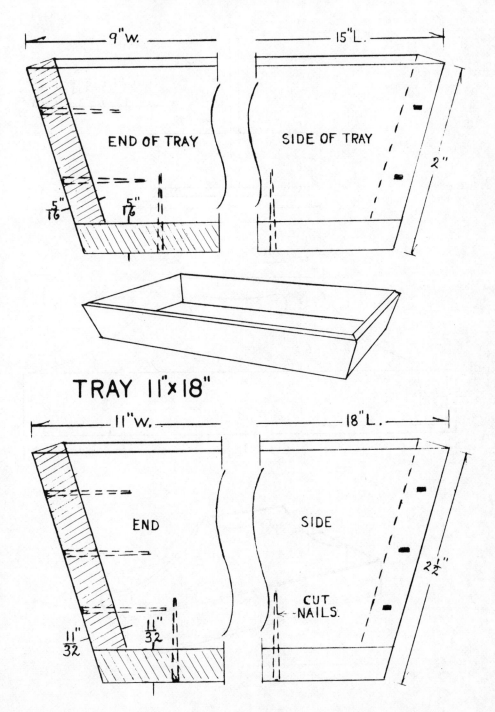

9"W.

15"L.

END OF TRAY

SIDE OF TRAY

2"

$\frac{5}{16}$" $1\frac{5}{16}$"

TRAY 11"× 18"

11"W.

18"L.

END

SIDE

$2\frac{1}{2}$"

CUT NAILS.

$\frac{11}{32}$" $\frac{11}{32}$"

DINING ROOM TRAY.

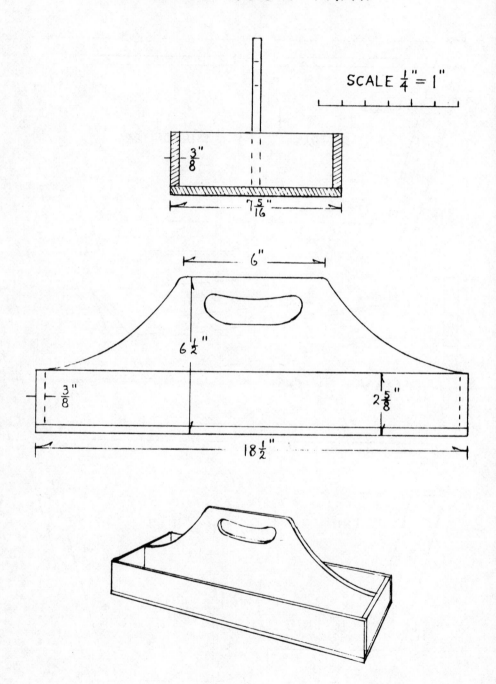

SCALE $\frac{1}{4}" = 1"$

$\frac{3}{8}"$

$7\frac{5}{16}"$

$6"$

$6\frac{1}{2}"$

$\frac{3}{8}"$

$2\frac{5}{8}"$

$18\frac{1}{2}"$

PINE DINING ROOM TRAY.

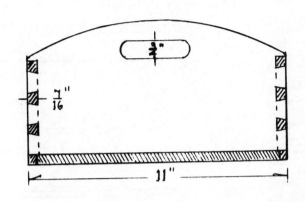

$\frac{3''}{4}$

$\frac{7''}{16}$

11"

SCALE $\frac{1}{4}'' = 1''$

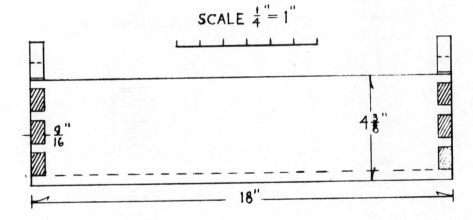

$\frac{9''}{16}$

$4\frac{3}{8}''$

18"

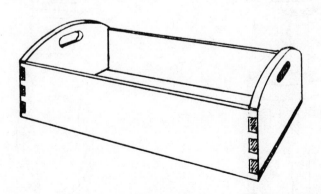

CLAMP-ON CUSHIONS.

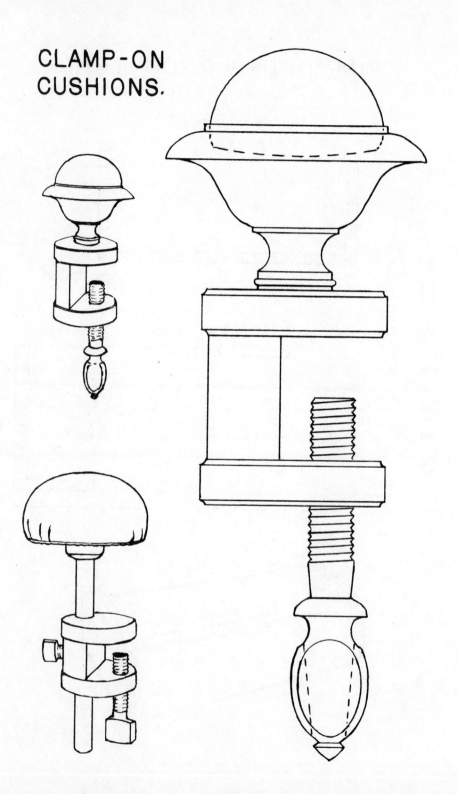

SPOOL HOLDER.

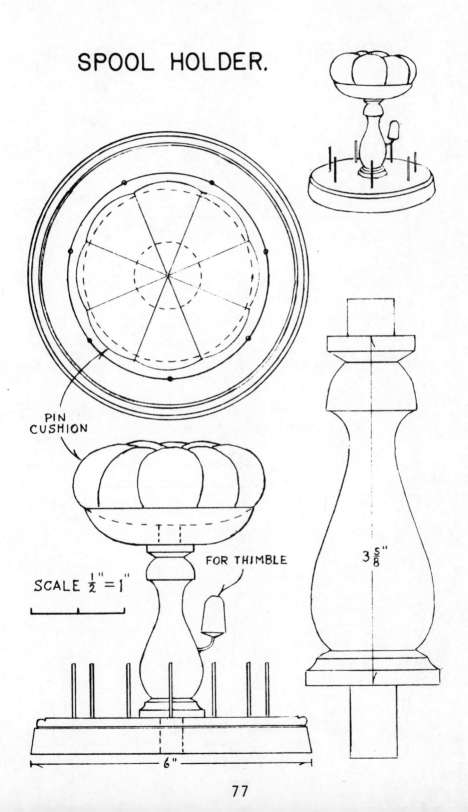

PIN
CUSHION

FOR THIMBLE

SCALE $\frac{1}{2}'' = 1''$

$3\frac{5}{8}''$

6"

DIPPER.

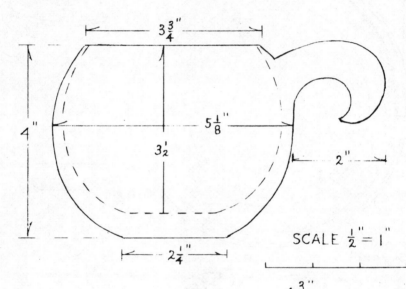

3¾"

4"

3½'

5⅛"

2"

2¼"

SCALE ½" = 1"

BERRY BOX.

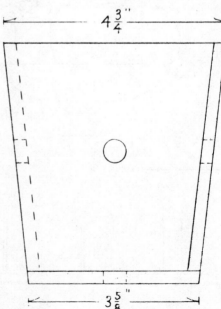

4¾"

3⅝"

DIPPER.

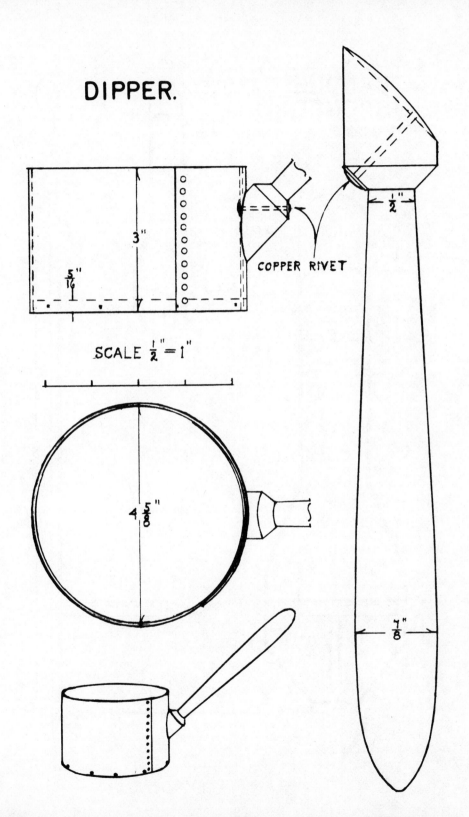

3"

$\frac{5}{16}$"

COPPER RIVET

$\frac{1}{2}$"

SCALE $\frac{1}{2}$" = 1"

4 $\frac{1}{100}$"

$\frac{7}{8}$"

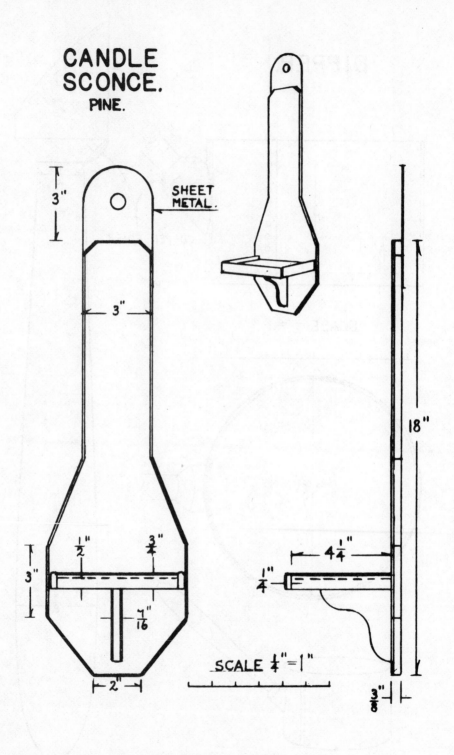

CANDLE
SCONCE.
PINE.

SHEET METAL.

3"

3"

3"

18"

4¼"

¼"

½" ¾"

7⁄16"

2"

3⁄8"

SCALE ¼" = 1"

CANDLE
SCONCE.

PINE.

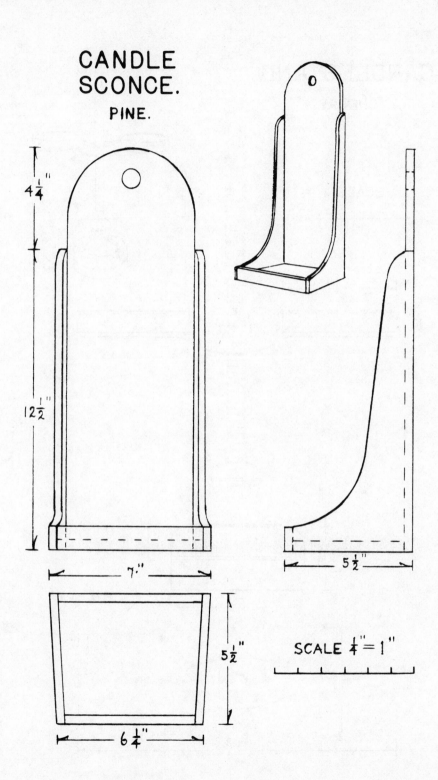

O

$4\frac{1}{4}$"

$12\frac{1}{2}$"

7."

$5\frac{1}{2}$"

$6\frac{1}{4}$"

$5\frac{1}{2}$"

SCALE $\frac{1}{4}$"= 1"

CANDLESTAND.

CHERRY

SCALE $\frac{1}{4}$" = 1"

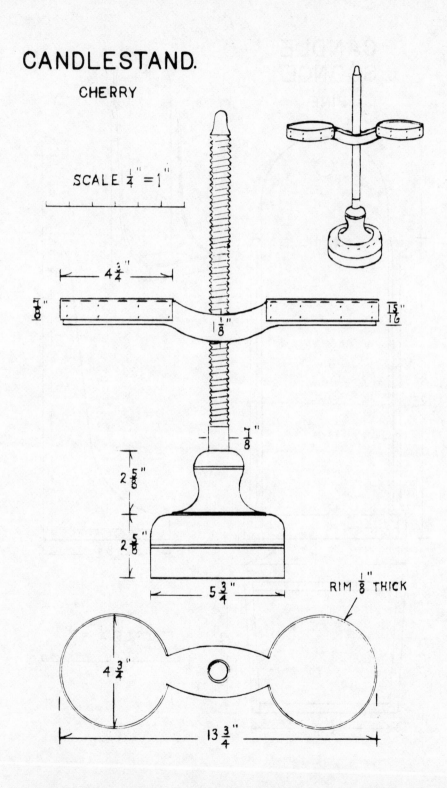

4 $\frac{3}{4}$"

$\frac{7}{8}$"

1 $\frac{1}{8}$"

$\frac{15}{16}$"

$\frac{7}{8}$"

2 $\frac{5}{8}$"

2 $\frac{5}{8}$"

5 $\frac{3}{4}$"

RIM $\frac{1}{8}$" THICK

4 $\frac{3}{4}$"

13 $\frac{3}{4}$"

COAT HANGERS.

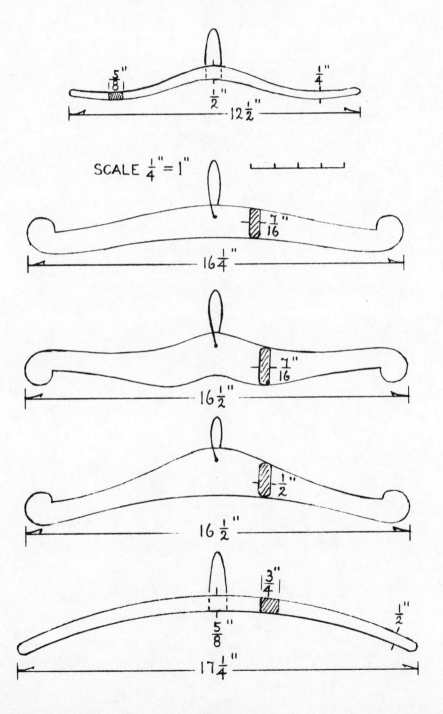

SCALE $\frac{1}{4}$" = 1"

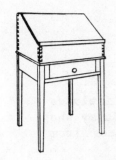
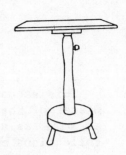

SHOP DRAWINGS
OF
SHAKER FURNITURE
AND
WOODENWARE

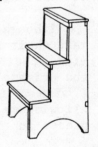

PART II

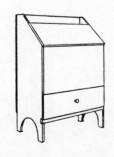
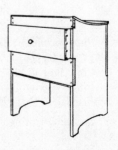

ACKNOWLEDGMENTS

This second book of "Shaker Drawings" includes pieces of Shaker furniture which have been in my shop as well as several other interesting pieces from collections mentioned below.

Special thanks are due Mrs. Edward Deming Andrews for permission to make measured drawings of several more pieces from the Andrews collection and for the help and information given me.

I am also very grateful for the cooperation and for similar help and permission at Hancock Shaker Village, Hancock, Massachusetts and the Shaker Museum, Old Chatham, New York.

Although the Shaker cabinetmakers were obliged to make their furniture and woodenware with utility in mind, their work is eagerly sought today by museums and private collectors for its simplicity and beauty. I wish to thank several of these collectors for allowing me to examine and make drawings of Shaker pieces in their possession.

E. H.

Photographs by Jane McWhorter
LC# 73-83797
Copyright © 1975 by
Ejner P. Handberg
ISBN No. 0-912944-29-3

Second Printing

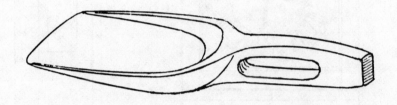

"BEAUTY RESTS ON UTILITY"

WALL CLOCK
BY I. N. YOUNGS
HANCOCK SHAKER VILLAGE, HANCOCK MASS.

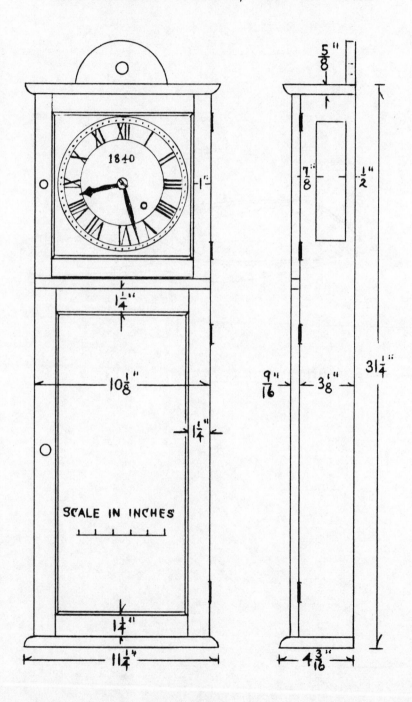

1840

SCALE IN INCHES

WALL CLOCK
BY I. N. YOUNGS
HANCOCK SHAKER VILLAGE, HANCOCK MASS.

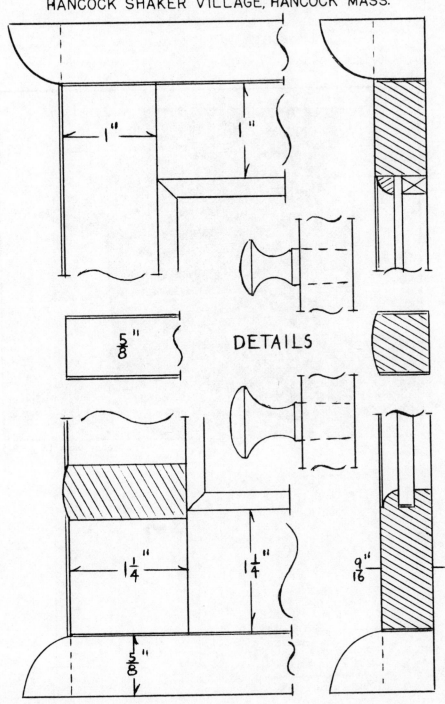

1"

1"

$\frac{5}{8}$"

DETAILS

$1\frac{1}{4}$"

$1\frac{1}{4}$"

$\frac{9}{16}$"

$\frac{5}{8}$"

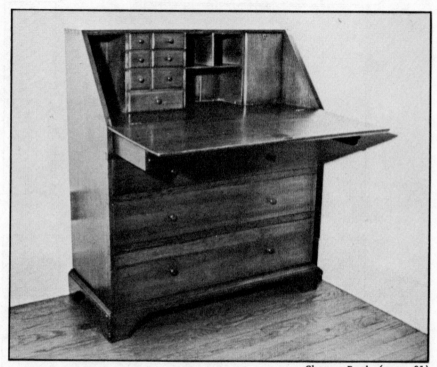

Cherry Desk (page 91)

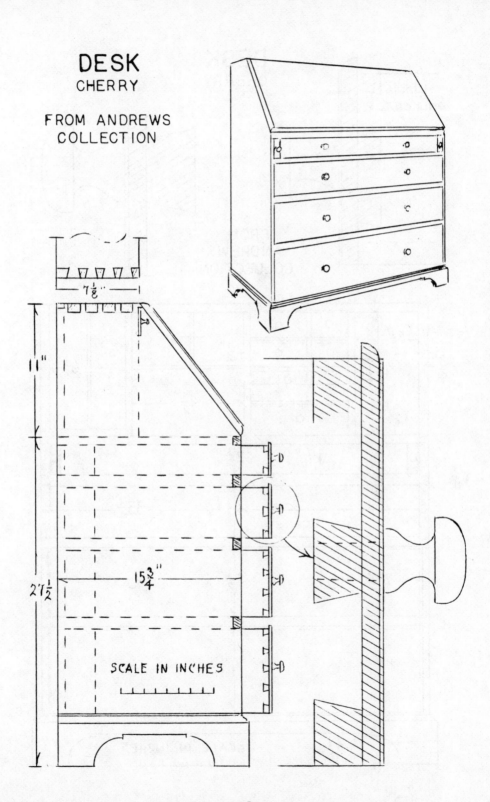

DESK
CHERRY

FROM ANDREWS
COLLECTION

$7\frac{1}{8}''$

$11''$

$27\frac{1}{2}$

$15\frac{3}{4}''$

SCALE IN INCHES

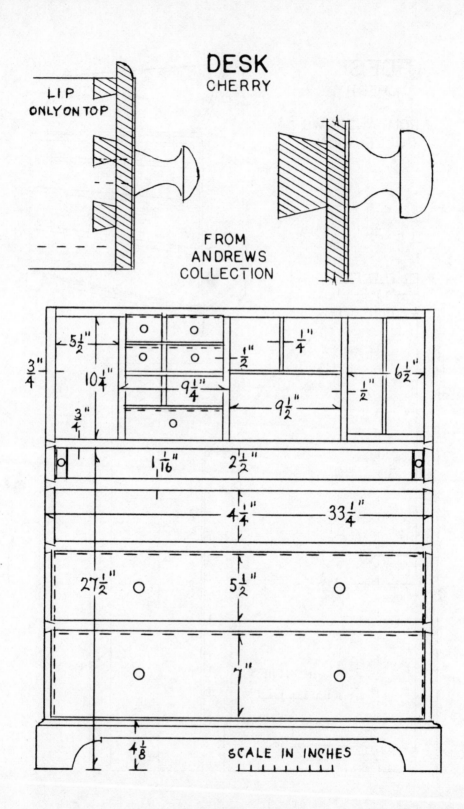

DESK
CHERRY

LIP
ONLY ON TOP

FROM
ANDREWS
COLLECTION

SCALE IN INCHES

92

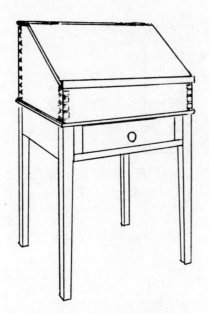

PINE DESK

THE SHAKER MUSEUM,
OLD CHATHAM, N.Y.

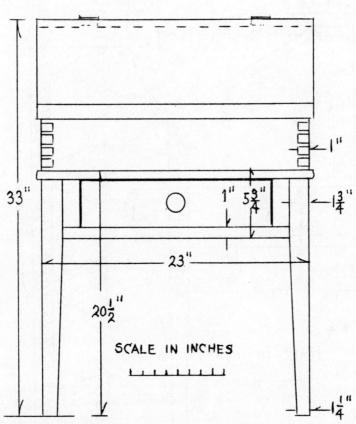

1"

33"

1" 5¾"

1¾"

23"

20½"

SCALE IN INCHES

1¼"

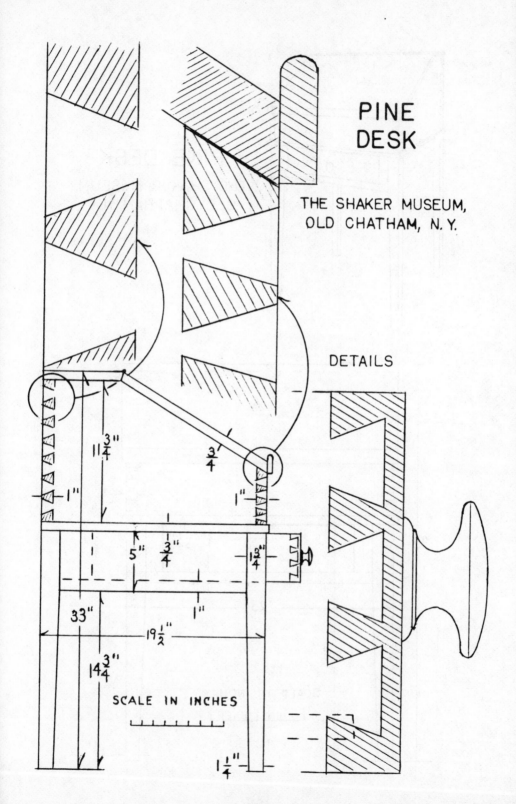

PINE
DESK

THE SHAKER MUSEUM,
OLD CHATHAM, N. Y.

DETAILS

$11\frac{3}{4}$"

$\frac{3}{4}$'

1"

1"

1

5" $\frac{3}{4}$"

$1\frac{3}{4}$"

33"

1"

$19\frac{1}{2}$"

$14\frac{3}{4}$"

SCALE IN INCHES

$1\frac{1}{4}$"

94

SEWING DESK
THE SHAKER MUSEUM, OLD CHATHAM, N.Y.

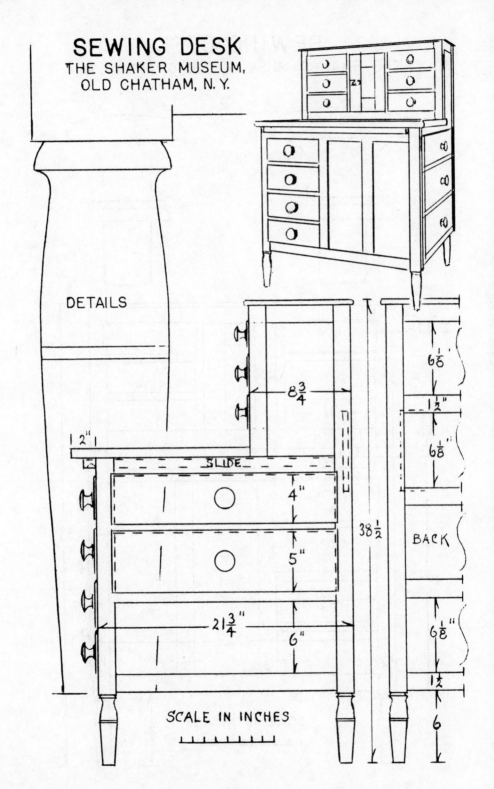

DETAILS

SLIDE

2"

8¾"

4"

5"

21¾"

6"

38½

6⅛"

1½"

6⅛"

BACK

6⅛"

1½"

6

SCALE IN INCHES

SEWING DESK
THE SHAKER MUSEUM, OLD CHATHAM, N.Y.

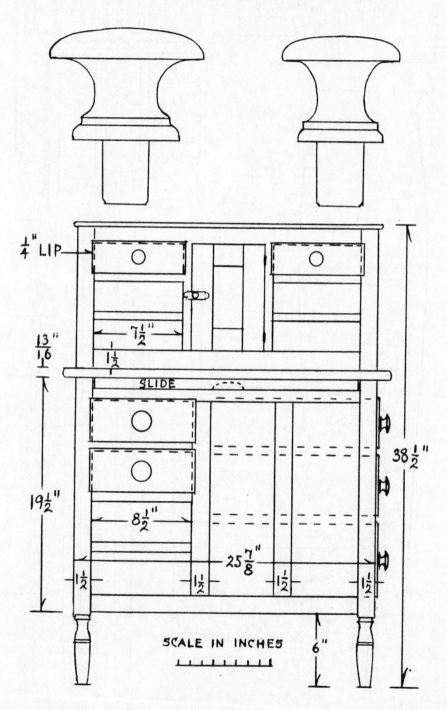

$\frac{1}{4}"$ LIP

$\frac{13}{16}"$

$1\frac{1}{2}$

SLIDE

$7\frac{1}{2}"$

$19\frac{1}{2}"$

$8\frac{1}{2}"$

$\frac{1}{2}$

$25\frac{7}{8}"$

$1\frac{1}{2}$

$1\frac{1}{2}$

$1\frac{1}{2}$

$38\frac{1}{2}"$

$6"$

SCALE IN INCHES

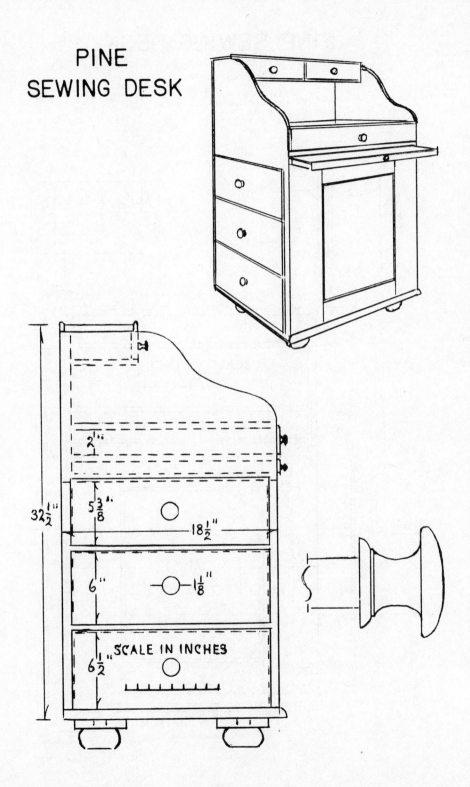

PINE
SEWING DESK

$32\frac{1}{2}$"

$2\frac{1}{2}$"

$5\frac{3}{8}$"

$18\frac{1}{2}$"

6"

$1\frac{1}{8}$"

$6\frac{1}{2}$"

SCALE IN INCHES

PINE SEWING DESK

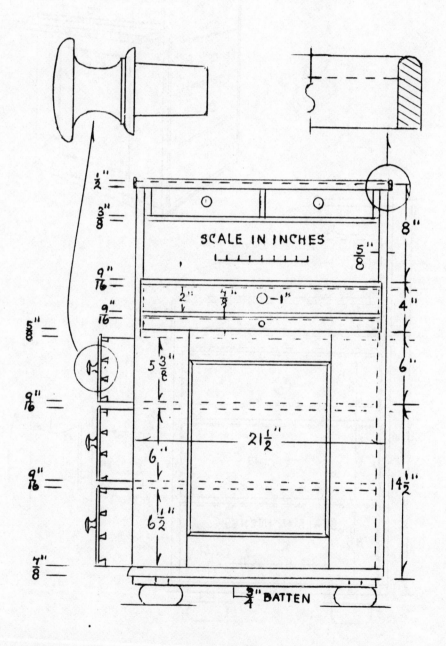

SCALE IN INCHES

$\frac{3}{4}$" BATTEN

SEWING TABLE
THE SHAKER MUSEUM, OLD CHATHAM, N.Y.
CHERRY WITH PINE TOP

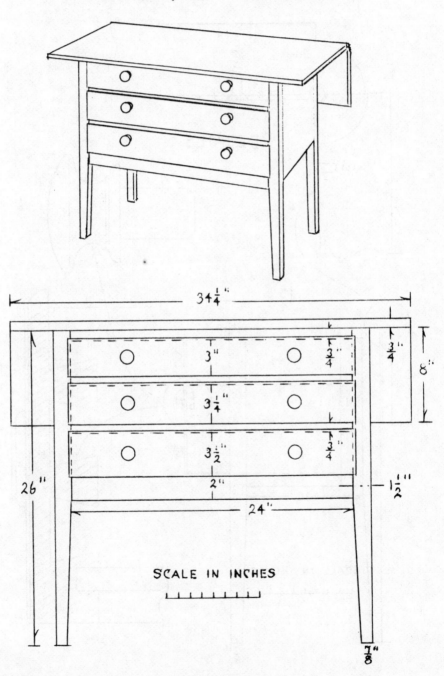

SCALE IN INCHES

SEWING TABLE
THE SHAKER MUSEUM, OLD CHATHAM, N. Y.

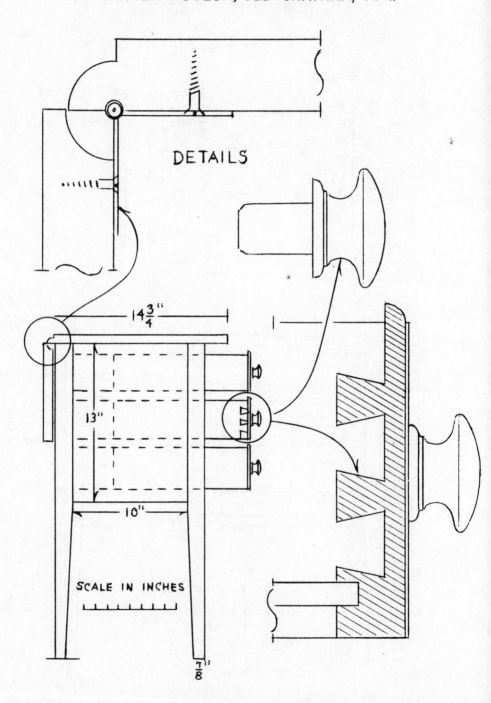

DETAILS

$14\frac{3}{4}"$

13"

10"

SCALE IN INCHES

$\frac{7}{8}"$

PINE TABLE
STAINED RED
FROM ANDREWS COLLECTION

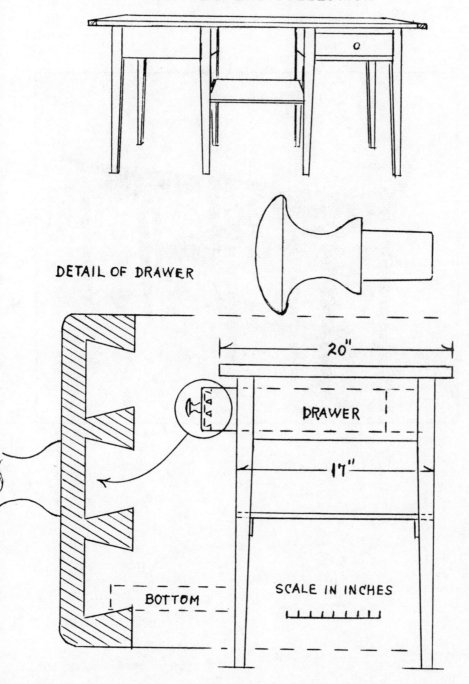

DETAIL OF DRAWER

20"

DRAWER

17"

BOTTOM

SCALE IN INCHES

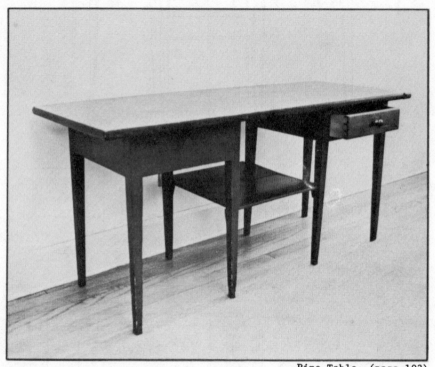

Pine Table (page 103)

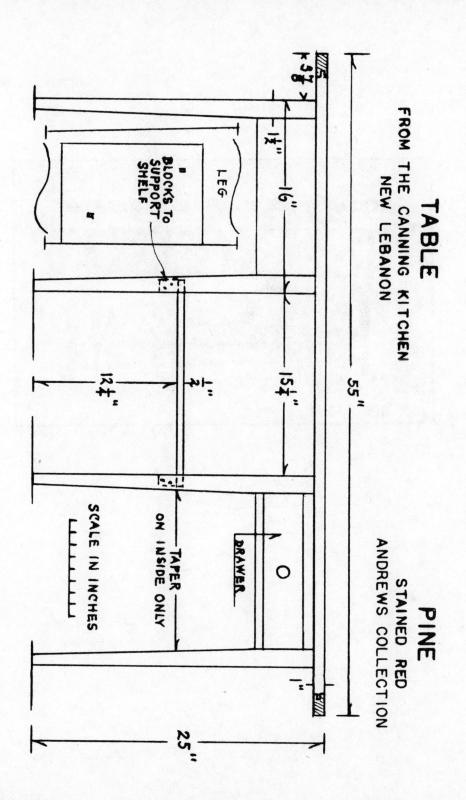

TABLE

FROM THE CANNING KITCHEN
NEW LEBANON

PINE

STAINED RED
ANDREWS COLLECTION

LEG

BLOCKS TO
SUPPORT
SHELF

DRAWER

TAPER
ON INSIDE ONLY

SCALE IN INCHES

5⅜"

1½"

16"

15¼"

55"

12¼"

½"

25"

1"

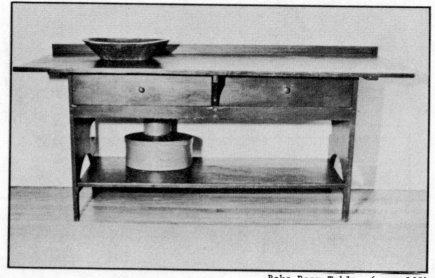

Bake-Room Table (page 105)

BAKE-ROOM TABLE

FROM ANDREWS COLLECTION

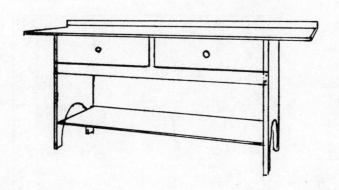

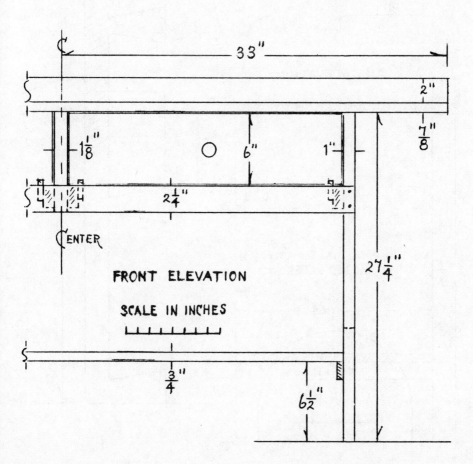

FRONT ELEVATION

SCALE IN INCHES

BAKE-ROOM TABLE

FROM ANDREWS COLLECTION

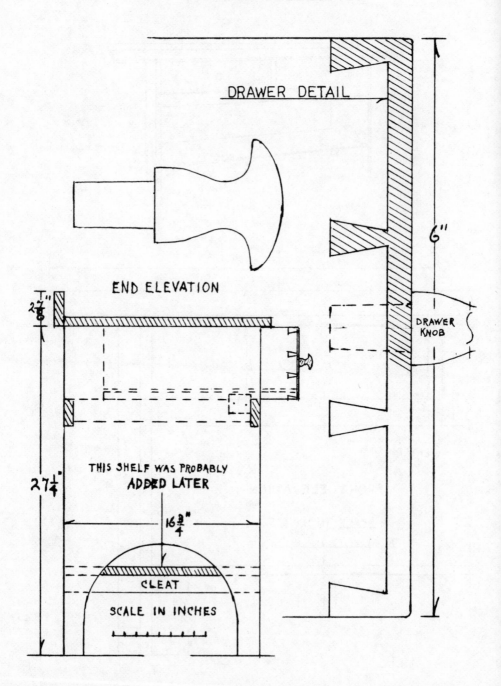

DRAWER DETAIL

END ELEVATION

$2\frac{7}{8}$"

DRAWER KNOB

6"

$27\frac{1}{4}$"

THIS SHELF WAS PROBABLY ADDED LATER

$16\frac{3}{4}$"

CLEAT

SCALE IN INCHES

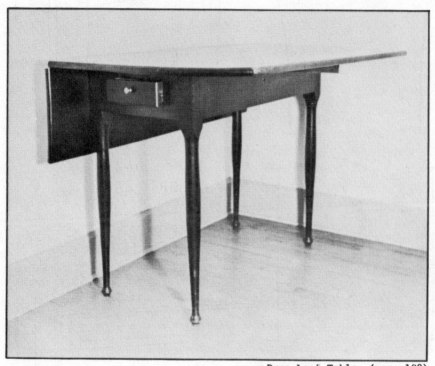
Drop-Leaf Table (page 108)

DROP-LEAF TABLE

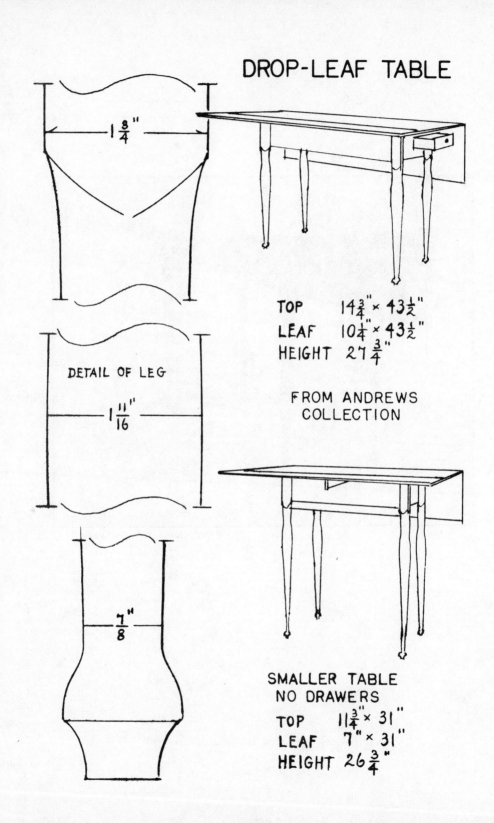

DETAIL OF LEG

$1\frac{3}{4}$"

$1\frac{11}{16}$"

$\frac{7}{8}$"

TOP $14\frac{3}{4}$"× $43\frac{1}{2}$"
LEAF $10\frac{1}{4}$"× $43\frac{1}{2}$"
HEIGHT $27\frac{3}{4}$"

FROM ANDREWS
COLLECTION

SMALLER TABLE
NO DRAWERS
TOP $11\frac{3}{4}$"× 31"
LEAF 7"× 31"
HEIGHT $26\frac{3}{4}$"

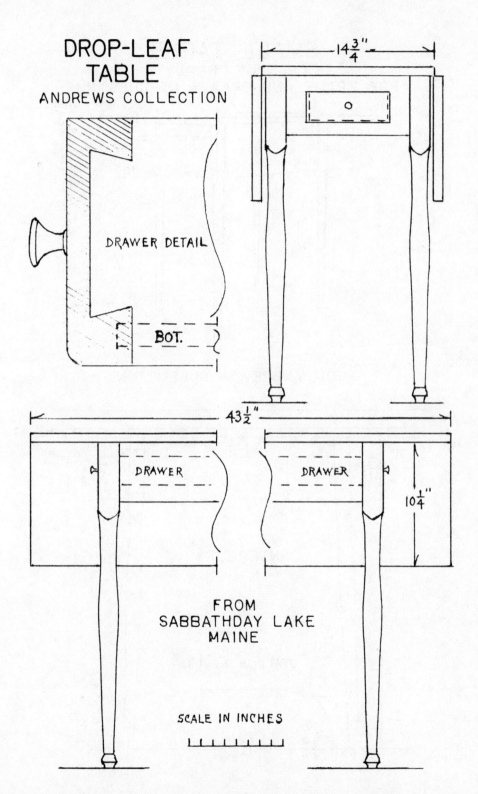

DROP-LEAF TABLE

ANDREWS COLLECTION

14¾"

DRAWER DETAIL

BOT.

43½"

DRAWER

DRAWER

10¼"

FROM
SABBATHDAY LAKE
MAINE

SCALE IN INCHES

SMALL TABLE
LEGS OF CHERRY
TOP, FRAME AND DRAWER OF CHESTNUT

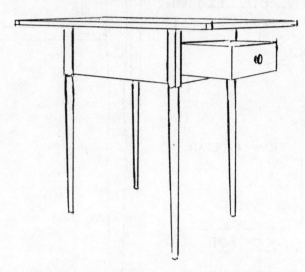

FROM ANDREWS COLLECTION

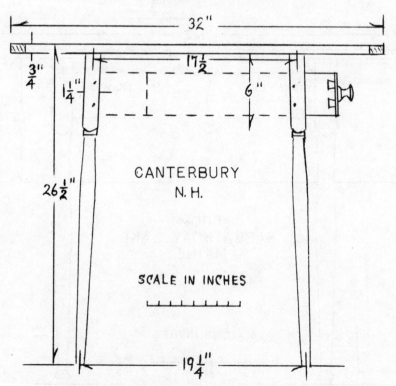

CANTERBURY
N. H.

SCALE IN INCHES

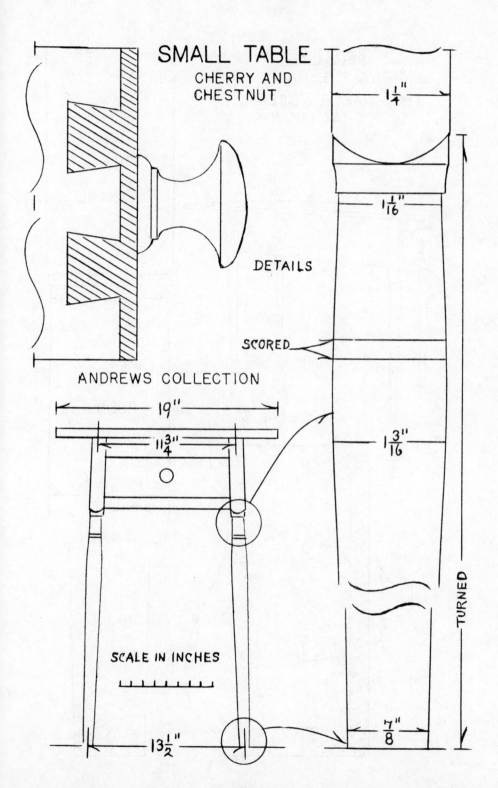

SMALL TABLE
CHERRY AND CHESTNUT

DETAILS

ANDREWS COLLECTION

$1\frac{1}{4}$"

$1\frac{1}{16}$"

SCORED

$1\frac{3}{16}$"

TURNED

19"

$11\frac{3}{4}$"

SCALE IN INCHES

$13\frac{1}{2}$"

$\frac{7}{8}$"

111

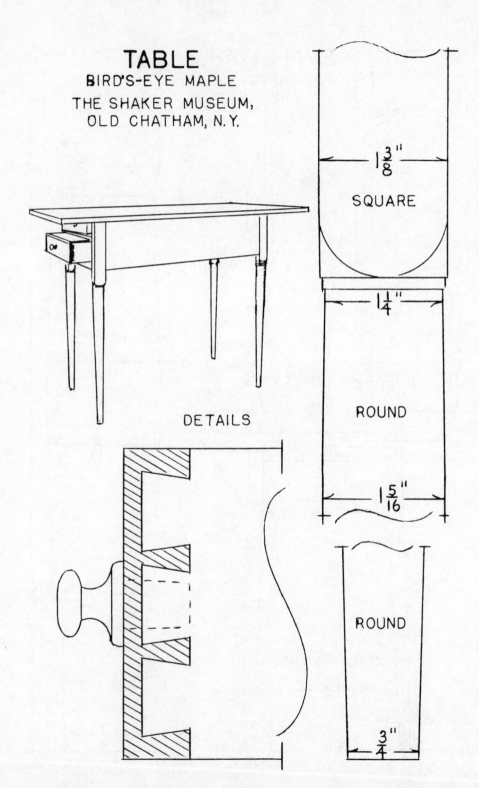

TABLE

BIRD'S-EYE MAPLE

THE SHAKER MUSEUM,
OLD CHATHAM, N.Y.

DETAILS

$1\frac{3}{8}$"

SQUARE

$1\frac{1}{4}$"

ROUND

$1\frac{5}{16}$"

ROUND

$\frac{3}{4}$"

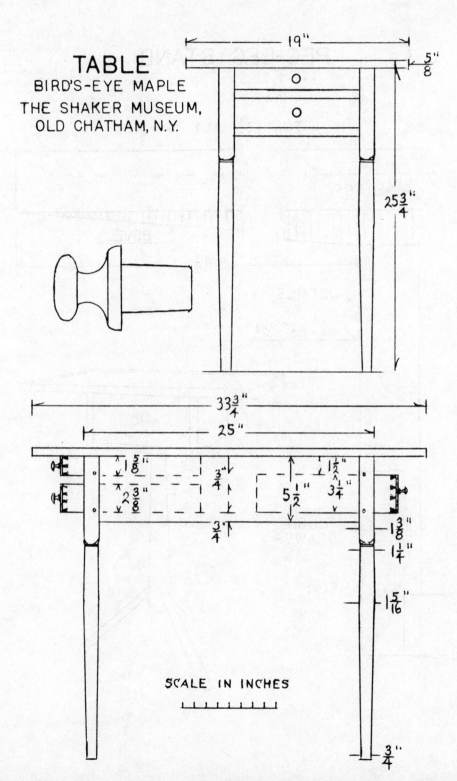

TABLE
BIRD'S-EYE MAPLE
THE SHAKER MUSEUM,
OLD CHATHAM, N.Y.

19"

$\frac{5}{8}$"

$25\frac{3}{4}$"

$33\frac{3}{4}$"

25"

$1\frac{5}{8}$"

$\frac{3}{4}$"

$1\frac{1}{2}$"

$2\frac{3}{8}$"

$5\frac{1}{2}$"

$3\frac{1}{4}$"

$1\frac{1}{4}$"

$\frac{3}{4}$"

$1\frac{3}{8}$"

$1\frac{1}{4}$"

$1\frac{5}{16}$"

$\frac{3}{4}$"

SCALE IN INCHES

PEG-LEG STAND

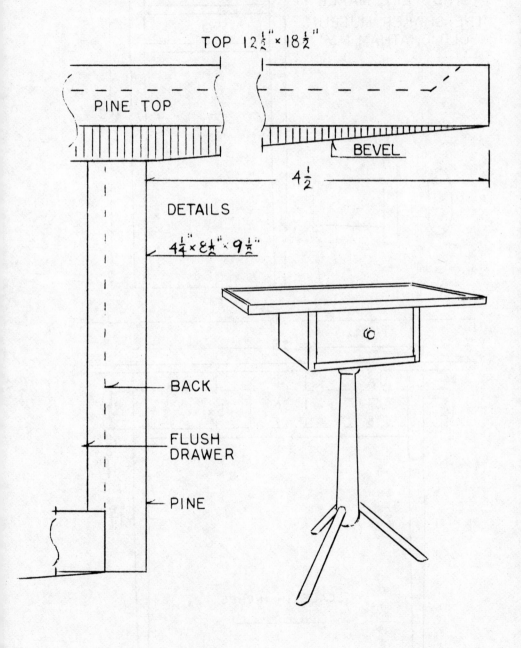

TOP 12½" × 18½"

PINE TOP

BEVEL

4½

DETAILS

4¼" × 8½" × 9½"

BACK

FLUSH
DRAWER

PINE

PEG-LEG STAND

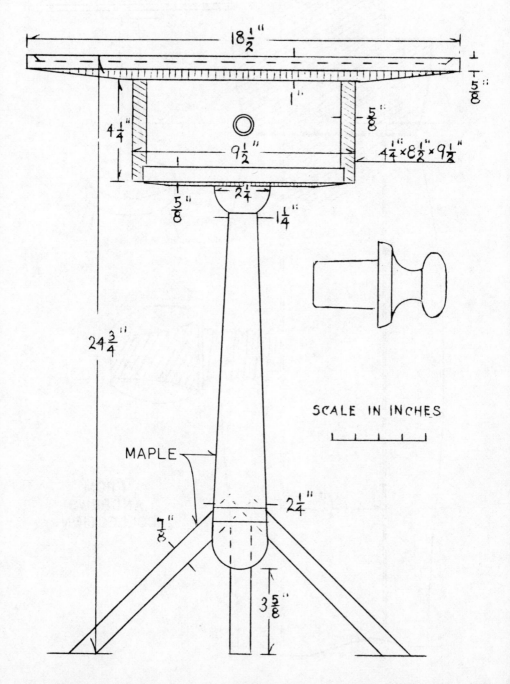

18½"

1"

⅝"

4¼"

9½"

8⅝"

4¼" × 8½" × 9½"

5/8"

2¼"

1¼"

24¾"

MAPLE

3¼"

2¼"

3⅝"

SCALE IN INCHES

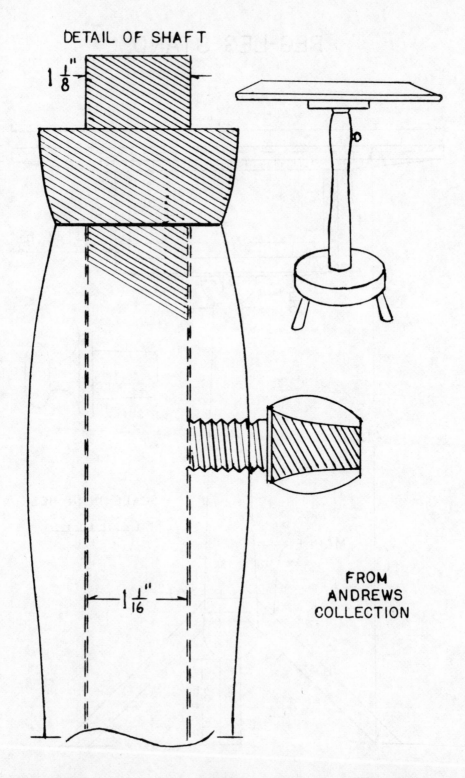

DETAIL OF SHAFT

$1\frac{1}{8}"$

$1\frac{1}{16}"$

FROM
ANDREWS
COLLECTION

116

EARLY STAND
WITH ADJUSTABLE TOP

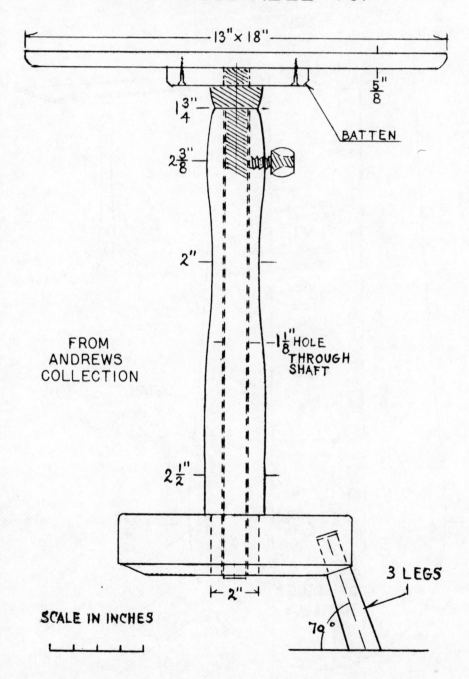

13" × 18"

$\frac{5}{8}$"

BATTEN

$1\frac{3}{4}$"

$2\frac{3}{8}$"

2"

FROM
ANDREWS
COLLECTION

$1\frac{1}{8}$" HOLE
THROUGH
SHAFT

$2\frac{1}{2}$"

2"

3 LEGS

79°

SCALE IN INCHES

STAND WITH ADJUSTABLE TOP
MAPLE AND PINE

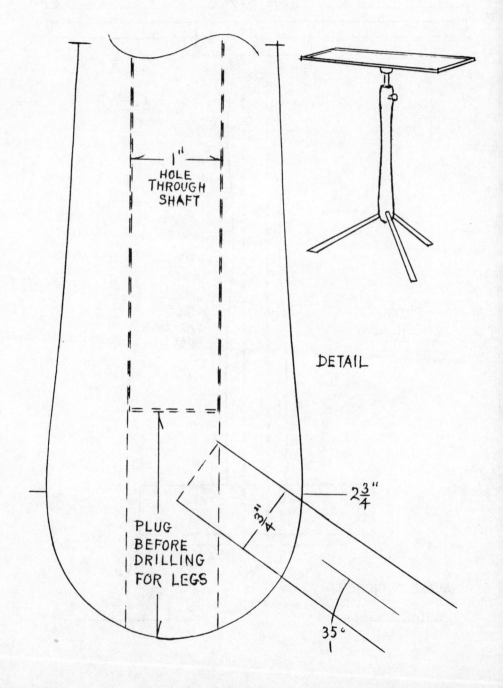

HOLE
THROUGH
SHAFT

1"

DETAIL

PLUG
BEFORE
DRILLING
FOR LEGS

$2\frac{3}{4}$"

$\frac{3}{4}$"

35°

STAND WITH ADJUSTABLE TOP
SHAFT AND LEGS OF MAPLE TOP OF PINE

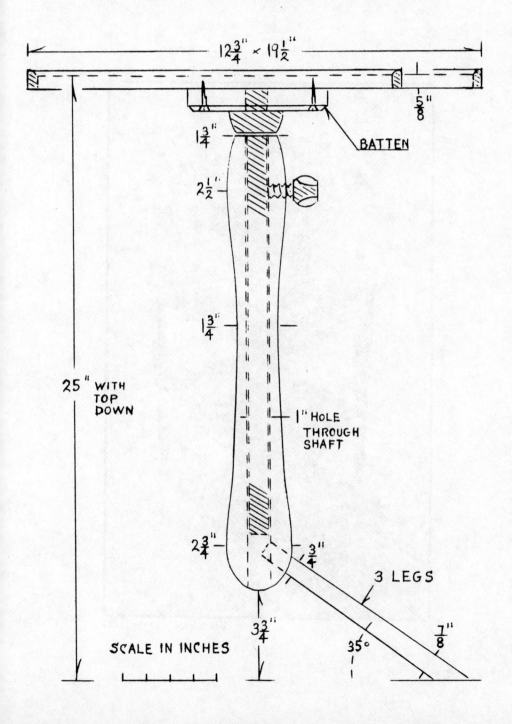

$12\frac{3}{4}"\times 19\frac{1}{2}"$

$\frac{5}{8}"$

BATTEN

$1\frac{3}{4}"$

$2\frac{1}{2}"$

$1\frac{3}{4}"$

1" HOLE THROUGH SHAFT

25" WITH TOP DOWN

$2\frac{3}{4}"$

$\frac{3}{4}"$

3 LEGS

$3\frac{3}{4}"$

$35°$

$\frac{7}{8}"$

SCALE IN INCHES

119

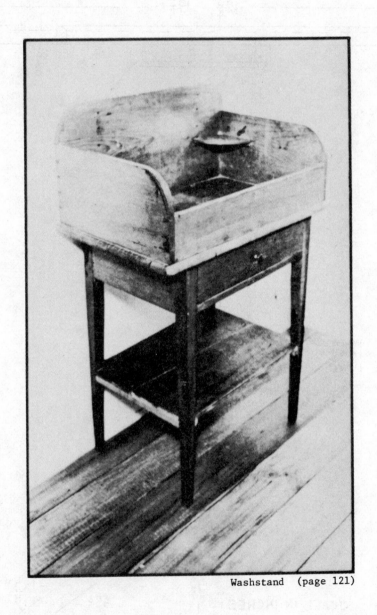

Washstand (page 121)

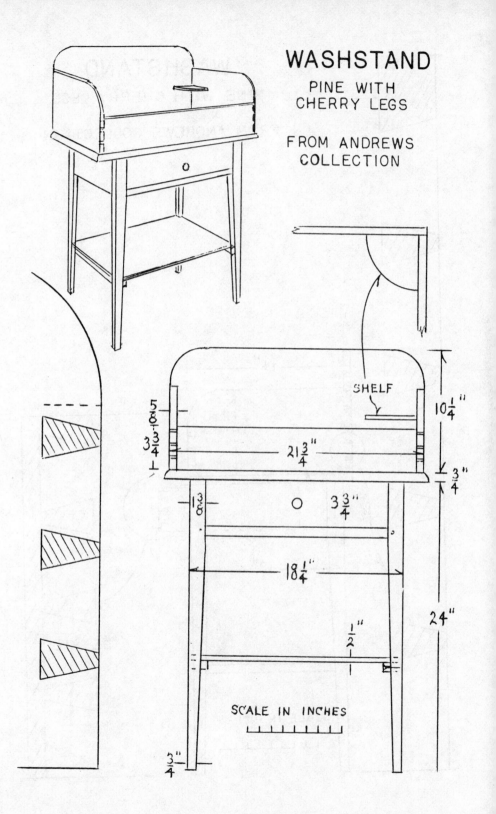

WASHSTAND

PINE WITH
CHERRY LEGS

FROM ANDREWS
COLLECTION

SHELF

$10\frac{1}{4}$"

$3\frac{3}{4}$ - $10\frac{5}{8}$

$3\frac{3}{4}$

$21\frac{3}{4}$"

$\frac{3}{4}$

$1\frac{3}{8}$

$3\frac{3}{4}$"

$18\frac{1}{4}$"

24"

$\frac{1}{2}$"

SCALE IN INCHES

$\frac{3}{4}$"

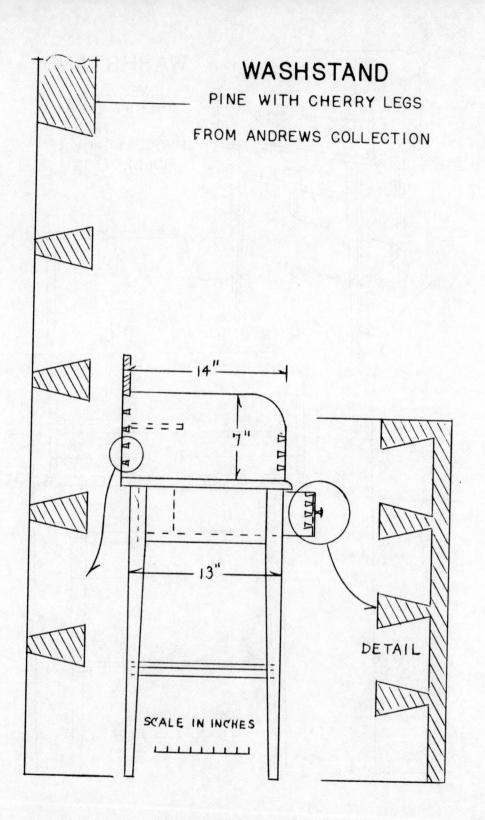

WASHSTAND

PINE WITH CHERRY LEGS

FROM ANDREWS COLLECTION

14"

7"

13"

DETAIL

SCALE IN INCHES

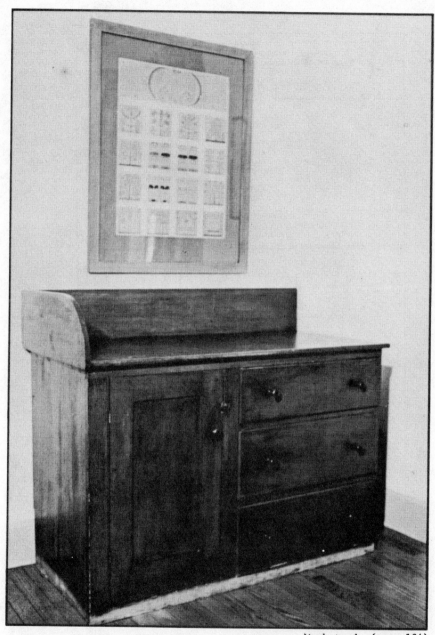

Washstand (page 124)

WASHSTAND

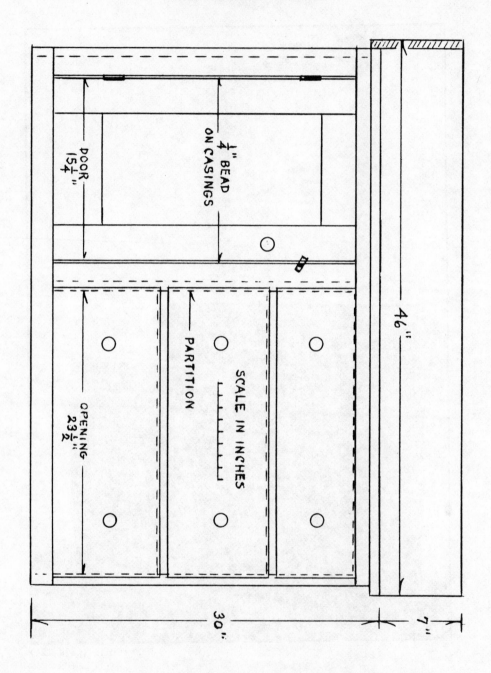

FROM ANDREWS COLLECTION

124

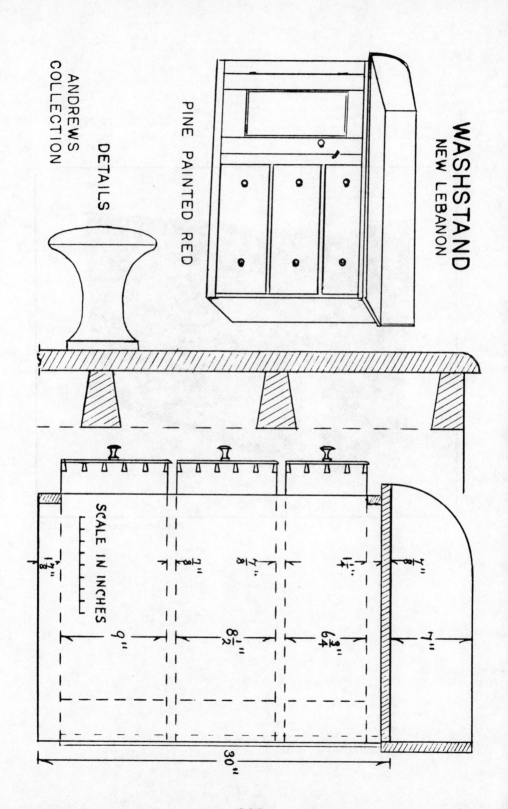

WASHSTAND
NEW LEBANON

PINE PAINTED RED

DETAILS

ANDREWS
COLLECTION

SCALE IN INCHES

$1\frac{3}{8}$"

$\frac{7}{8}$"

$\frac{7}{8}$"

$\frac{7}{8}$"

$1\frac{1}{4}$"

$\frac{7}{8}$"

9"

$8\frac{1}{2}$"

$6\frac{3}{4}$"

7"

30"

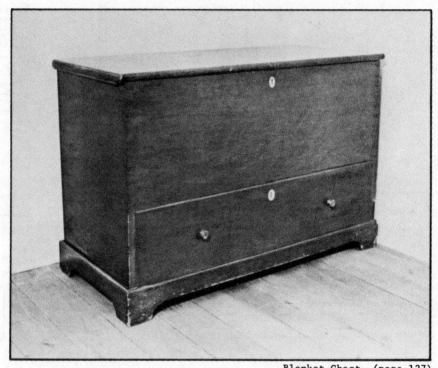

Blanket Chest (page 127)

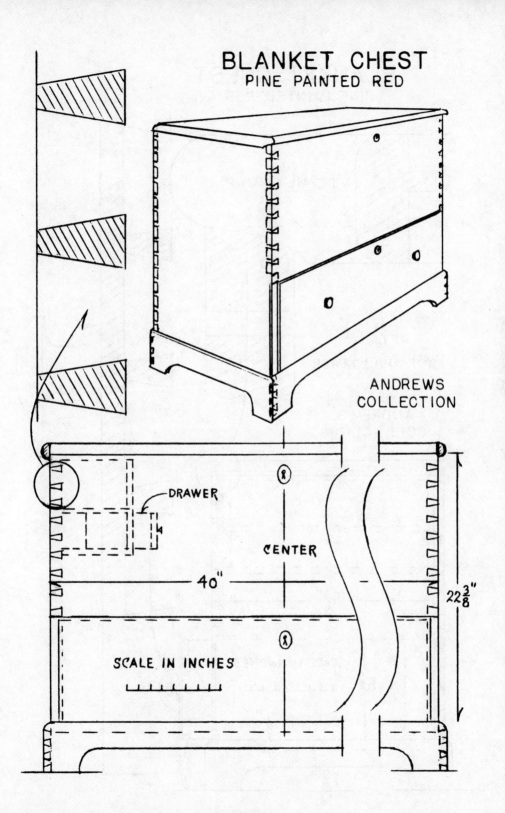

BLANKET CHEST
PINE PAINTED RED

ANDREWS
COLLECTION

DRAWER

CENTER

40"

22 3/8"

SCALE IN INCHES

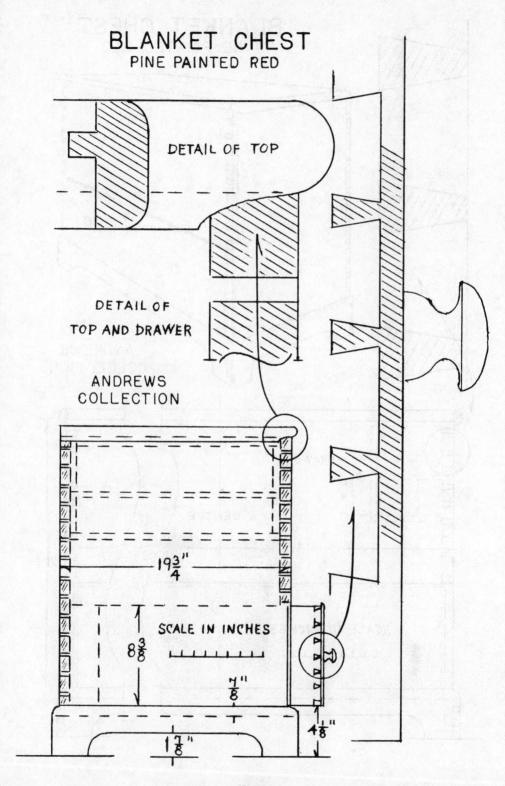

BLANKET CHEST
PINE PAINTED RED

DETAIL OF TOP

DETAIL OF
TOP AND DRAWER

ANDREWS
COLLECTION

19¾"

8⅜"

SCALE IN INCHES

⅞"

4⅛"

1⅞"

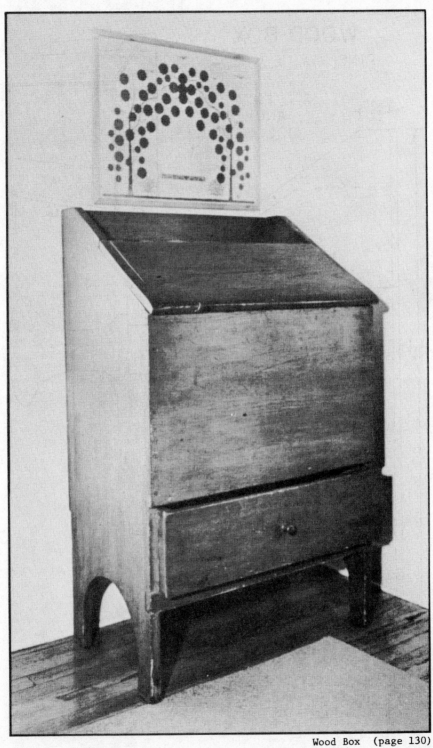

Wood Box (page 130)

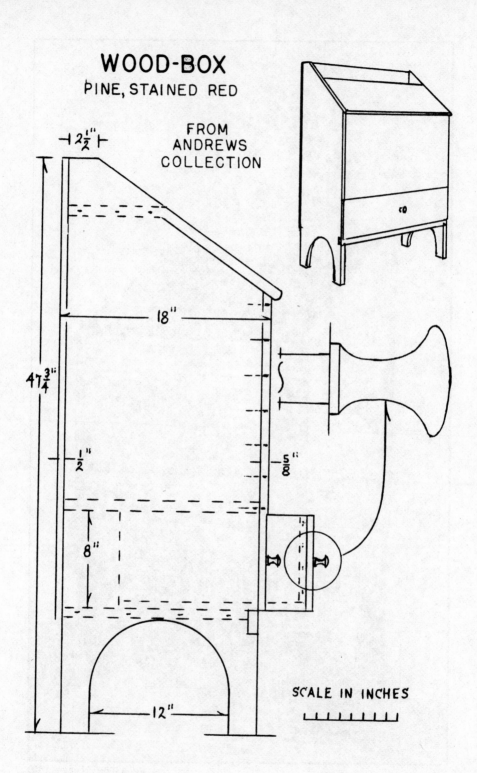

WOOD-BOX
PINE, STAINED RED

FROM
ANDREWS
COLLECTION

$2\frac{1}{2}$"

18"

$47\frac{3}{4}$"

$\frac{1}{2}$"

$\frac{5}{8}$"

8"

12"

SCALE IN INCHES

WOOD-BOX
MADE FOR THE MINISTRY CANTERBURY N.H.

FROM ANDREWS COLLECTION

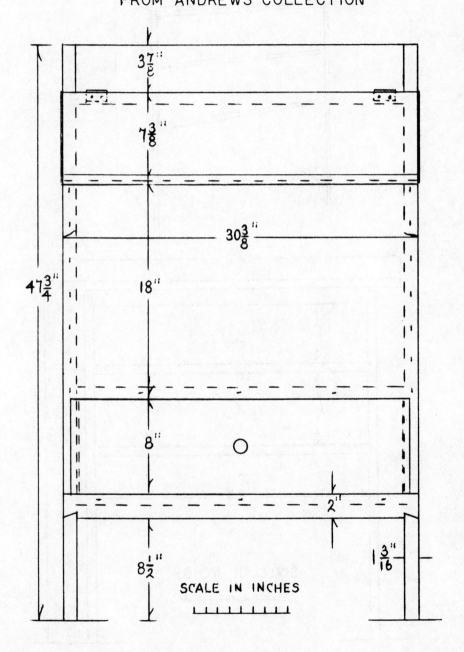

$3\frac{7}{8}$"

$7\frac{3}{8}$"

$30\frac{3}{8}$"

$47\frac{3}{4}$"

18"

8"

2"

$8\frac{1}{2}$"

$1\frac{3}{16}$"

SCALE IN INCHES

2 DRAWER UTILITY CHEST

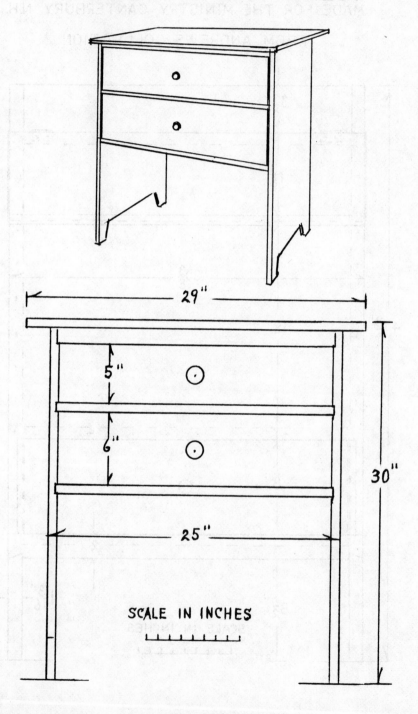

29"

5"

6"

30"

25"

SCALE IN INCHES

2 DRAWER UTILITY CHEST

FROM ANDREWS COLLECTION

DETAILS

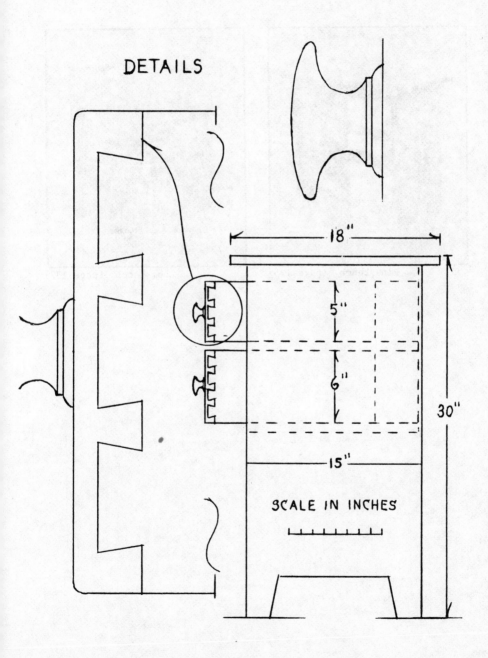

18"

5"

6"

30"

15"

SCALE IN INCHES

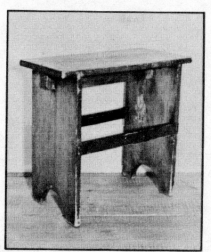

Pine Bench (page 135)

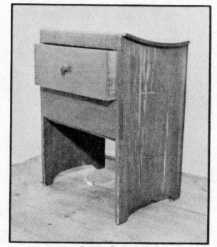

Loom Bench (page 137)

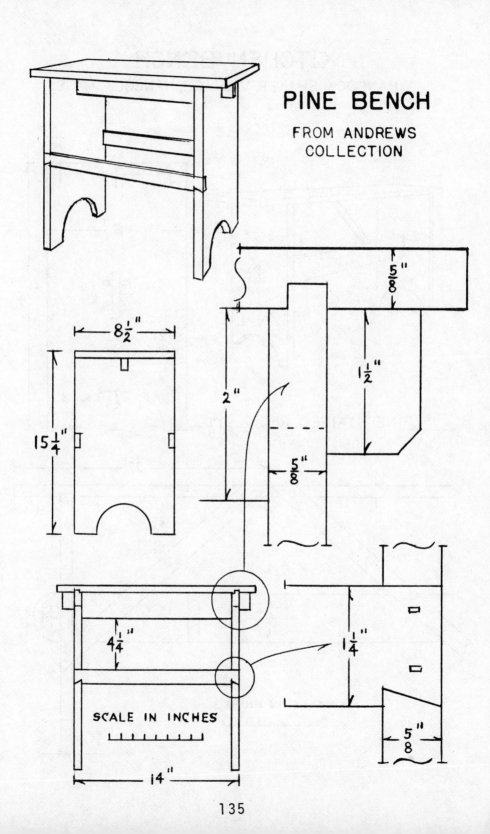

PINE BENCH

FROM ANDREWS COLLECTION

8½"

15¼"

2"

5/8"

1½"

5/8"

4¼"

1¼"

5/8"

SCALE IN INCHES

14"

KITCHEN BENCH
HANCOCK SHAKER VILLAGE, HANCOCK MASS.

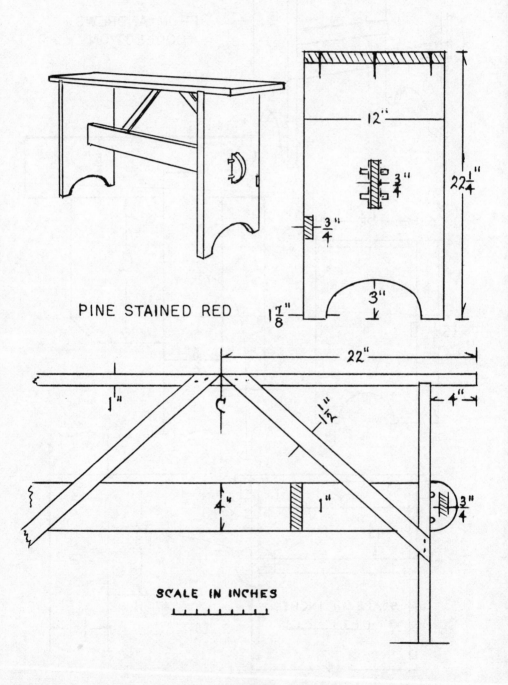

PINE STAINED RED

SCALE IN INCHES

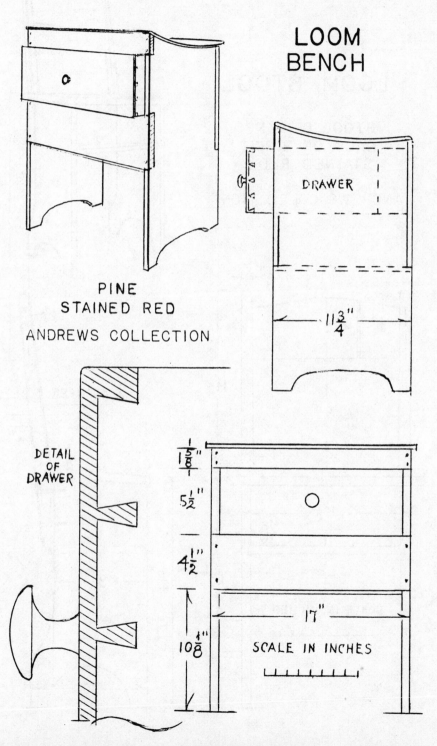

LOOM BENCH

PINE
STAINED RED

ANDREWS COLLECTION

DRAWER

$11\frac{3}{4}''$

DETAIL
OF
DRAWER

$1\frac{5}{8}''$

$5\frac{1}{2}''$

$4\frac{1}{2}''$

$10\frac{1}{8}''$

$17''$

SCALE IN INCHES

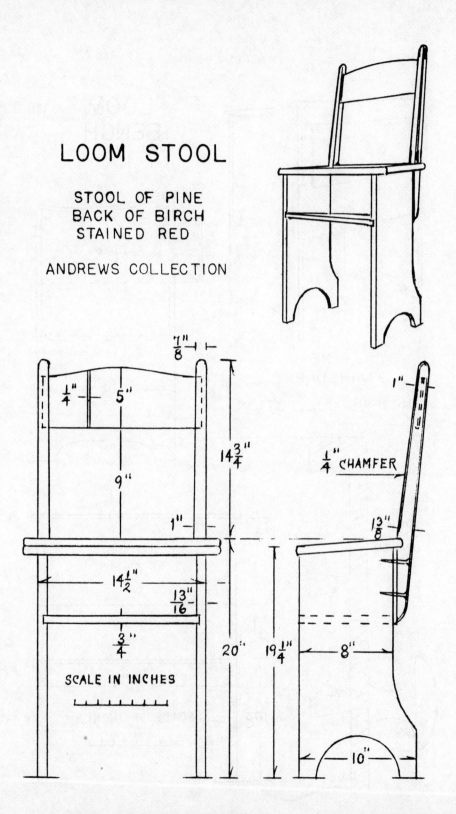

LOOM STOOL

STOOL OF PINE
BACK OF BIRCH
STAINED RED

ANDREWS COLLECTION

$\frac{7}{8}$"

$\frac{1}{4}$" 5"

$14\frac{3}{4}$"

9"

1"

$14\frac{1}{2}$"

$\frac{13}{16}$"

$\frac{3}{4}$"

20"

$19\frac{1}{4}$"

1"

$\frac{1}{4}$" CHAMFER

$\frac{13}{8}$"

8"

10"

SCALE IN INCHES

138

STEP-STOOL

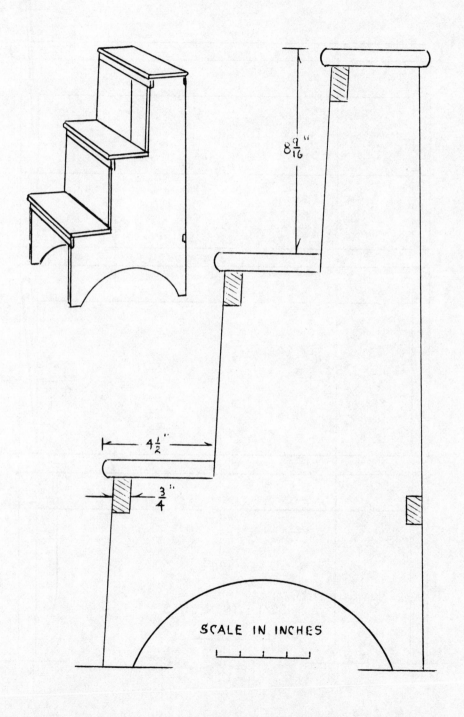

$8\frac{9}{16}''$

$4\frac{1}{2}''$

$\frac{3}{4}''$

SCALE IN INCHES

STEP-STOOL

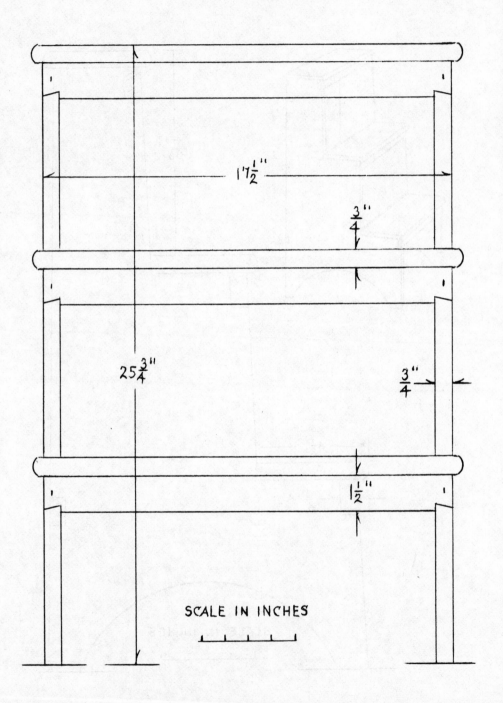

$17\frac{1}{2}$"

$\frac{3}{4}$"

$25\frac{3}{4}$"

$\frac{3}{4}$"

$1\frac{1}{2}$"

SCALE IN INCHES

140

REVOLVING STOOL

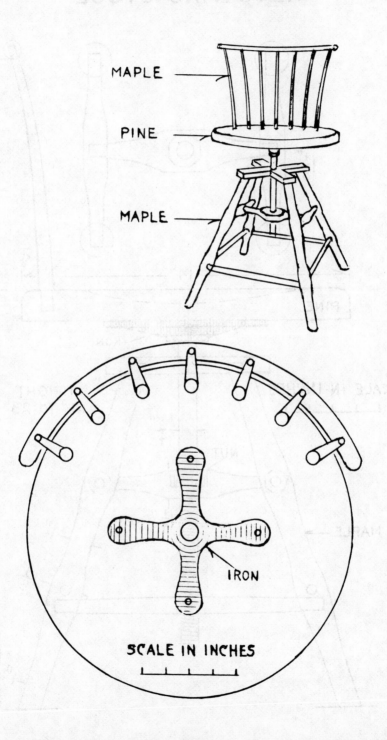

MAPLE

PINE

MAPLE

IRON

SCALE IN INCHES

REVOLVING STOOL

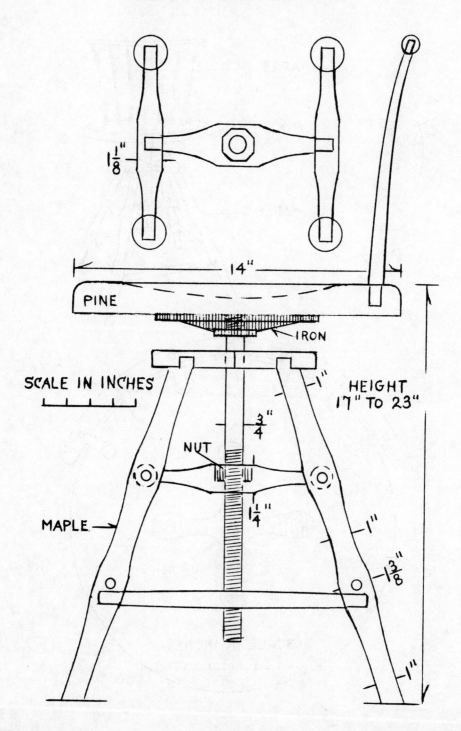

$1\frac{1}{8}$"

14"

PINE

IRON

SCALE IN INCHES

HEIGHT 17" TO 23"

$\frac{3}{4}$"

NUT

$1\frac{1}{4}$"

MAPLE

1"

1"

$1\frac{3}{8}$"

1"

STOOL MT. LEBANON

THE SHAKER MUSEUM
OLD CHATHAM, N.Y.

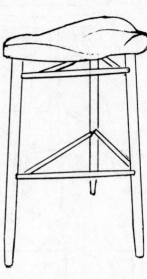

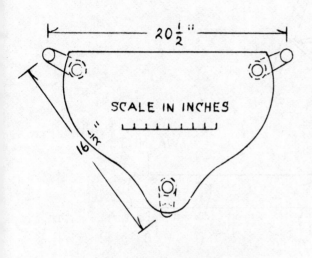

20½"

16½"

SCALE IN INCHES

LEATHER COVERED SEAT

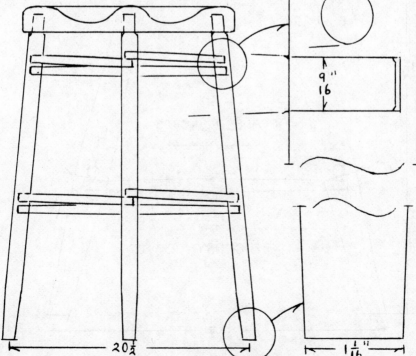

$1\frac{3}{8}$"

$\frac{9}{16}$"

$1\frac{1}{16}$"

20½

143

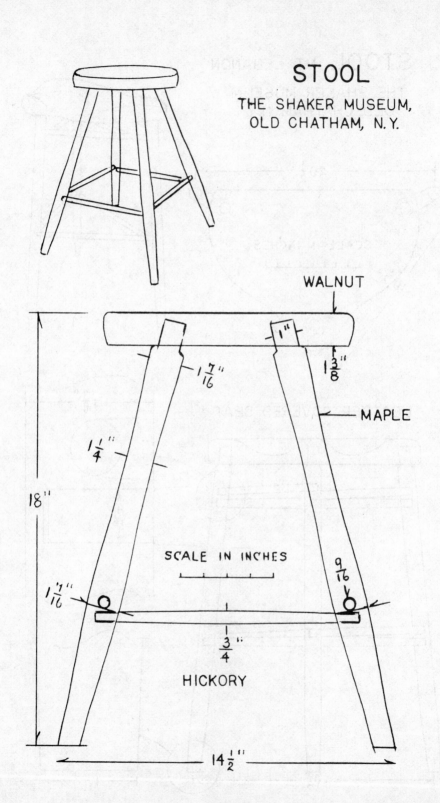

STOOL

THE SHAKER MUSEUM,
OLD CHATHAM, N.Y.

WALNUT

1"

$1\frac{3}{8}$"

$1\frac{7}{16}$"

MAPLE

$1\frac{1}{4}$"

18"

SCALE IN INCHES

$\frac{9}{16}$

$1\frac{7}{16}$"

$\frac{3}{4}$"

HICKORY

$14\frac{1}{2}$"

144

ELDER ROBERT M. WAGAN
CHAIRMAKER

Illustrated Catalogue

AND

PRICE LIST

OF

Shakers' * Chairs,

MANUFACTURED BY THE

Society * of * Shakers.

R. M. WAGAN & CO,

MOUNT LEBANON, N. Y.

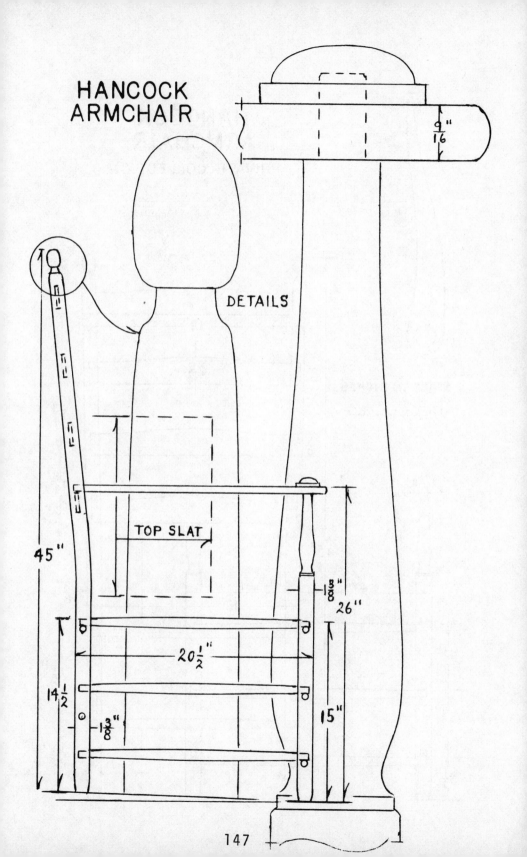

HANCOCK
ARMCHAIR

DETAILS

$\frac{9''}{16}$

TOP SLAT

45"

$1\frac{3}{8}''$

26"

$20\frac{1}{2}''$

$14\frac{1}{2}$

$1\frac{3}{8}''$

15"

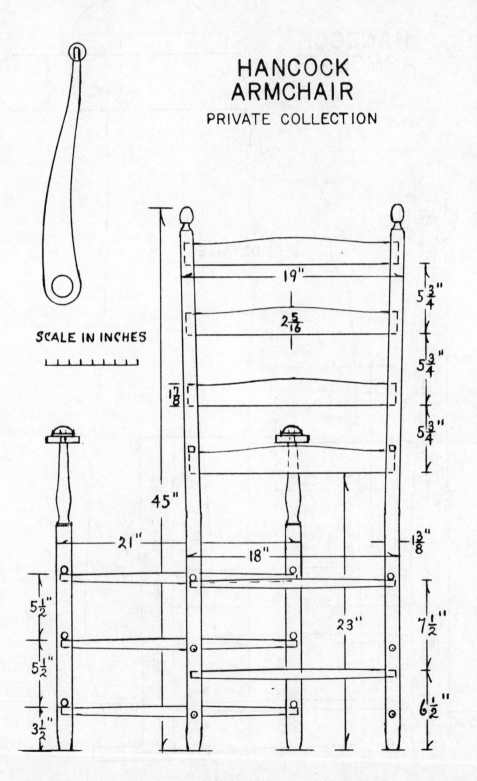

HANCOCK
ARMCHAIR
PRIVATE COLLECTION

SCALE IN INCHES

19"

$2\frac{5}{16}$

$5\frac{3}{4}$"

$5\frac{3}{4}$"

$5\frac{3}{4}$"

$1\frac{7}{8}$

45"

21"

18"

$1\frac{3}{8}$

$5\frac{1}{2}$"

$5\frac{1}{2}$"

23"

$7\frac{1}{2}$"

$3\frac{1}{2}$"

$6\frac{1}{2}$"

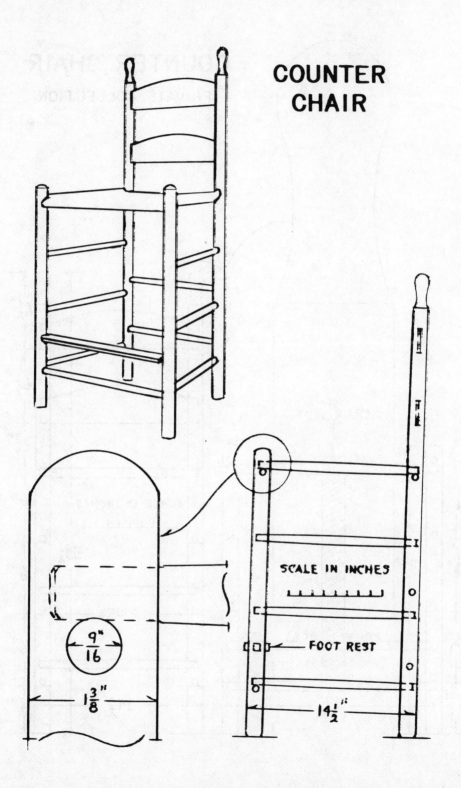

COUNTER
CHAIR

SCALE IN INCHES

FOOT REST

$\frac{9"}{16}$

$1\frac{3}{8}"$

$14\frac{1}{2}"$

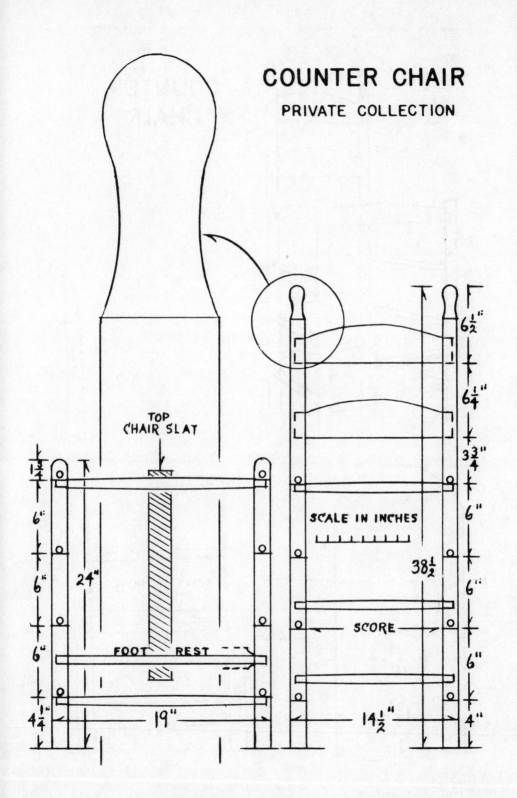

COUNTER CHAIR
PRIVATE COLLECTION

TOP
CHAIR SLAT

FOOT REST

SCALE IN INCHES

SCORE

$6\frac{1}{2}$"

$6\frac{1}{4}$"

$3\frac{3}{4}$"

6"

6"

6"

4"

$1\frac{3}{4}$"

6"

6"

6"

$4\frac{1}{4}$"

24"

$38\frac{1}{2}$

19"

$14\frac{1}{2}$"

150

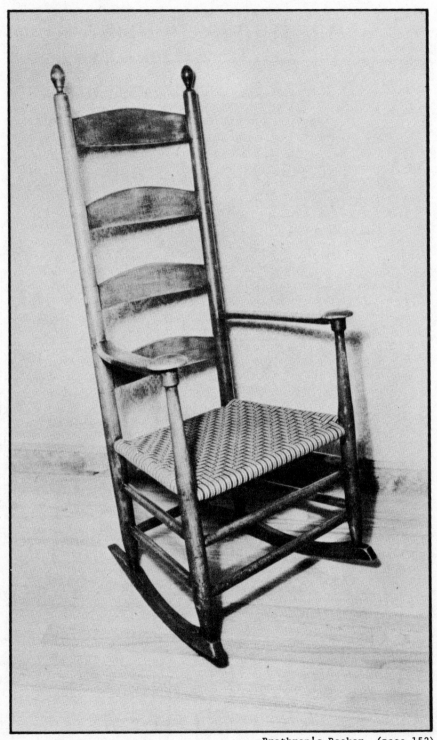

Brethren's Rocker (page 152)

BRETHREN'S ROCKER
NEW LEBANON N.Y.

PRIVATE COLLECTION

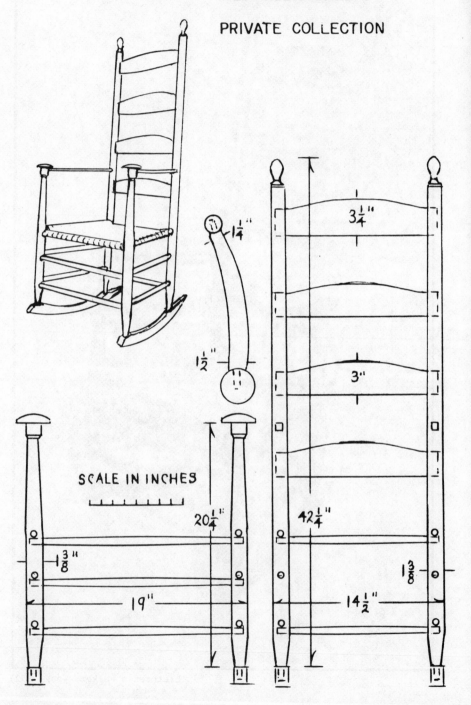

$3\frac{1}{4}$"

$1\frac{1}{4}$"

$1\frac{1}{2}$"

3"

SCALE IN INCHES

$20\frac{1}{4}$"

$42\frac{1}{4}$"

$1\frac{3}{8}$"

19"

$14\frac{1}{2}$"

$1\frac{3}{8}$

152

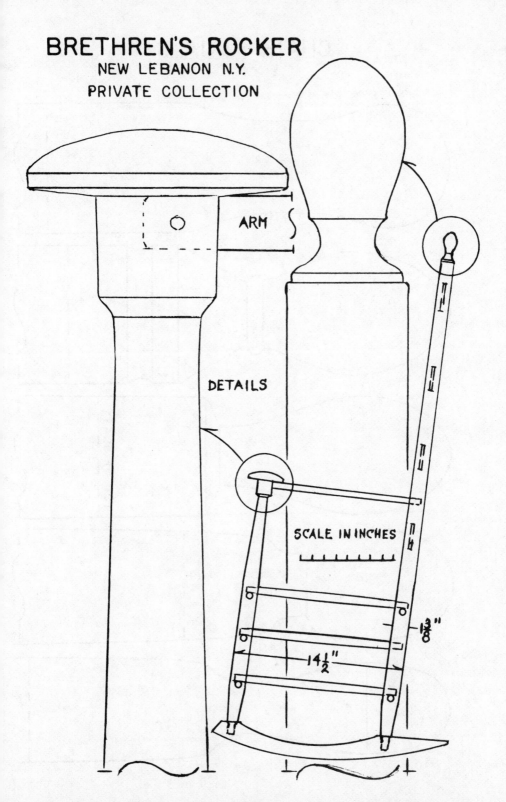

BRETHREN'S ROCKER
NEW LEBANON N.Y.
PRIVATE COLLECTION

ARM

DETAILS

SCALE IN INCHES

$14\frac{1}{2}$"

$1\frac{3}{16}$"

153

CHAIR FINIALS

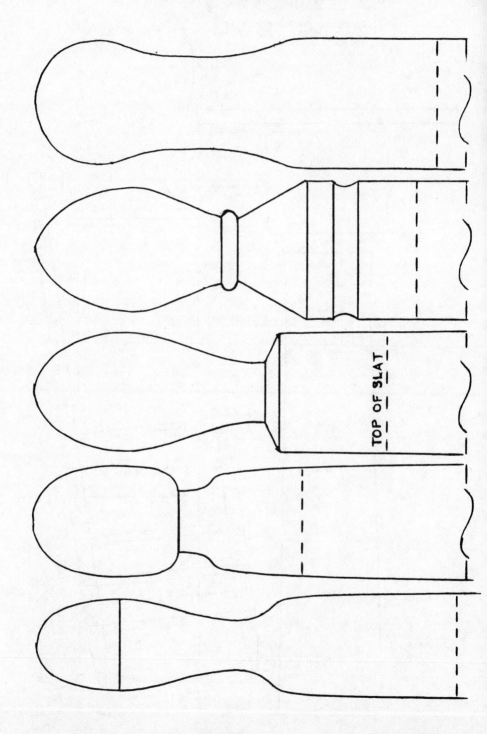

TOP OF SLAT

CHAIR MUSHROOMS
AND TILTING BUTTONS

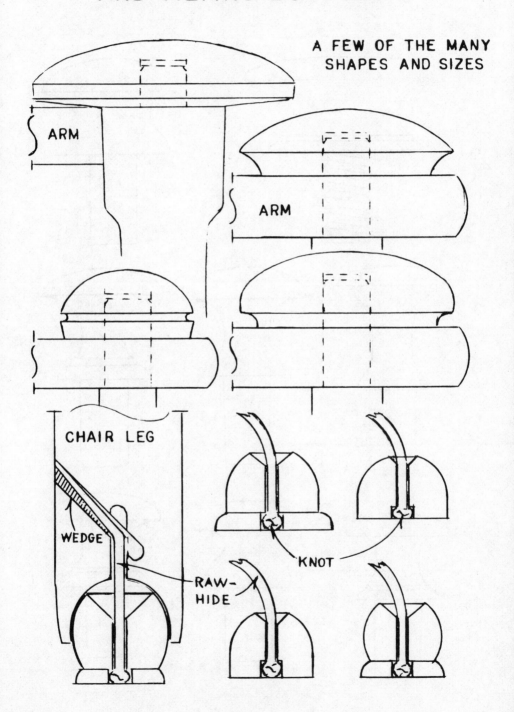

A FEW OF THE MANY
SHAPES AND SIZES

ARM

ARM

CHAIR LEG

WEDGE

RAW-
HIDE

KNOT

DRAWER PULLS

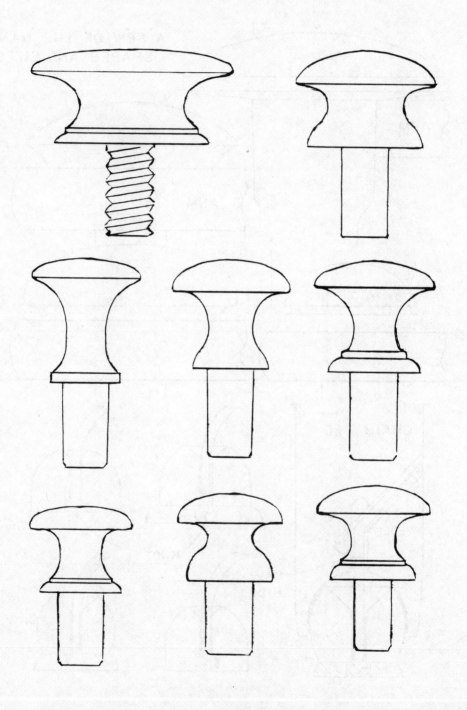

BED CASTERS

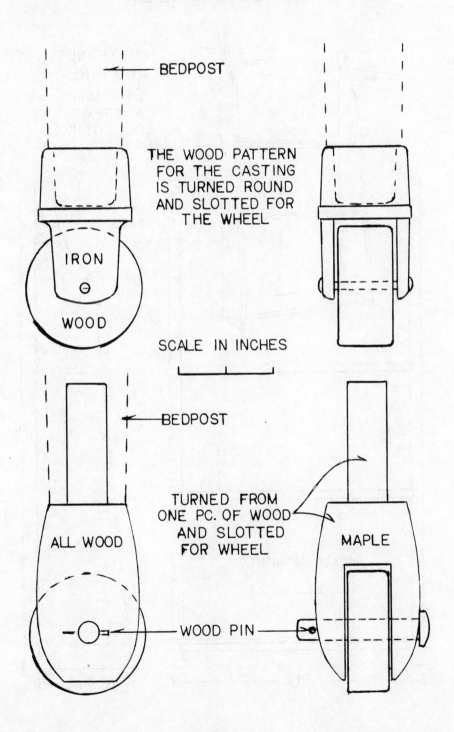

BEDPOST

THE WOOD PATTERN
FOR THE CASTING
IS TURNED ROUND
AND SLOTTED FOR
THE WHEEL

IRON

WOOD

SCALE IN INCHES

BEDPOST

TURNED FROM
ONE PC. OF WOOD
AND SLOTTED
FOR WHEEL

ALL WOOD

MAPLE

WOOD PIN

157

HANGING SHELF

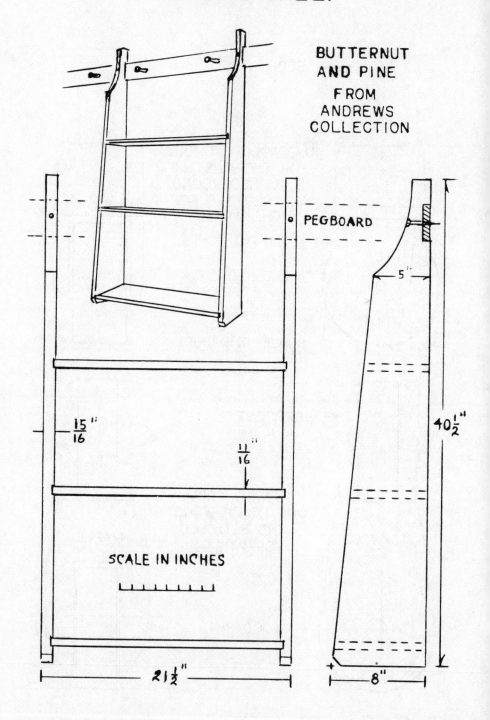

BUTTERNUT
AND PINE

FROM
ANDREWS
COLLECTION

PEGBOARD

$\frac{15}{16}$"

$\frac{11}{16}$"

$40\frac{1}{2}$"

5"

8"

$21\frac{1}{2}$"

SCALE IN INCHES

SMALL WALL CUPBOARD

HANCOCK SHAKER VILLAGE, HANCOCK MASS.

DETAILS

PINE

$\frac{7}{16}$" × $\frac{3}{4}$" BATTENS

$11\frac{1}{8}$"

$\frac{1}{4}$"

$4\frac{1}{2}$"

SCALE IN INCHES

13"

$\frac{3}{8}$"

$\frac{1}{4}$"

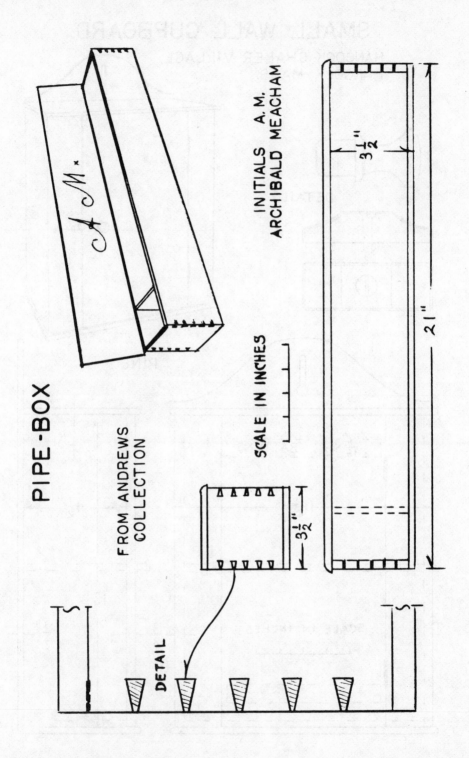

PIPE-BOX

FROM ANDREWS
COLLECTION

INITIALS A. M.
ARCHIBALD MEACHAM

A M.

$3\frac{1}{2}$"

$3\frac{1}{2}$"

21"

SCALE IN INCHES

DETAIL

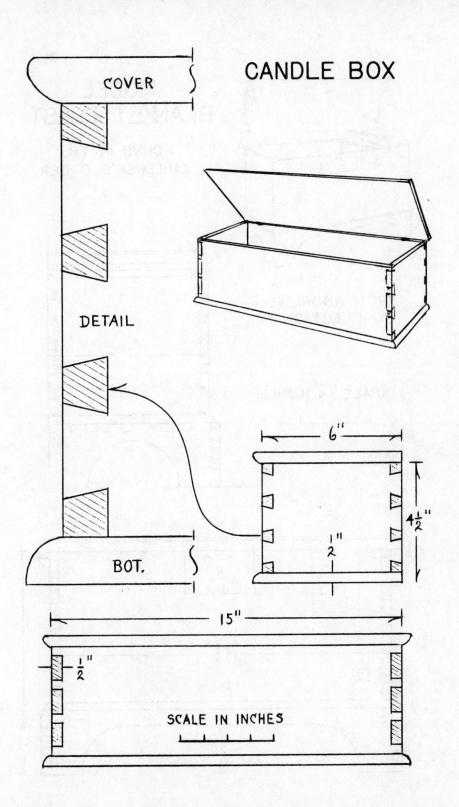

CANDLE BOX

COVER

DETAIL

BOT.

6"

$4\frac{1}{2}$"

$\frac{1}{2}$"

15"

$\frac{1}{2}$"

SCALE IN INCHES

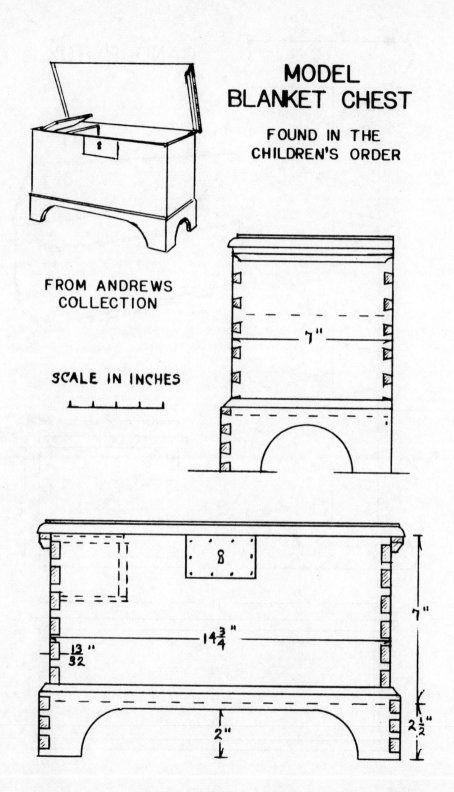

MODEL
BLANKET CHEST

FOUND IN THE
CHILDREN'S ORDER

FROM ANDREWS
COLLECTION

SCALE IN INCHES

7"

8

14¾"

13/32 "

7"

2"

2½"

WALNUT TRAY

NEW LEBANON, N.Y. PRIVATE COLLECTION

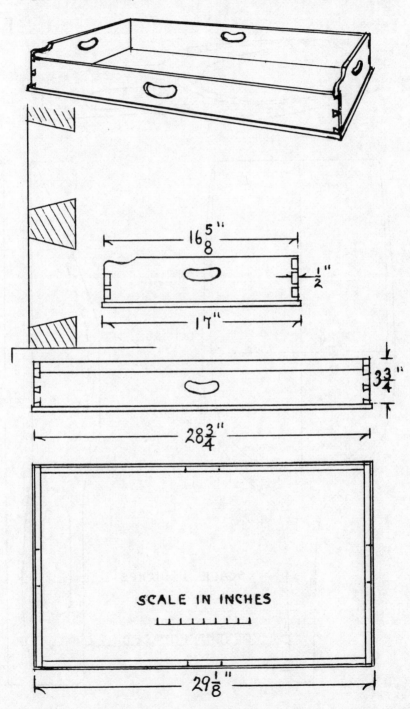

$16\frac{5}{8}"$

$\frac{1}{2}"$

$17"$

$3\frac{3}{4}"$

$28\frac{3}{4}"$

SCALE IN INCHES

$29\frac{1}{8}"$

SCOOP
PRIVATE COLLECTION

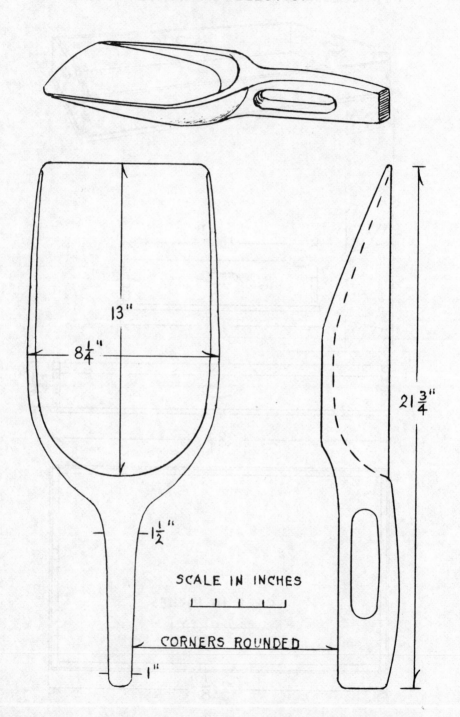

13"

8¼"

1½"

1"

SCALE IN INCHES

CORNERS ROUNDED

21¾"

MORTAR AND PESTLE
THE SHAKER MUSEUM, OLD CHATHAM, N.Y.

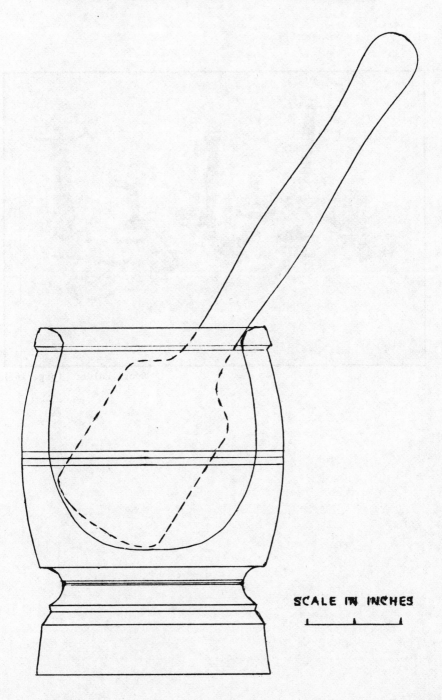

SCALE IN INCHES

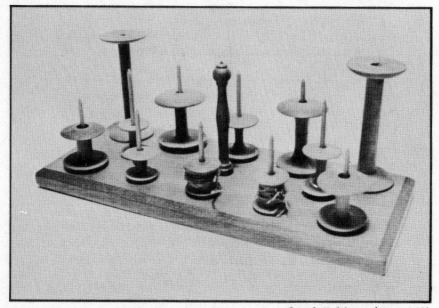

Spool Holder (page 167)

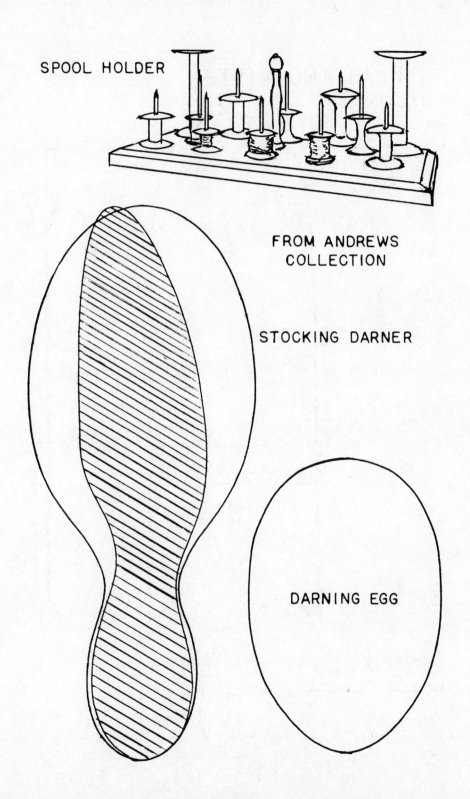

SPOOL HOLDER

FROM ANDREWS
COLLECTION

STOCKING DARNER

DARNING EGG

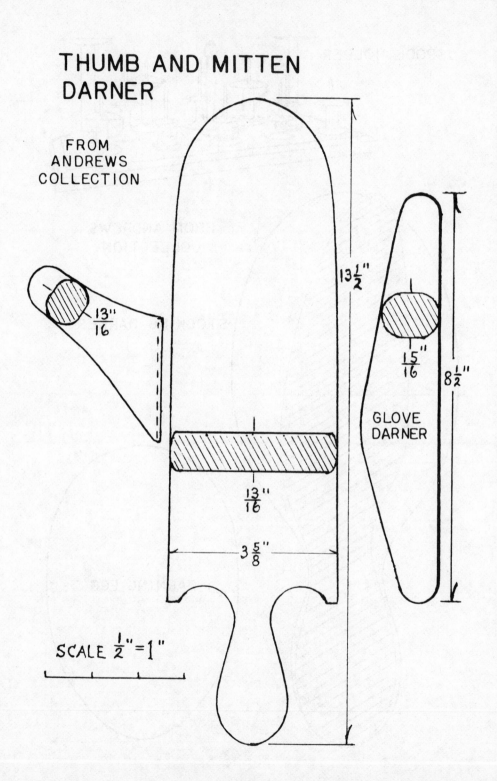

THUMB AND MITTEN DARNER

FROM
ANDREWS
COLLECTION

$\frac{13"}{16}$

$13\frac{1}{2}"$

$\frac{15"}{16}$

$8\frac{1}{2}"$

GLOVE
DARNER

$\frac{13"}{16}$

$3\frac{5}{8}"$

SCALE $\frac{1}{2}" = 1"$

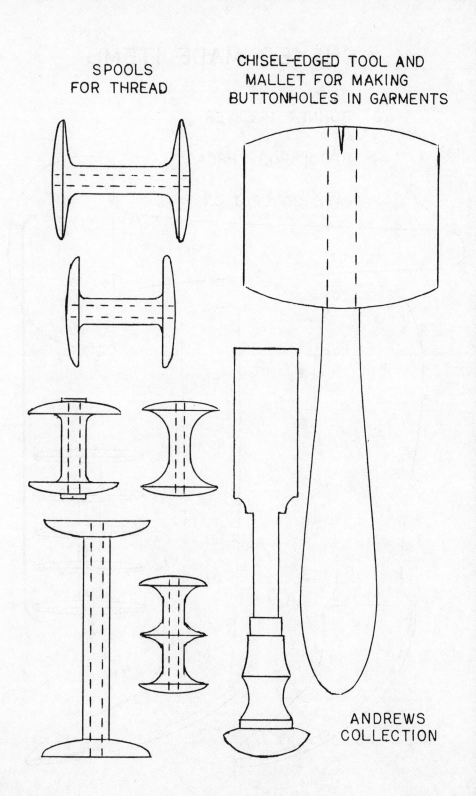

SPOOLS
FOR THREAD

CHISEL–EDGED TOOL AND
MALLET FOR MAKING
BUTTONHOLES IN GARMENTS

ANDREWS
COLLECTION

SHAKER MADE ITEMS

1 DARNER
2 BONNET PLEATER
3 " "
4 SPOOL FOR THREAD

PRIVATE COLLECTION

1

2

3

4

MT. LEBANON STOVE

DOUBLE FOR MORE EFFICIENT HEATING

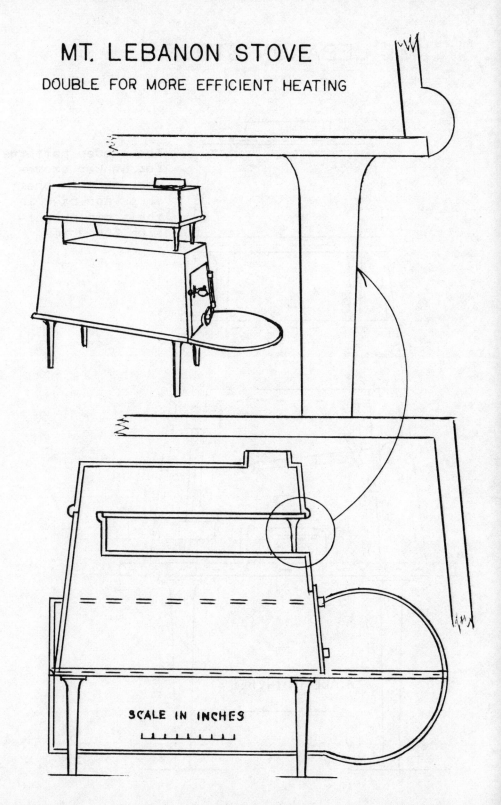

SCALE IN INCHES

MT. LEBANON STOVE

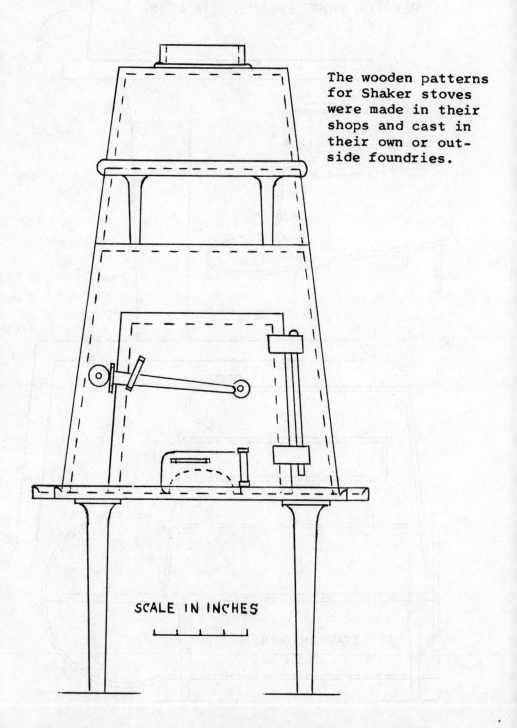

The wooden patterns for Shaker stoves were made in their shops and cast in their own or outside foundries.

SCALE IN INCHES

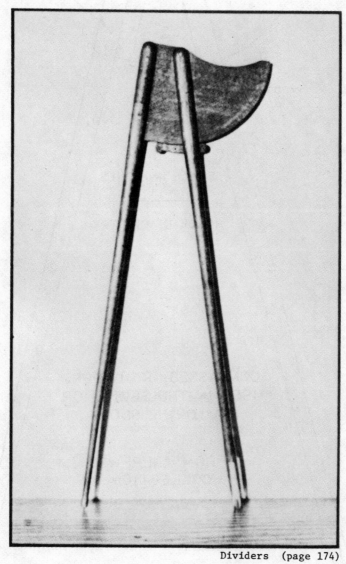

Dividers (page 174)

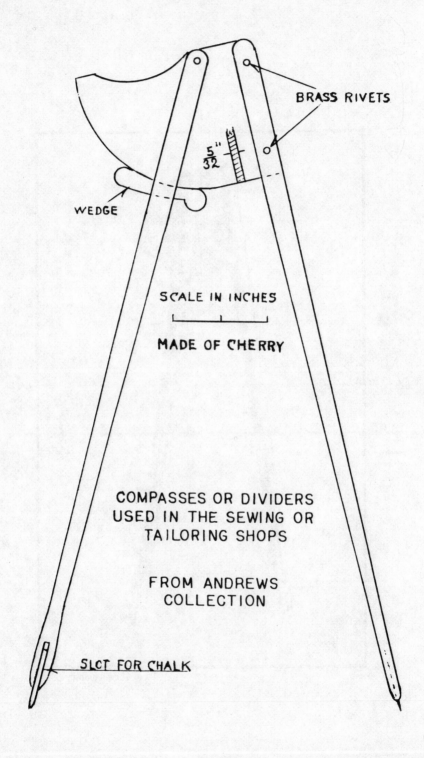

BRASS RIVETS

WEDGE

$\frac{5"}{32}$

SCALE IN INCHES

MADE OF CHERRY

COMPASSES OR DIVIDERS
USED IN THE SEWING OR
TAILORING SHOPS

FROM ANDREWS
COLLECTION

SLOT FOR CHALK

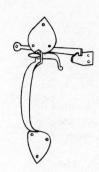

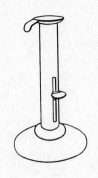

SHOP DRAWINGS
OF
SHAKER IRON
AND
TINWARE

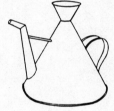

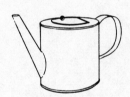

PART III

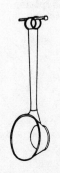

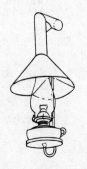

ACKNOWLEDGMENTS

I first made measured drawings to scale of Shaker-made furniture from the pieces that came to my shop and, later, from pieces in private collections and museums. These were used in *Shop Drawings of Shaker Furniture and Woodenware, Volumes I and II*.

In the course of my work I also came across a large number of fine pieces of original Shaker iron and tinware including hardware, tools and various household utensils, each made with the simple, practical design and fine workmanship characteristic of the Shakers.

Although I have never worked with metal beyond making some simple repairs, naturally I had the desire to make a collection of measured drawings to scale from some of these fine pieces.

I am very grateful for the cooperation of The Hancock Shaker Village, Hancock, Massachusetts, The Shaker Museum, Old Chatham, New York, and private collectors who allowed me to examine and make drawings of the wrought iron, cast iron and tinware that I found most interesting. I hope that these drawings will be helpful to collectors and craftsmen alike.

PHOTOGRAPH CREDITS:
The following photographs are reprinted through the courtesy of The Andrews Shaker Collection: Door Latch, from New Lebanon, N.Y., p. 77; The Andrews Living Room at Shaker Farm, Richmond, Mass., photo by Tom Yee, p. 83; Tea Pot, initialed BC, p. 81. The following photographs are reprinted through the courtesy of The Henry Francis du Pont Winterthur Museum, The Edward Deming Andrews Memorial Shaker Collection: Kitchen, Church Family, Niskeyuna, N.Y., p. 81; Shaker Sisters Preparing Maple Sugar Cakes, p. 85. All other photographs by Ejner Handberg.

Copyright © 1976 by Ejner P. Handberg
ISBN #0-912944-36-6
Library of Congress #76-12896

All rights reserved.
Printed in the United States of America.

SHAKER IRON AND TINWARE

FROM THE COLLECTION OF
MR. and MRS. DAVID V. ANDREWS

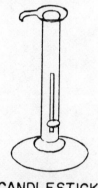

CANDLESTICK
PAGE 201

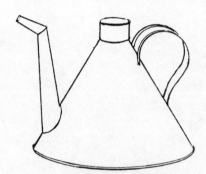

LAMP FILLER
PAGE 242

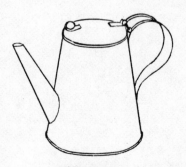

TEAPOT
PAGE 227

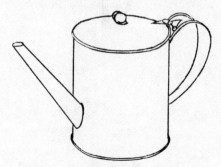

TEAPOT
PAGE 224

SHAKER-MADE WROUGHT IRON

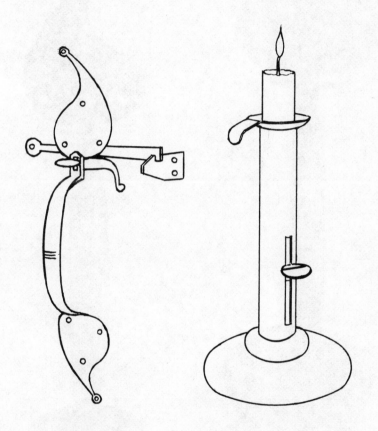

"ALL BEAUTY THAT HAS NOT
A FOUNDATION IN USE SOON
GROWS DISTASTEFUL AND NEEDS
CONTINUAL REPLACEMENT"

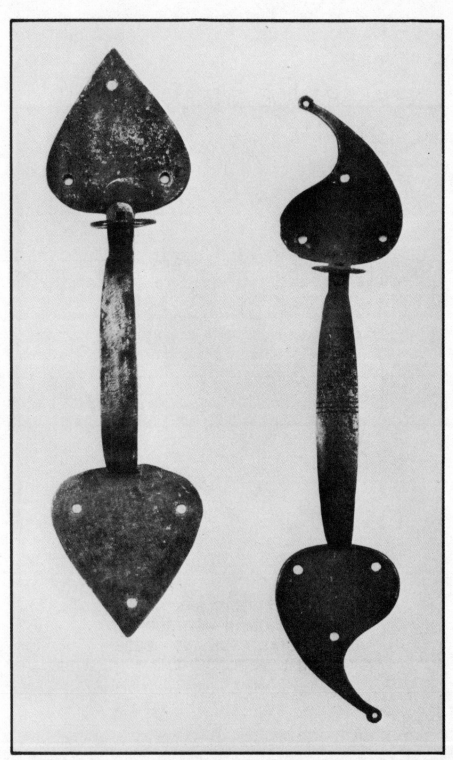

Wrought-Iron Door Latches (pages 181, 182, 183)

WROUGHT-IRON DOOR LATCH

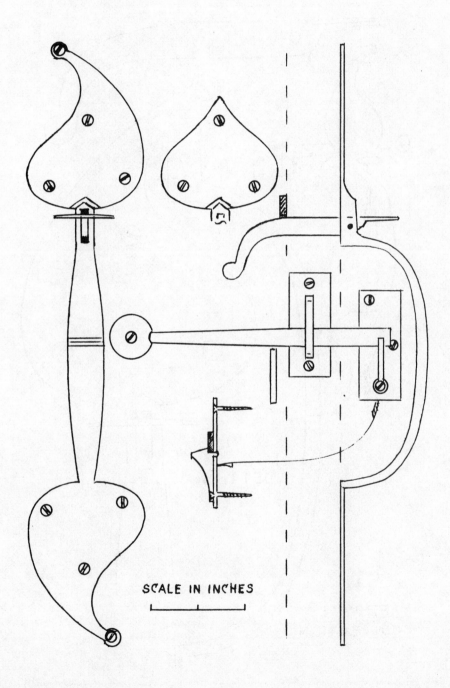

SCALE IN INCHES

WROUGHT-IRON DOOR LATCH

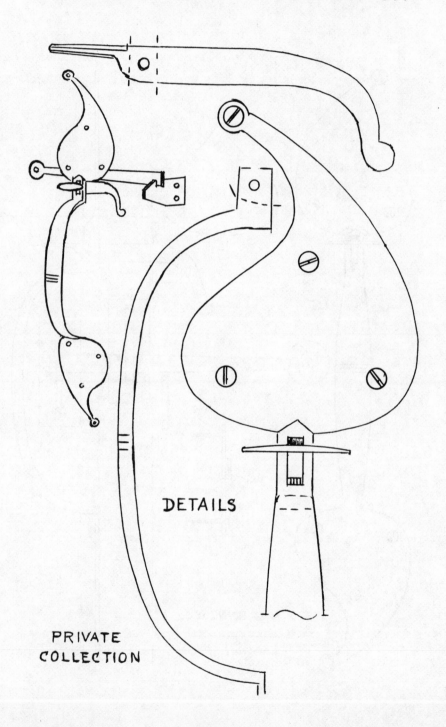

DETAILS

PRIVATE
COLLECTION

182

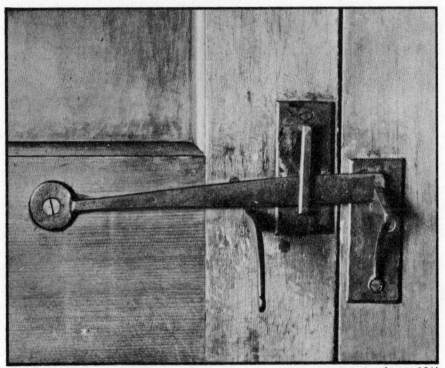

Interior Latch (page 184)

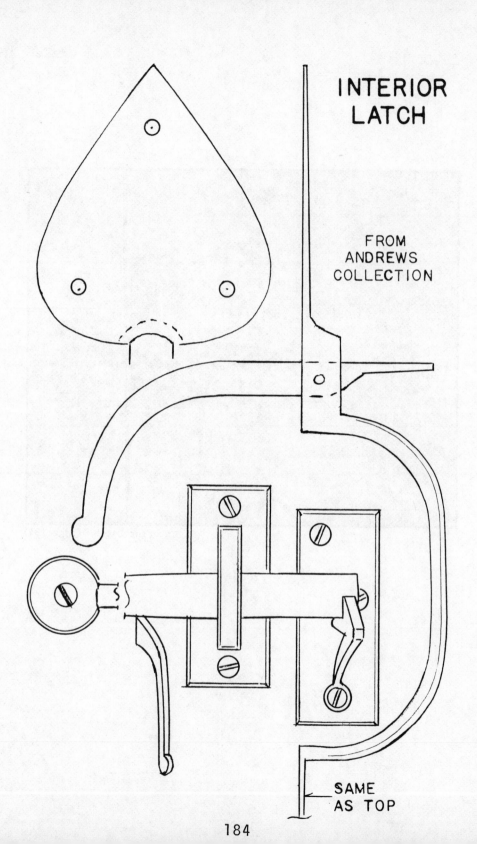

INTERIOR
LATCH

FROM
ANDREWS
COLLECTION

SAME
AS TOP

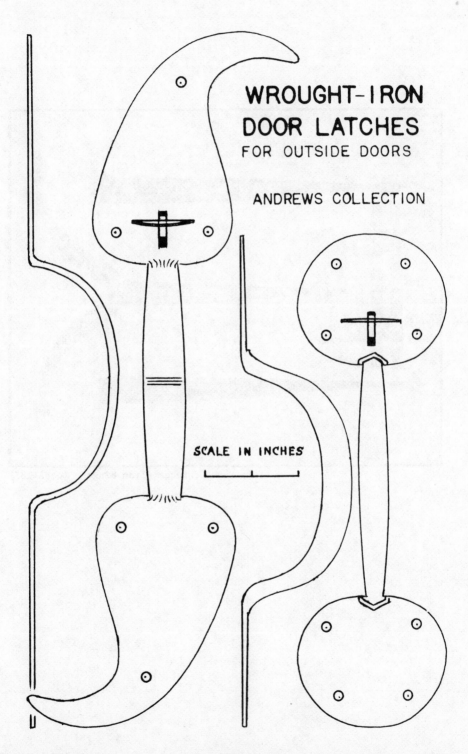

WROUGHT-IRON
DOOR LATCHES
FOR OUTSIDE DOORS

ANDREWS COLLECTION

SCALE IN INCHES

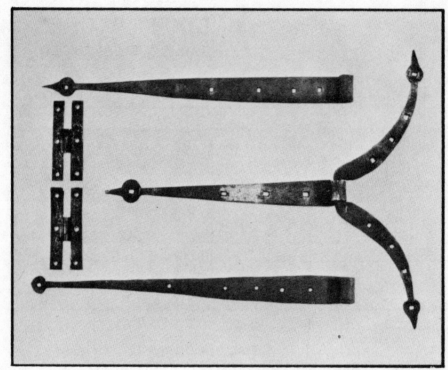

Wrought-Iron Hinges (page 187)

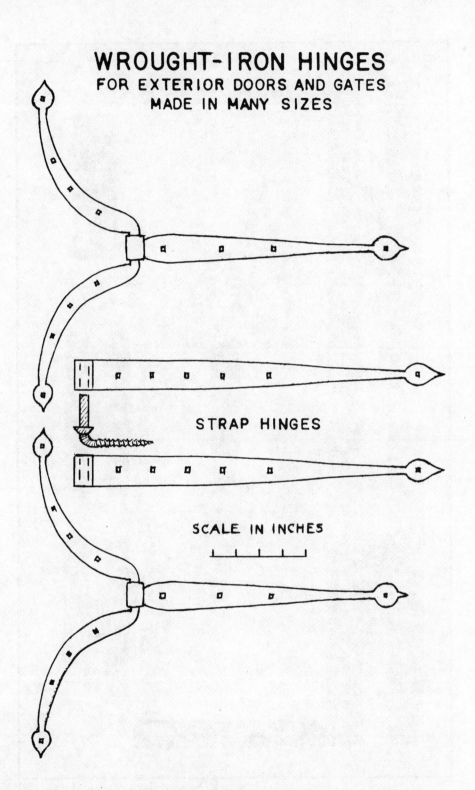

WROUGHT-IRON HINGES
FOR EXTERIOR DOORS AND GATES
MADE IN MANY SIZES

STRAP HINGES

SCALE IN INCHES

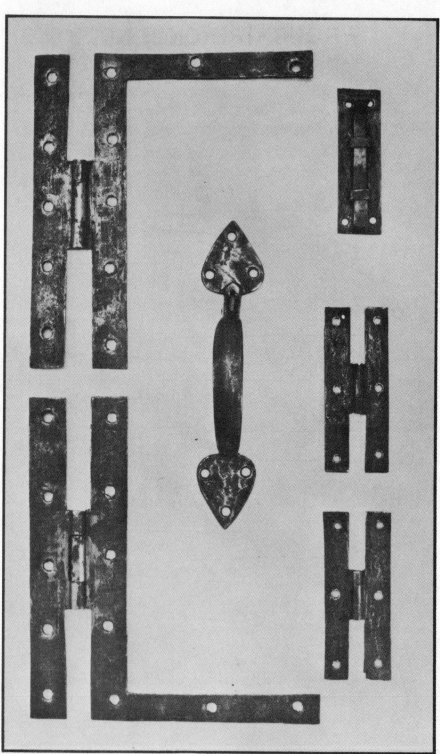

Wrought-Iron Hinges (page 189)

WROUGHT-IRON HINGES
FOR INTERIOR DOORS AND CUPBOARDS
MADE IN MANY SIZES

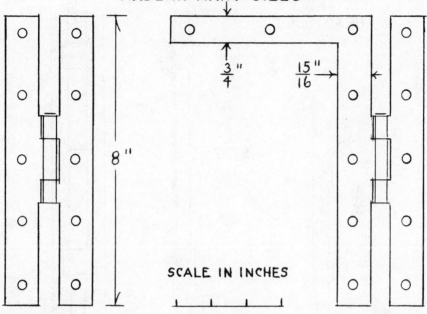

$\frac{3}{4}$"

$\frac{15}{16}$"

8"

SCALE IN INCHES

H
HINGES

H AND L
HINGES

BUTTERFLY
HINGES

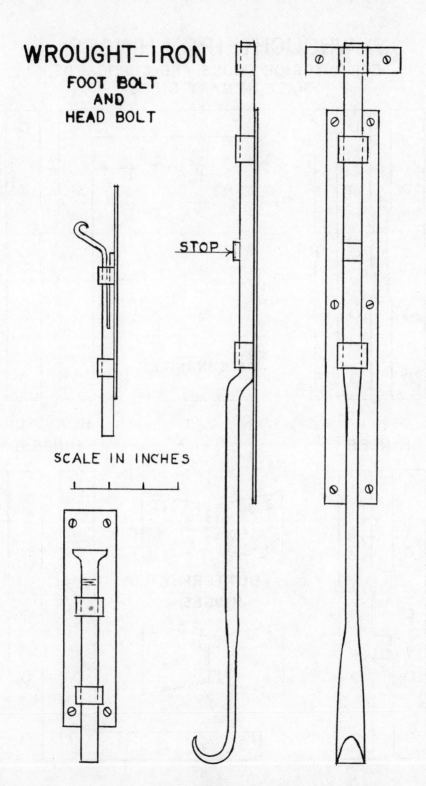

WROUGHT–IRON

FOOT BOLT
AND
HEAD BOLT

STOP

SCALE IN INCHES

WROUGHT-IRON WINGNUT

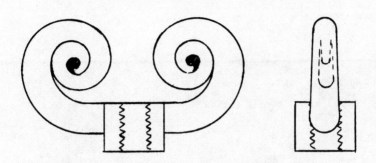

WROUGHT-IRON TOOL
FOR TIGHTENING SLOTTED BED BOLTS

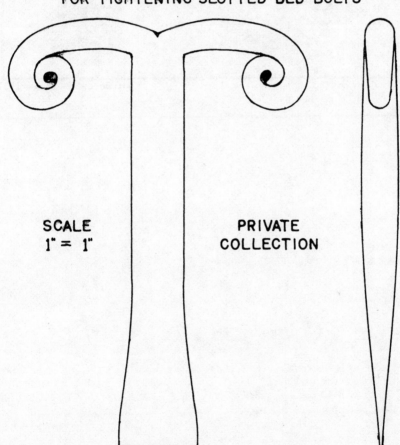

SCALE
1" = 1"

PRIVATE
COLLECTION

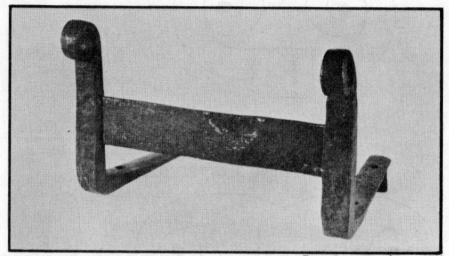

Foot Scraper (page 193)

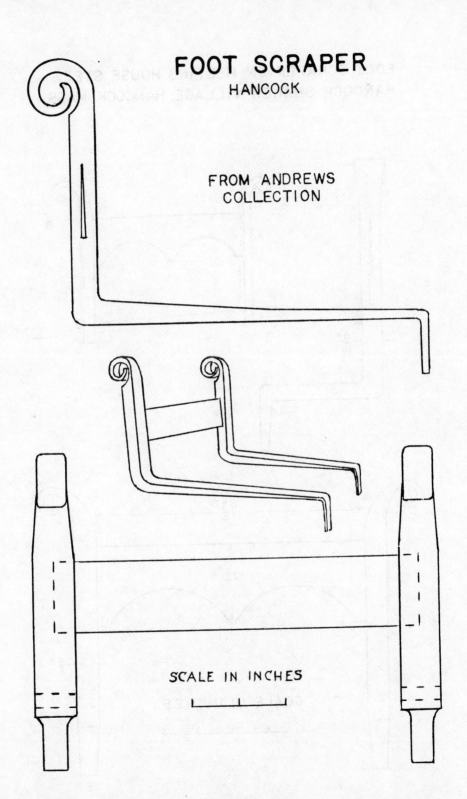

FOOT SCRAPER
HANCOCK

FROM ANDREWS
COLLECTION

SCALE IN INCHES

FOOT SCRAPER ON MEETING HOUSE STEPS
HANCOCK SHAKER VILLAGE, HANCOCK MASS.

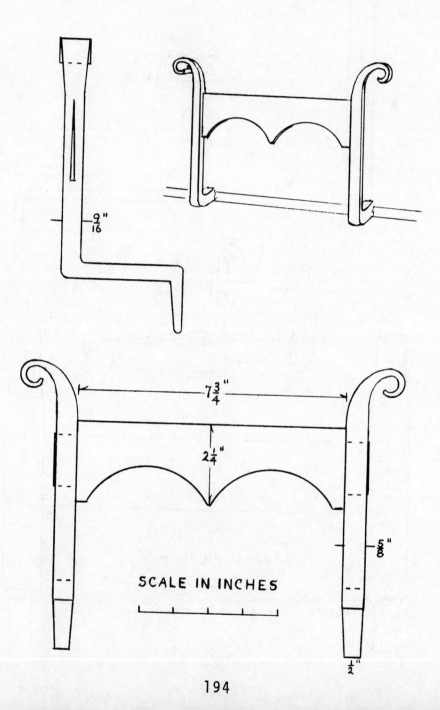

$\frac{9}{16}$"

$7\frac{3}{4}$"

$2\frac{1}{4}$"

$\frac{5}{8}$"

$\frac{1}{2}$"

SCALE IN INCHES

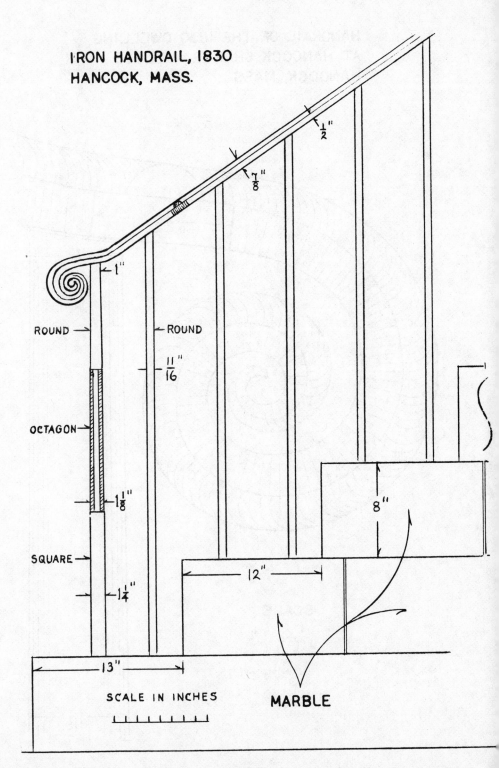

IRON HANDRAIL, 1830
HANCOCK, MASS.

$\frac{1}{2}$"

$\frac{7}{8}$"

1"

ROUND →

← ROUND

$\frac{11}{16}$"

OCTAGON →

$1\frac{1}{8}$"

8"

SQUARE →

12"

$1\frac{1}{4}$"

13"

SCALE IN INCHES

MARBLE

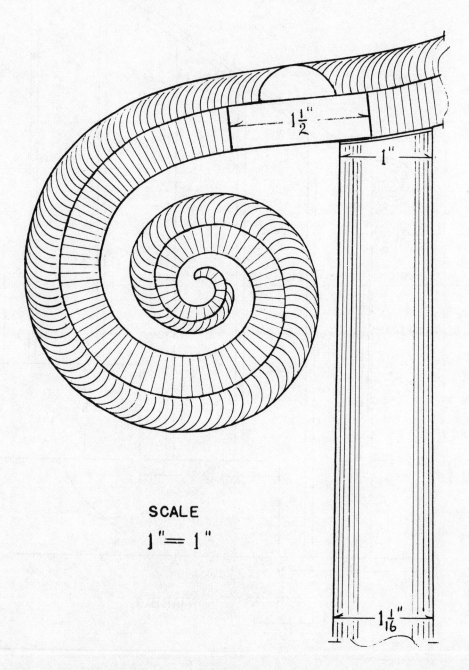

HANDRAIL OF THE 1830 DWELLING
AT HANCOCK SHAKER VILLAGE,
HANCOCK, MASS.

$1\frac{1}{2}''$

$1''$

SCALE
$1'' = 1''$

$1\frac{1}{16}''$

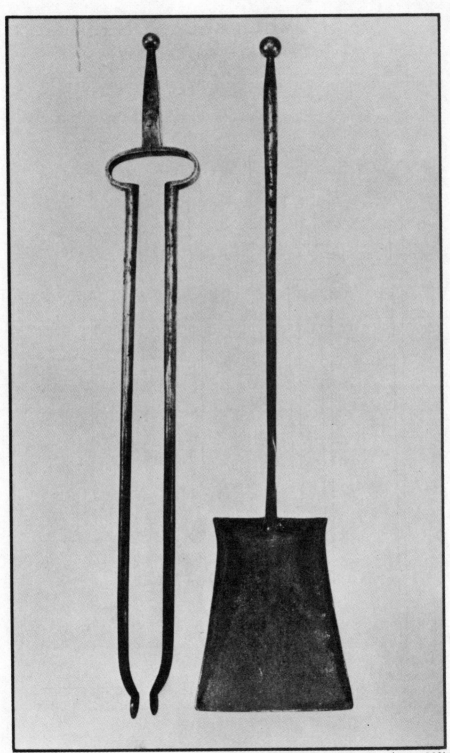

Shovel and Tongs (page 198)

SHOVEL AND TONGS
PRIVATE COLLECTION

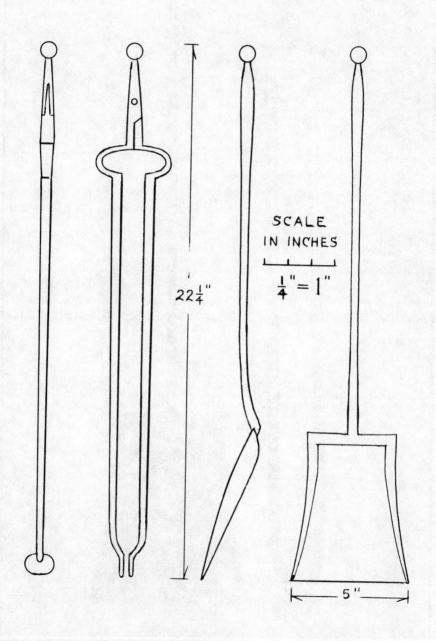

$22\frac{1}{4}$"

SCALE
IN INCHES

$\frac{1}{4}$" = 1"

5"

SHOVEL AND TONGS

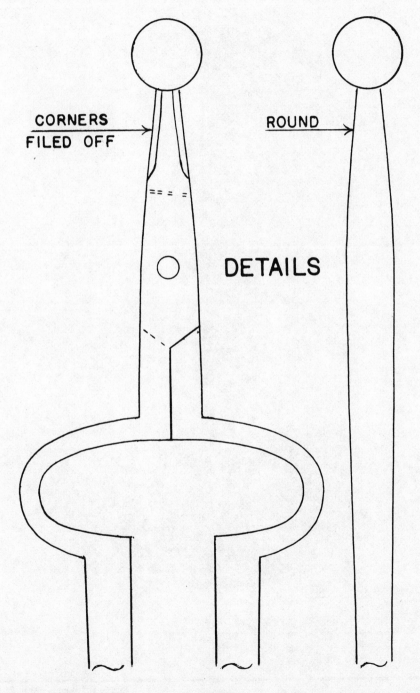

CORNERS
FILED OFF

ROUND

DETAILS

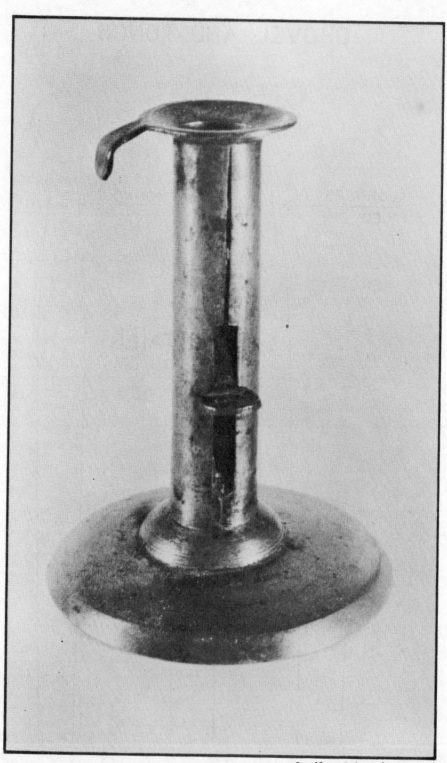

Candlesticks (page 201)

CANDLESTICK

ANDREWS COLLECTION

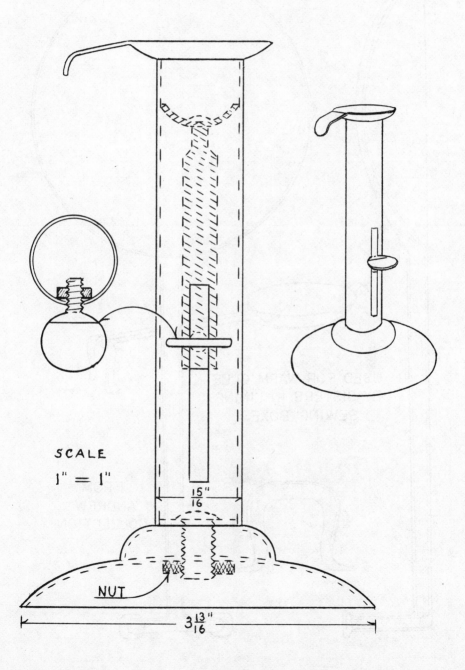

SCALE

1" = 1"

$\frac{15}{16}$"

NUT

$3\frac{13}{16}$"

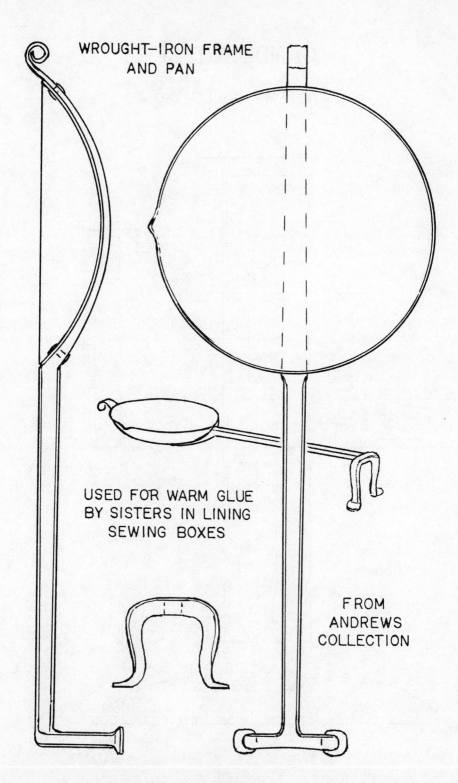

WROUGHT-IRON FRAME
AND PAN

USED FOR WARM GLUE
BY SISTERS IN LINING
SEWING BOXES

FROM
ANDREWS
COLLECTION

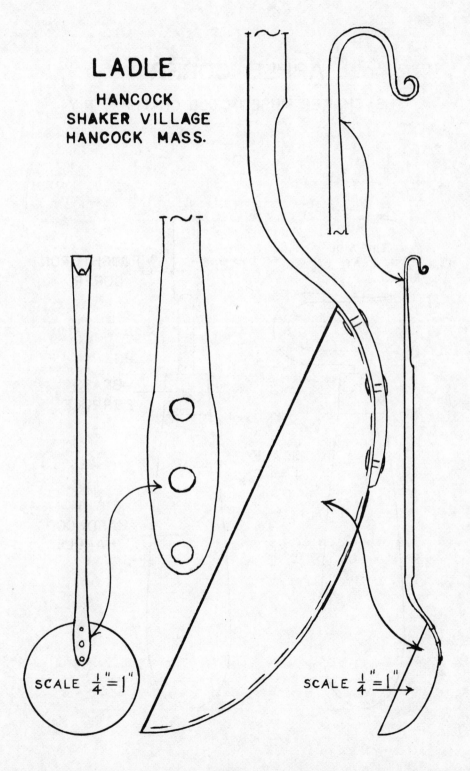

LADLE

HANCOCK
SHAKER VILLAGE
HANCOCK MASS.

SCALE $\frac{1}{4}$" = 1"

SCALE $\frac{1}{4}$" = 1"

APPLE CORER

THE SHAKER MUSEUM, OLD CHATHAM, N.Y.

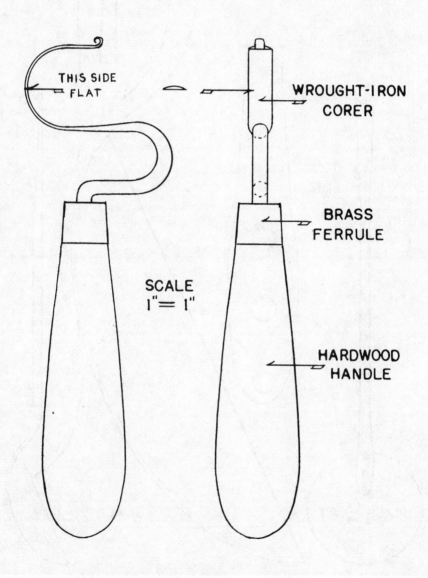

THIS SIDE FLAT

WROUGHT-IRON CORER

BRASS FERRULE

SCALE
1" = 1"

HARDWOOD HANDLE

CHOPPER
HANCOCK SHAKER VILLAGE, HANCOCK MASS.

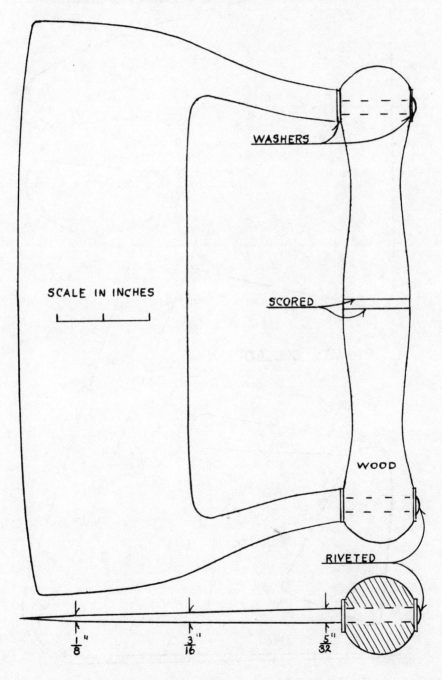

WASHERS

SCALE IN INCHES

SCORED

WOOD

RIVETED

$\frac{1}{8}$" $\frac{3}{16}$" $\frac{5}{32}$"

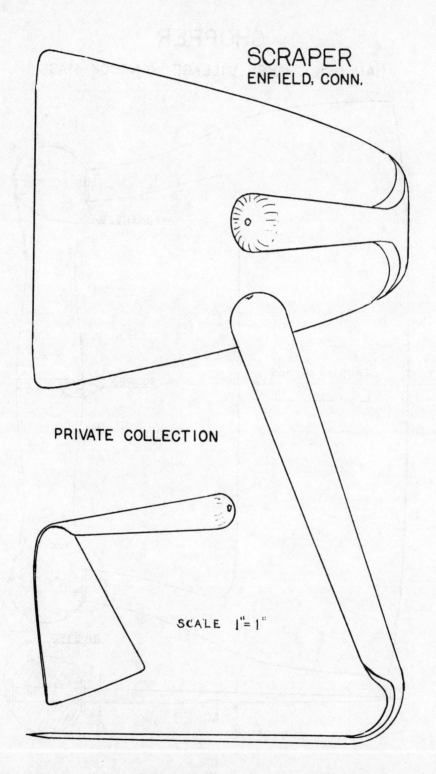

SCRAPER
ENFIELD, CONN.

PRIVATE COLLECTION

SCALE 1"= 1"

CHISEL
FOR CUTTING SEED PACKETS
THE SHAKER MUSEUM, OLD CHATHAM, N.Y.

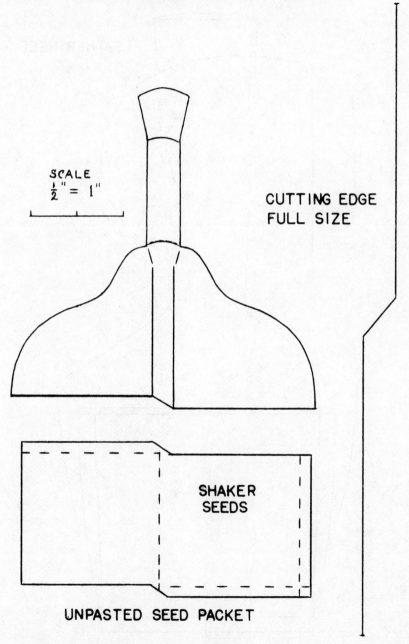

SCALE
$\frac{1}{2}$" = 1"

CUTTING EDGE
FULL SIZE

SHAKER
SEEDS

UNPASTED SEED PACKET

COBBLER'S PUNCH
FOR CUTTING LEATHER HEELS
HANCOCK SHAKER VILLAGE, HANCOCK MASS.

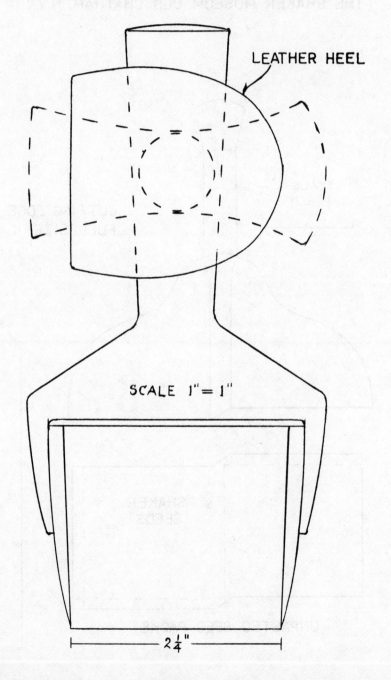

LEATHER HEEL

SCALE 1" = 1"

$2\frac{1}{4}$"

SHAKER-MADE CAST IRON

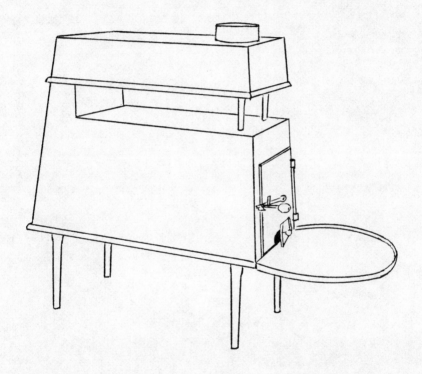

"WE FIND OUT BY TRIAL WHAT IS THE
BEST AND WHEN WE HAVE FOUND A
GOOD THING WE STICK TO IT"

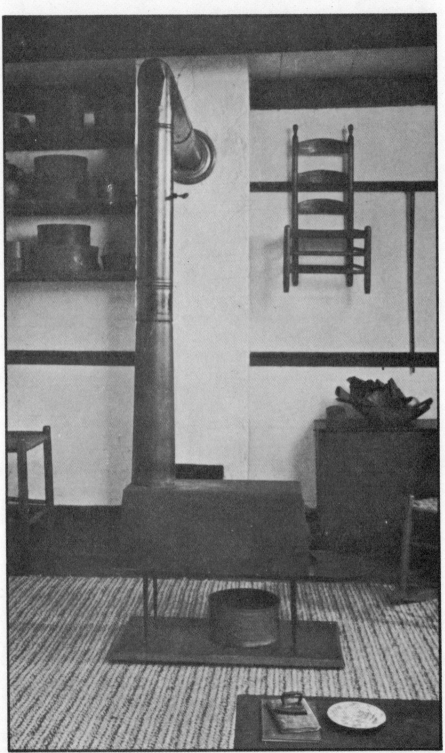

Shaker Stove (pages 211, 212)

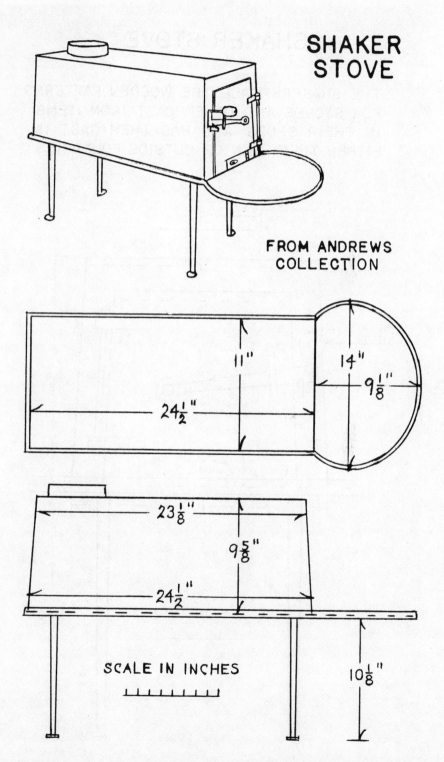

SHAKER STOVE

FROM ANDREWS COLLECTION

11"

14"

9 1/8"

24 1/2"

23 1/8"

9 5/8"

24 1/2"

SCALE IN INCHES

10 1/8"

211

SHAKER STOVE

THE SHAKERS MADE THE WOODEN PATTERNS
FOR STOVES AND OTHER CAST-IRON ITEMS
IN THEIR SHOPS AND HAD THEM CAST IN
EITHER THEIR OWN OR OUTSIDE FOUNDRIES

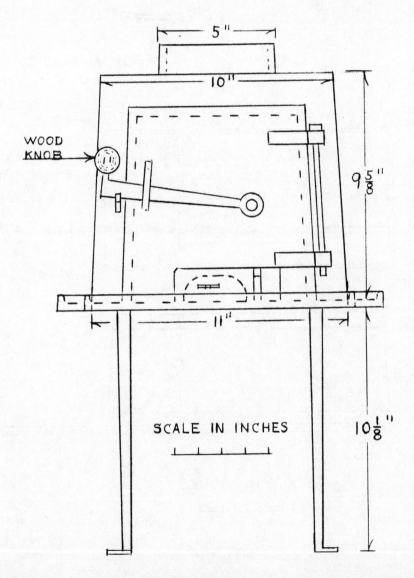

SCALE IN INCHES

LAUNDRY STOVE FROM NEW LEBANON.
THE SHAKER MUSEUM, OLD CHATHAM, N.Y.

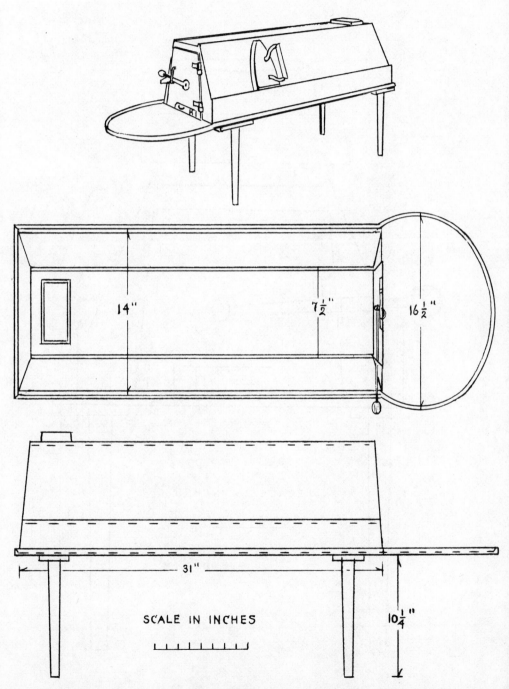

14"

7½"

16½"

31"

SCALE IN INCHES

10¼"

LAUNDRY STOVE FROM NEW LEBANON.
THE SHAKER MUSEUM, OLD CHATHAM, N.Y.

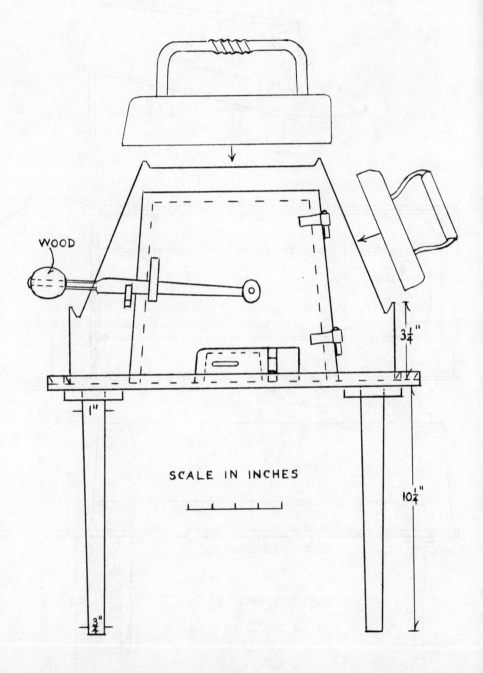

WOOD

$3\frac{1}{4}$"

1"

$10\frac{1}{4}$"

SCALE IN INCHES

$3\frac{1}{4}$"

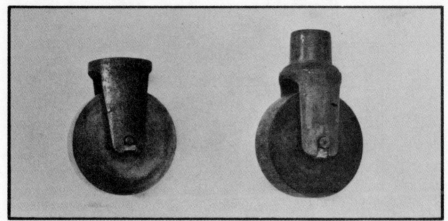
Cast-Iron Casters (pages 216, 217)

CAST–IRON BED CASTERS

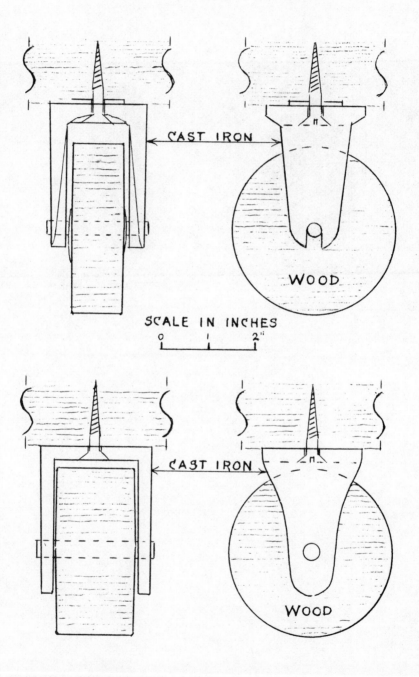

CAST IRON

WOOD

SCALE IN INCHES

0 1 2"

CAST IRON

WOOD

216

CAST-IRON BED CASTERS

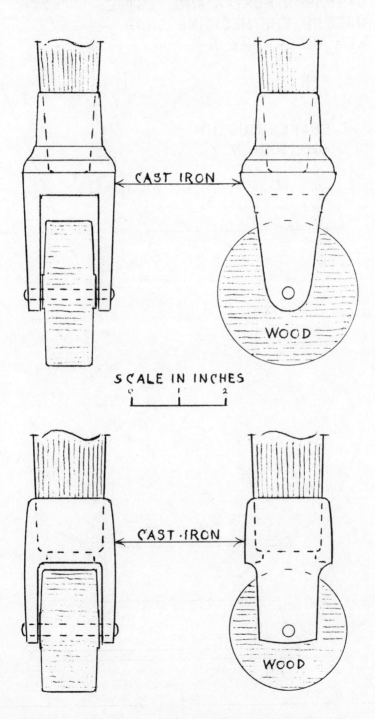

CAST IRON

WOOD

SCALE IN INCHES

0 1 2

CAST·IRON

WOOD

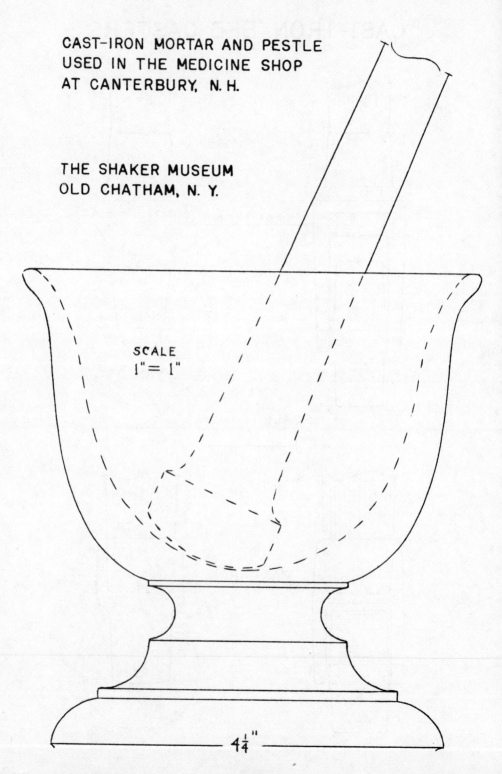

CAST-IRON MORTAR AND PESTLE
USED IN THE MEDICINE SHOP
AT CANTERBURY, N. H.

THE SHAKER MUSEUM
OLD CHATHAM, N. Y.

SCALE
1" = 1"

4¼"

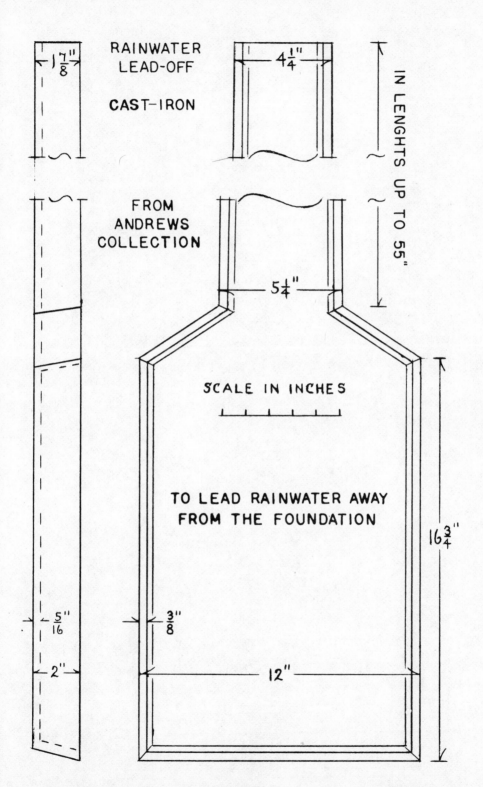

RAINWATER
LEAD-OFF

CAST-IRON

FROM
ANDREWS
COLLECTION

$1\frac{7}{8}$"

$4\frac{1}{4}$"

IN LENGHTS UP TO 55"

$5\frac{1}{4}$"

SCALE IN INCHES

TO LEAD RAINWATER AWAY
FROM THE FOUNDATION

$16\frac{3}{4}$"

$\frac{5}{16}$"

$\frac{3}{8}$"

2"

12"

SHAKER TINWARE

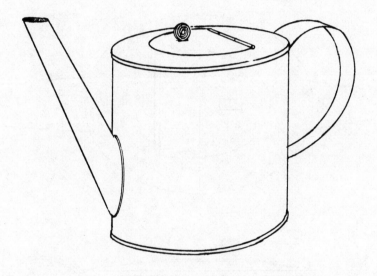

"LET IT BE PLAIN AND SIMPLE"

OVAL TEAPOT

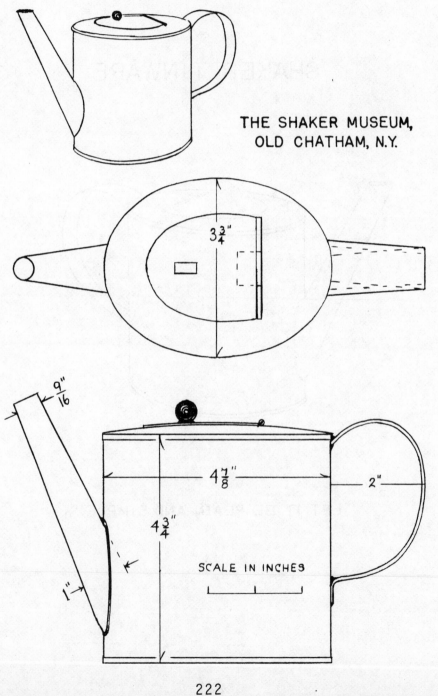

THE SHAKER MUSEUM,
OLD CHATHAM, N.Y.

$3\frac{3}{4}''$

$\frac{9''}{16}$

$4\frac{7}{8}''$

2"

$4\frac{3}{4}''$

1"

SCALE IN INCHES

222

TEACUP

TEAPOT

SHAKER MUSEUM
OLD CHATHAM N.Y.

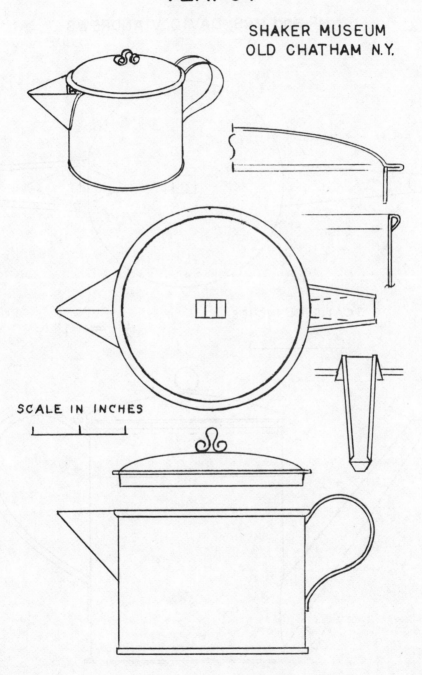

SCALE IN INCHES

TEAPOT
MR. and MRS. DAVID V. ANDREWS

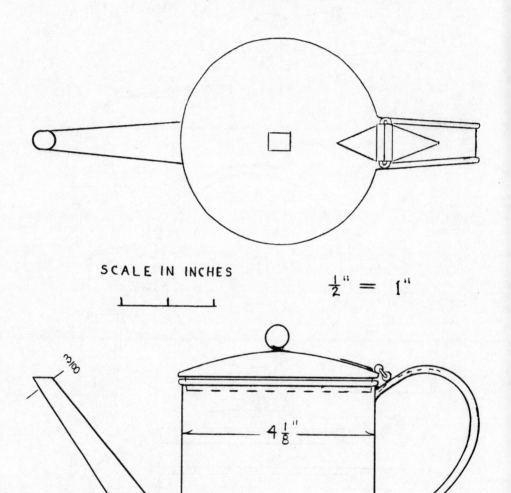

SCALE IN INCHES

$\frac{1}{2}" = 1"$

3/8

4 $\frac{1}{8}$"

7/8"

DETAILS OF TEAPOT
SCALE 1"= 1"

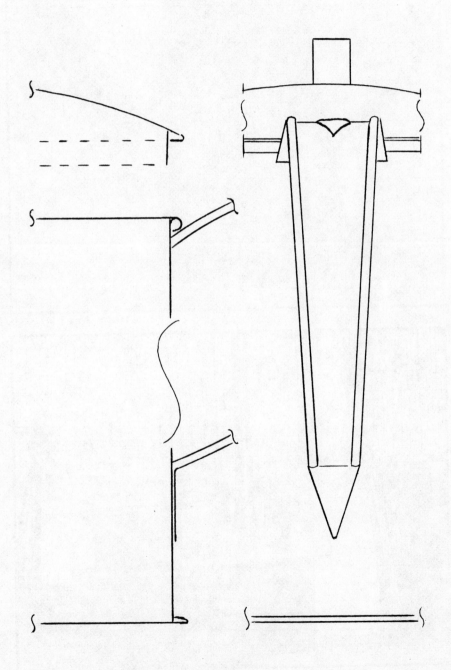

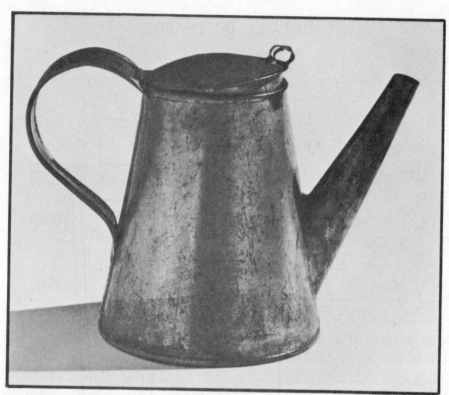

Teapot (pages 227, 228)

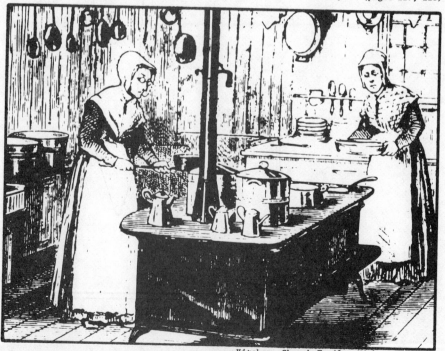

Kitchen, Church Family, Niskeyuna, N. Y.

TEAPOT

MR. and MRS. DAVID V. ANDREWS

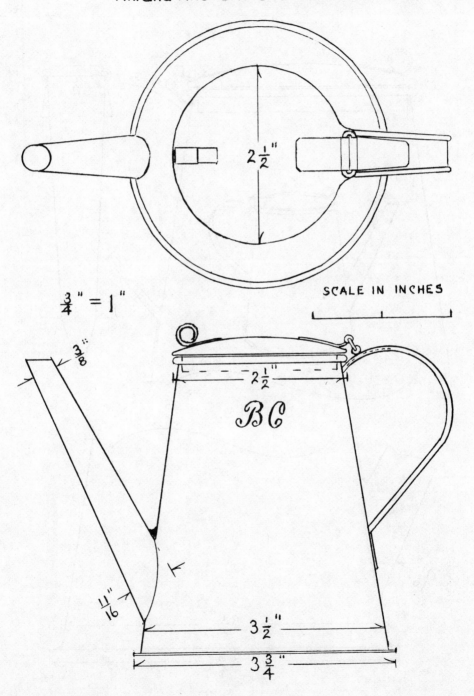

2½"

SCALE IN INCHES

¾" = 1"

3⅜"

2½"

ℬℭ

11″/16

3½"

3¾"

DETAILS OF TEAPOT
SCALE 1"= 1"

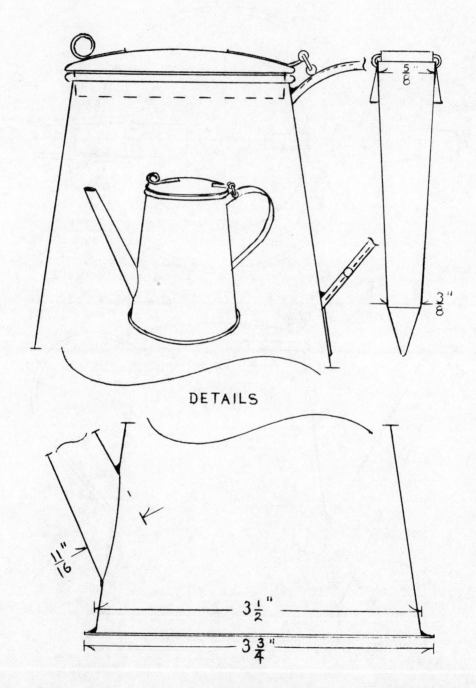

DETELS

TIN STRAINER

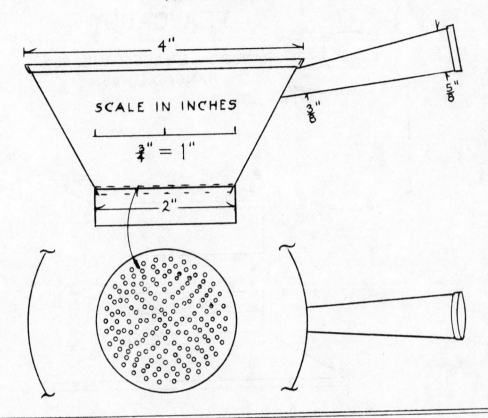

4"

SCALE IN INCHES

$\frac{3}{4}$" = 1"

2"

$\frac{3}{8}$"

$\frac{5}{8}$"

TIN CUP

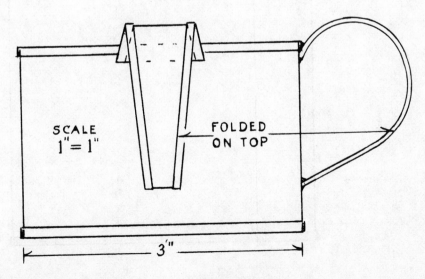

SCALE
1" = 1"

FOLDED
ON TOP

3"

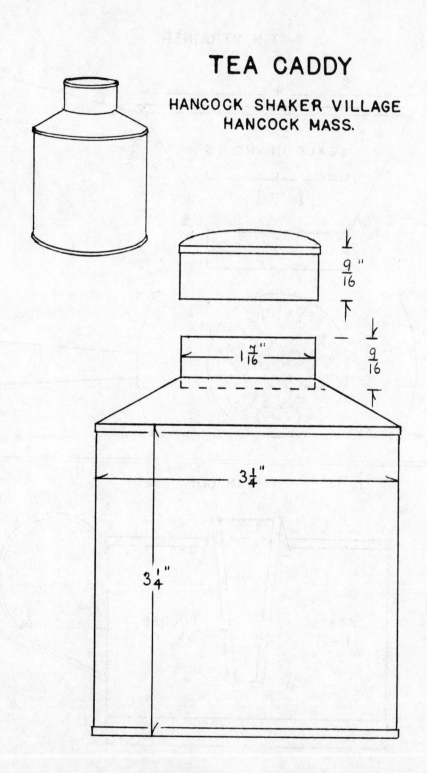

TEA CADDY

HANCOCK SHAKER VILLAGE
HANCOCK MASS.

$\frac{9}{16}$"

$1\frac{7}{16}$"

$\frac{9}{16}$"

$3\frac{1}{4}$"

$3\frac{1}{4}$"

SYRUP JUG

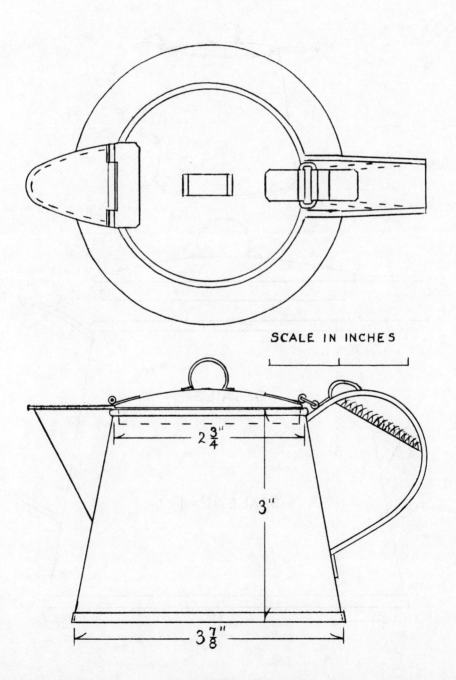

SCALE IN INCHES

$2\frac{3}{4}''$

$3''$

$3\frac{7}{8}''$

SYRUP JUG

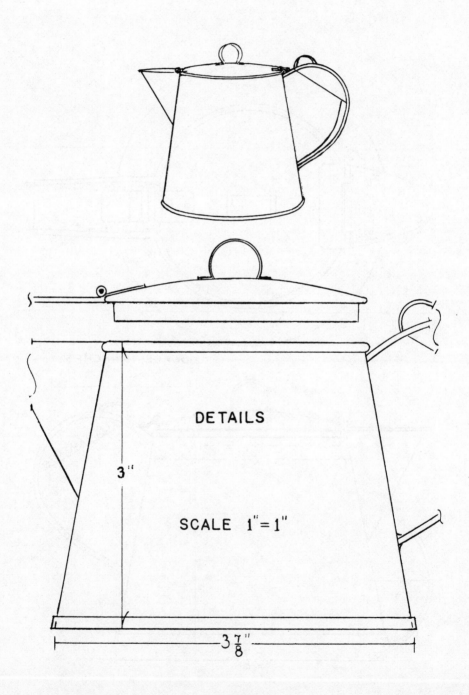

DETAILS

SCALE 1" = 1"

3"

3 7/8"

DIPPER

HANCOCK SHAKER VILLAGE, HANCOCK MASS.

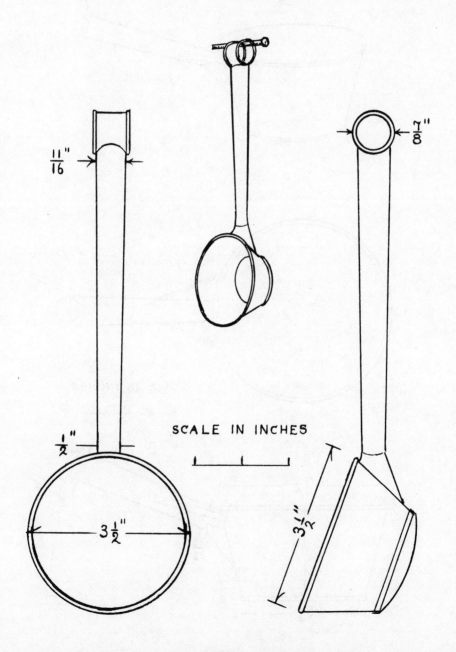

$\frac{11}{16}$"

$\frac{7}{8}$"

$\frac{1}{2}$"

$3\frac{1}{2}$"

SCALE IN INCHES

$3\frac{1}{2}$"

DIPPER

THE SHAKER MUSEUM, OLD CHATHAM, N.Y.

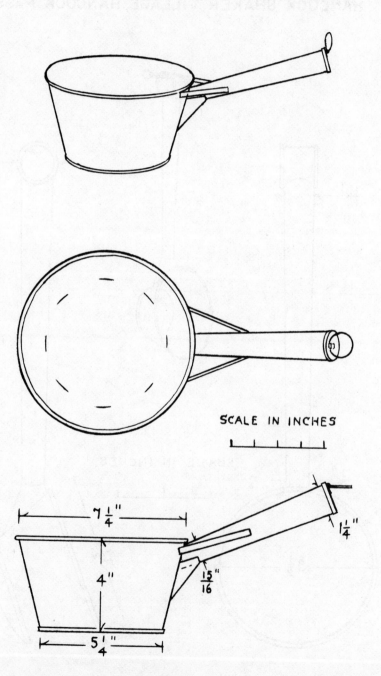

SCALE IN INCHES

7 1/4"

4"

5 1/4"

1 1/4"

15/16"

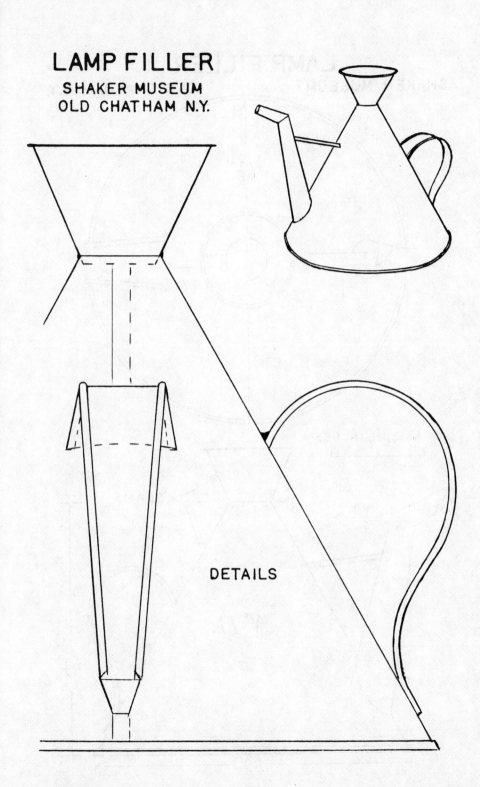

LAMP FILLER
SHAKER MUSEUM
OLD CHATHAM N.Y.

DETAILS

LAMP FILLER

$6\frac{7}{8}$"

SCALE IN INCHES

$\frac{7}{8}$"

SEAMS

$\frac{1}{2}$"

$N^o 11.$

$\frac{7}{8}$"

$5\frac{1}{4}$"

$6\frac{3}{4}$"

LAMP FILLER

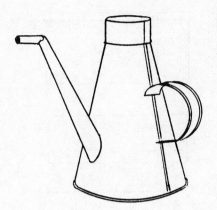

PRIVATE
COLLECTION

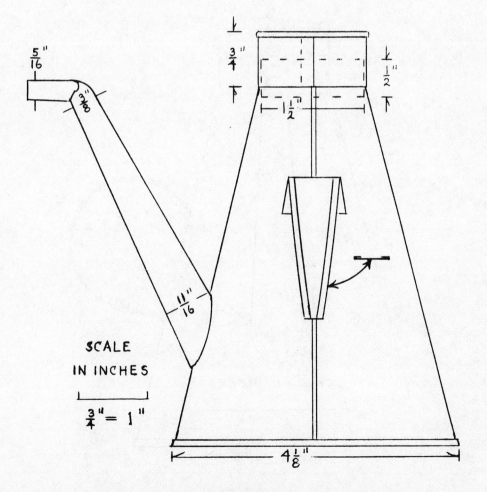

$\frac{5}{16}$"

$\frac{3}{8}$"

$\frac{11}{16}$"

$\frac{3}{4}$"

$\frac{1}{2}$"

$1\frac{1}{2}$

$4\frac{1}{8}$"

SCALE

IN INCHES

$\frac{3}{4}$" = 1"

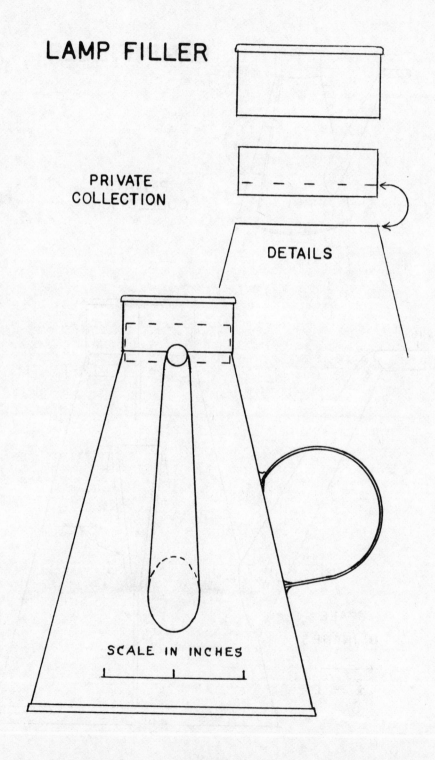

LAMP FILLER

PRIVATE
COLLECTION

DETAILS

SCALE IN INCHES

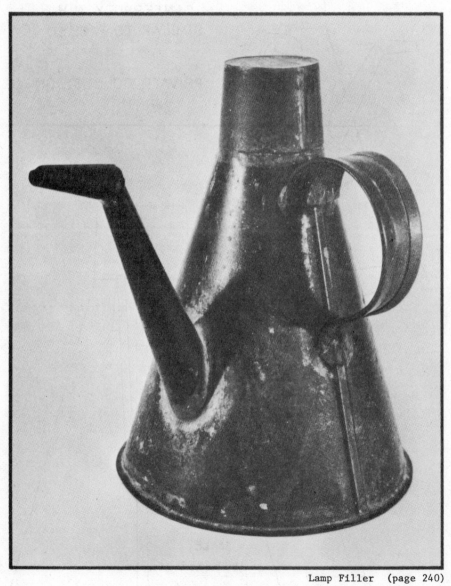

Lamp Filler (page 240)

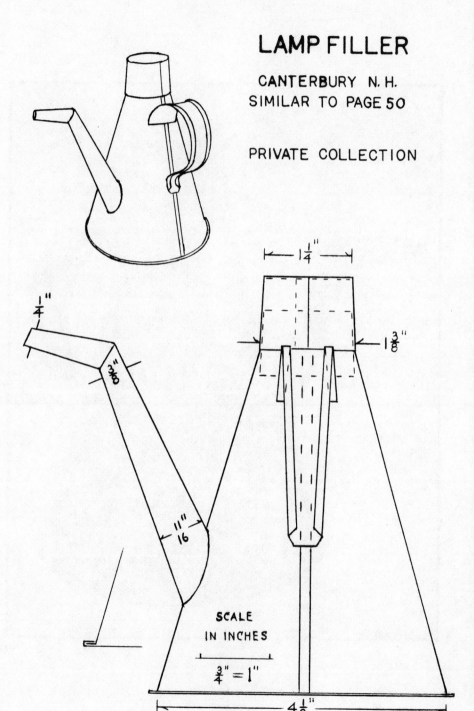

LAMP FILLER

CANTERBURY N. H.
SIMILAR TO PAGE 50

PRIVATE COLLECTION

$1\frac{1}{4}"$

$1\frac{3}{8}"$

$\frac{1}{4}"$

$3\frac{1}{8}0"$

$\frac{11"}{16}$

SCALE
IN INCHES

$\frac{3}{4}" = 1"$

$4\frac{1}{8}"$

LAMP FILLER
PRIVATE COLLECTION

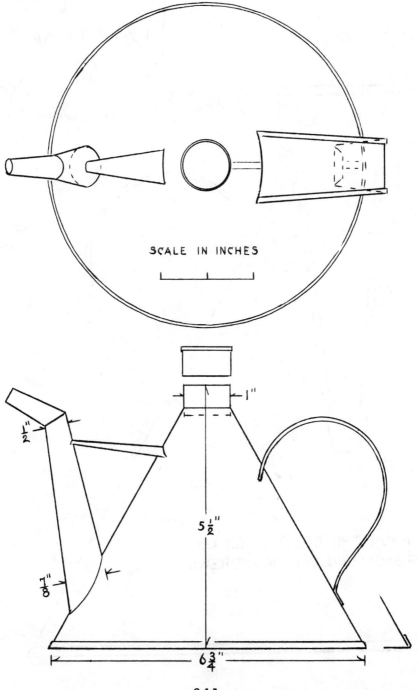

SCALE IN INCHES

1"

5½"

½"

⅛"

6¾"

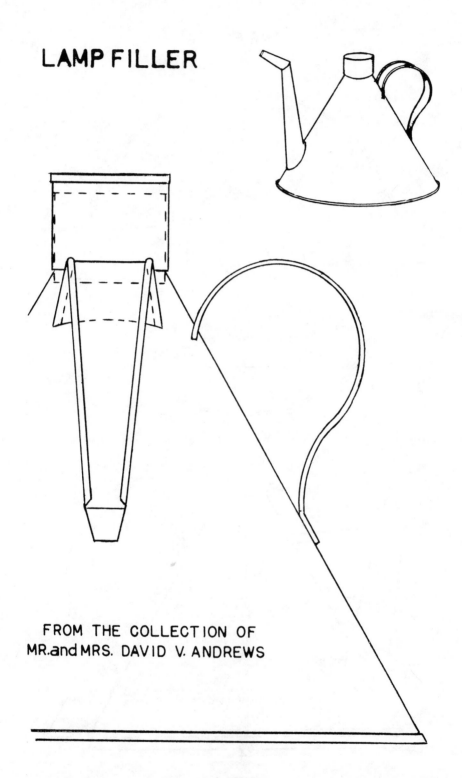

LAMP FILLER

FROM THE COLLECTION OF
MR. and MRS. DAVID V. ANDREWS

APPLE CORER
AND SLICER

THE SHAKER MUSEUM
OLD CHATHAM N.Y.

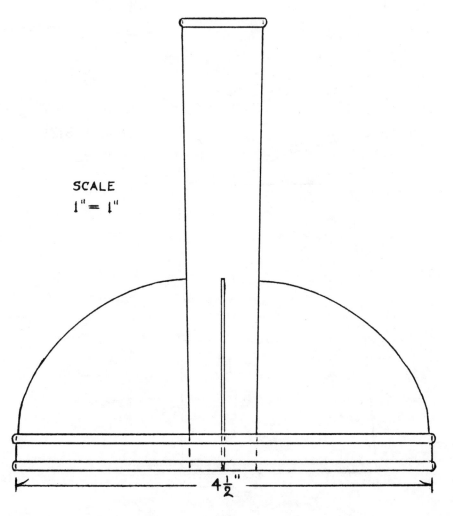

SCALE
$1'' = 1''$

$4\frac{1}{2}''$

MEASURE
HANCOCK SHAKER VILLAGE HANCOCK MASS.

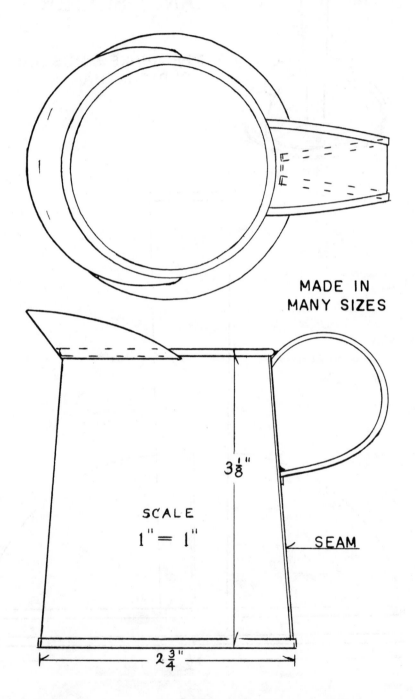

MADE IN
MANY SIZES

$3\frac{1}{8}"$

SCALE
$1" = 1"$

SEAM

$2\frac{3}{4}"$

SHAVING MUG

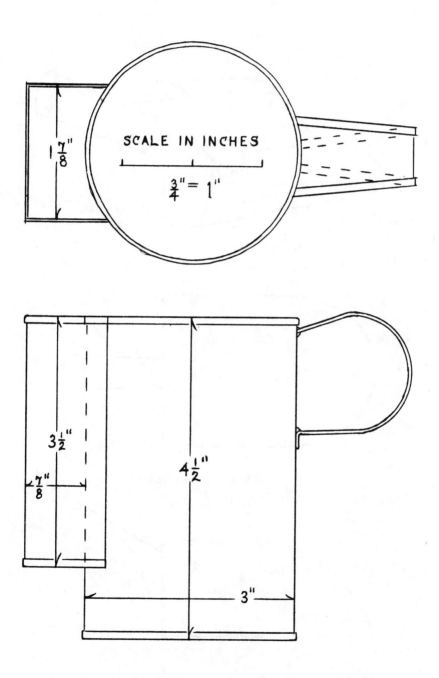

SCALE IN INCHES

$\frac{3}{4}" = 1"$

$1\frac{7}{8}"$

$3\frac{1}{2}"$

$\frac{7}{8}"$

$4\frac{1}{2}"$

$3"$

SCOOP

MADE IN MANY SIZES

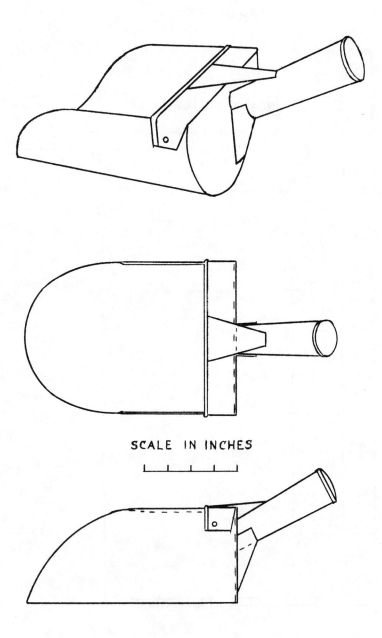

SCALE IN INCHES

TIN SCOOP
USED FOR DRIED APPLES

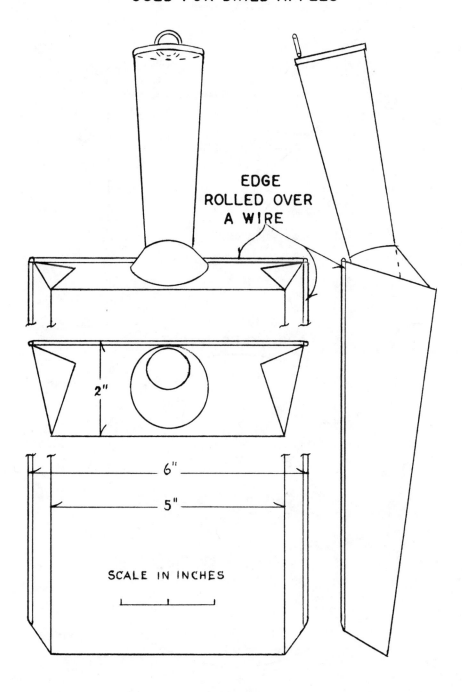

EDGE
ROLLED OVER
A WIRE

2"

6"

5"

SCALE IN INCHES

SPRINKLE POT
THE SHAKER MUSEUM, OLD CHATHAM, N. Y.

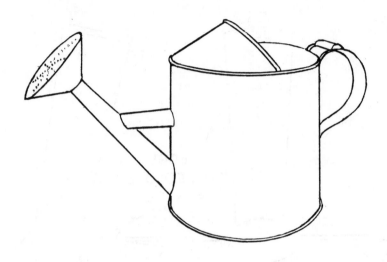

SPRINKLER HEAD

SPRINKLE POT
THE SHAKER MUSEUM, OLD CHATHAM, N. Y.

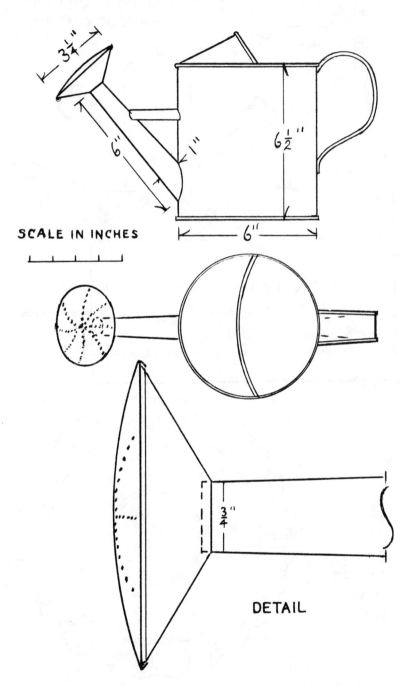

SCALE IN INCHES

DETAIL

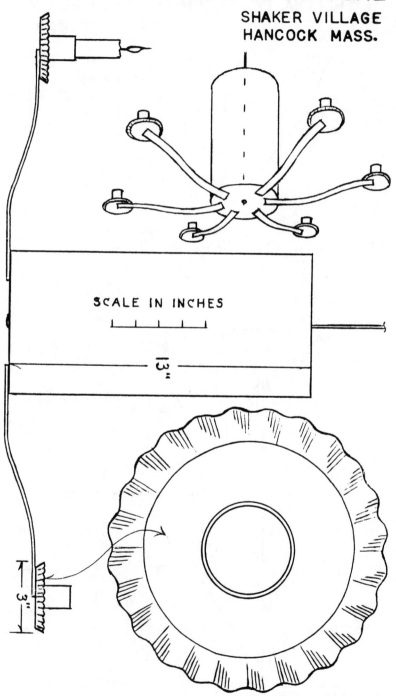

TIN CEILING FIXTURE

SHAKER VILLAGE
HANCOCK MASS.

SCALE IN INCHES

13"

3"

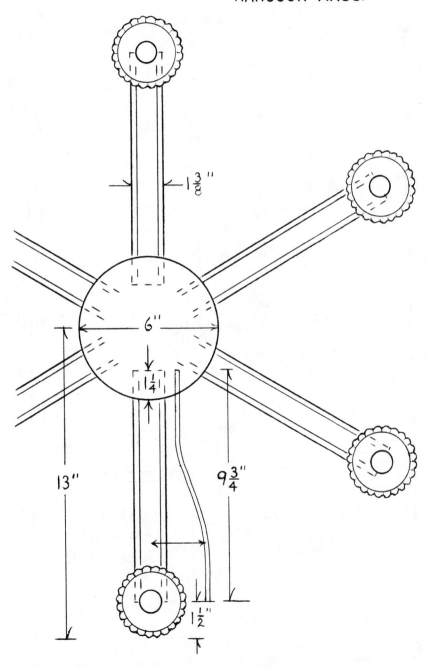

CANDLE SCONCE

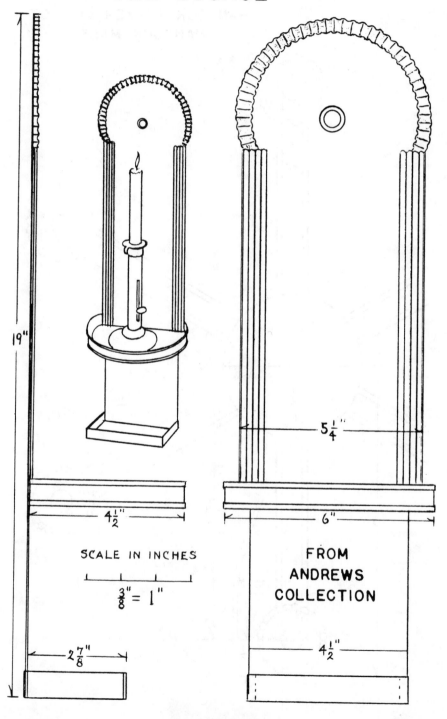

19"

4 1/2"

2 7/8"

SCALE IN INCHES

3/8" = 1"

5 1/4"

6"

FROM
ANDREWS
COLLECTION

4 1/2"

WALL FIXTURE FOR KEROSENE LAMP

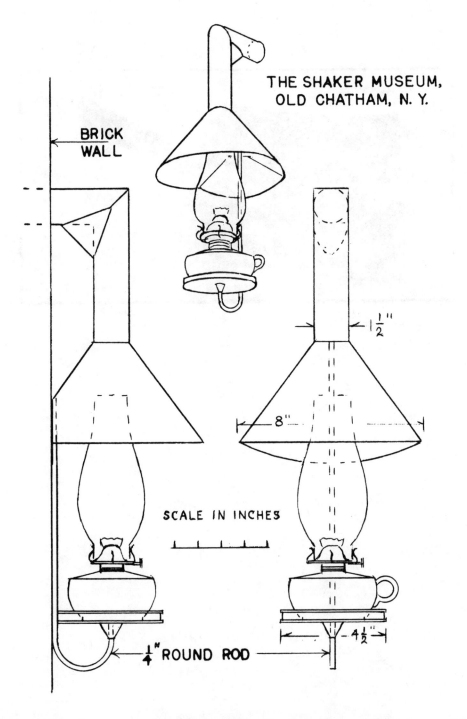

THE SHAKER MUSEUM,
OLD CHATHAM, N. Y.

BRICK
WALL

$1\frac{1}{2}$"

8"

SCALE IN INCHES

$\frac{1}{4}$" ROUND ROD

$4\frac{1}{2}$"

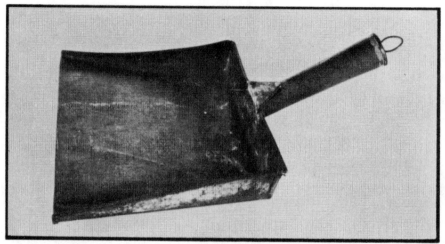

Dust Pan (page 255)

DUSTPAN

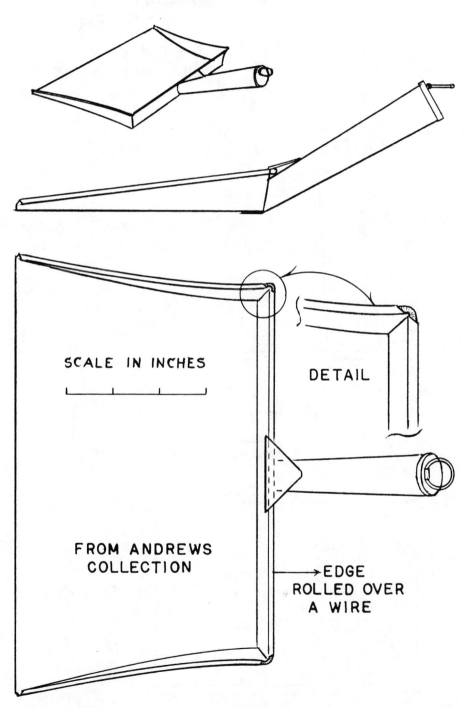

SCALE IN INCHES

DETAIL

FROM ANDREWS
COLLECTION

EDGE
ROLLED OVER
A WIRE

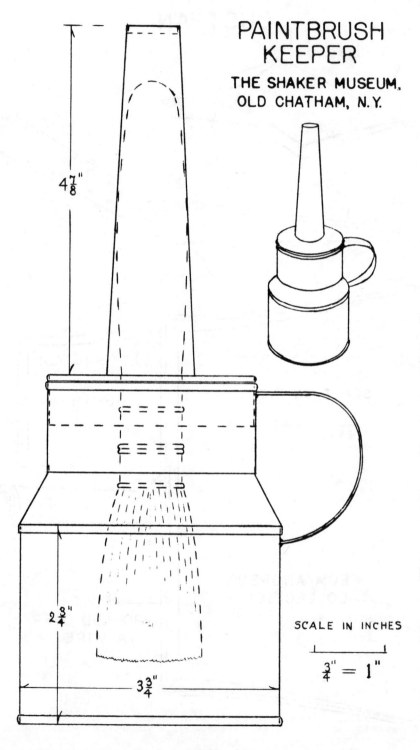

PAINTBRUSH KEEPER

THE SHAKER MUSEUM, OLD CHATHAM, N.Y.

$4\frac{7}{8}''$

$2\frac{3}{4}''$

$3\frac{3}{4}''$

SCALE IN INCHES

$\frac{3}{4}'' = 1''$

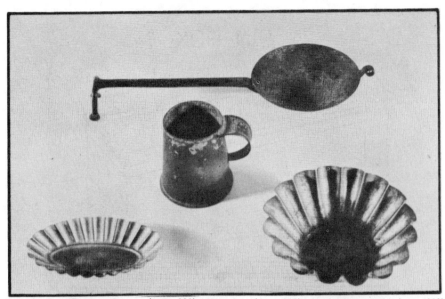

Wrought-Iron Frame and pan (page 202); Measure (page 255); Maple Sugar Mold (page 258)

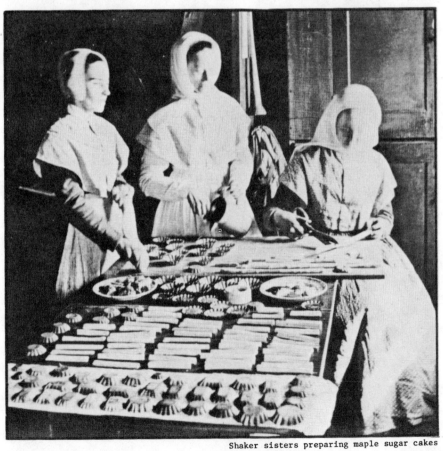

Shaker sisters preparing maple sugar cakes

PIN BOX

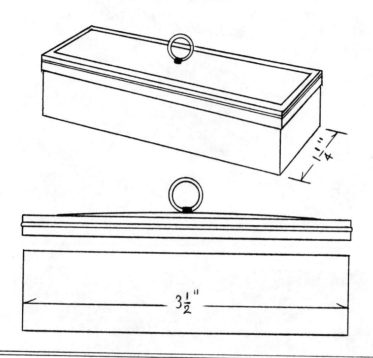

$3\frac{1}{2}''$

$\frac{1''}{4}$

MAPLE SUGAR MOLD

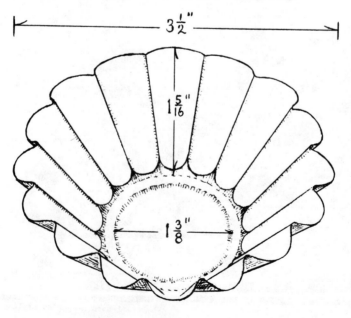

$3\frac{1}{2}''$

$1\frac{5}{16}''$

$1\frac{3}{8}''$

SNUFFBOX

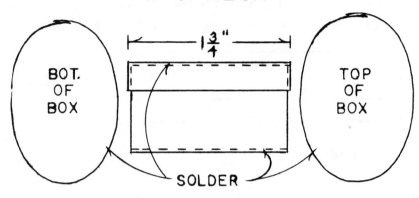

BOT.
OF
BOX

$1\frac{3}{4}"$

TOP
OF
BOX

SOLDER

MEASURE

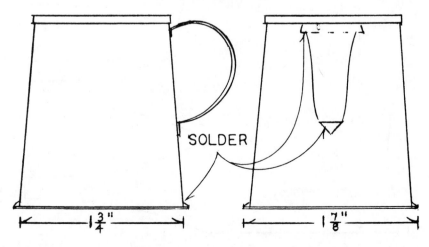

SOLDER

$1\frac{3}{4}"$

$1\frac{7}{8}"$

TIN PATTERNS
FOR MARKING THE BANDS FOR OVAL BOXES

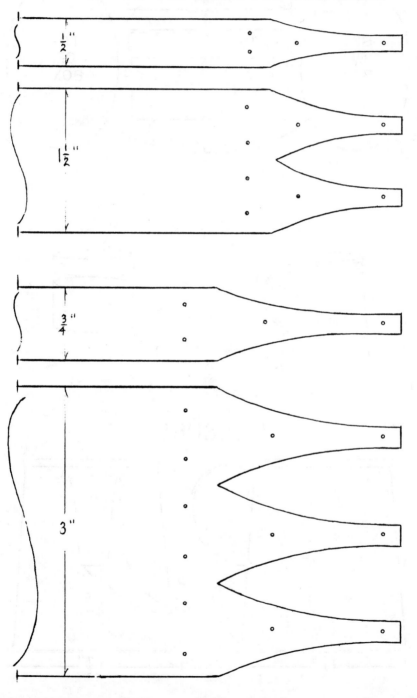

TIN PATTERNS
FOR MARKING THE BANDS FOR OVAL BOXES

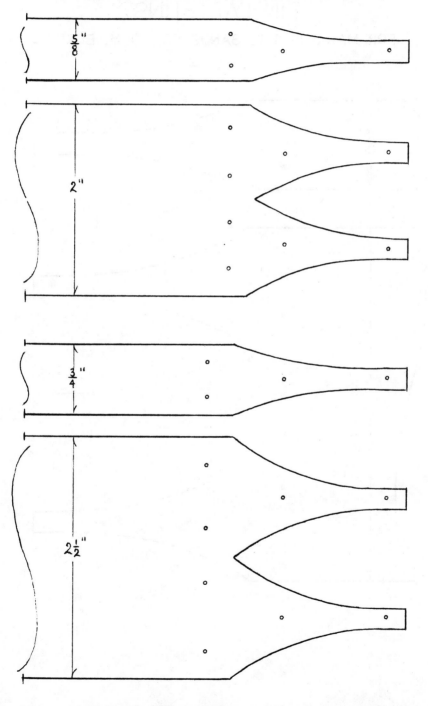

TIN PATTERNS
FOR MARKING THE BANDS FOR OVAL BOXES

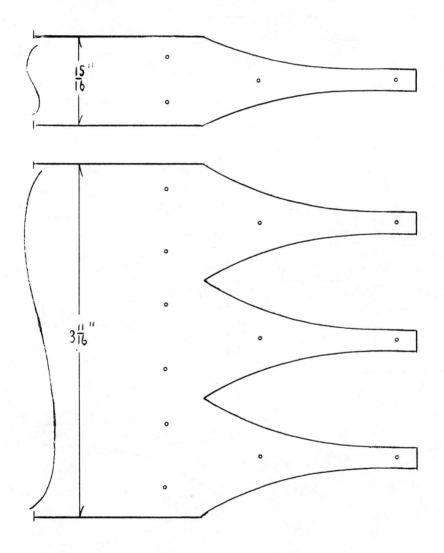

$\frac{15}{16}''$

$3\frac{11}{16}''$

TIN PATTERN
USED FOR QUILTING.
ENFIELD CONN.

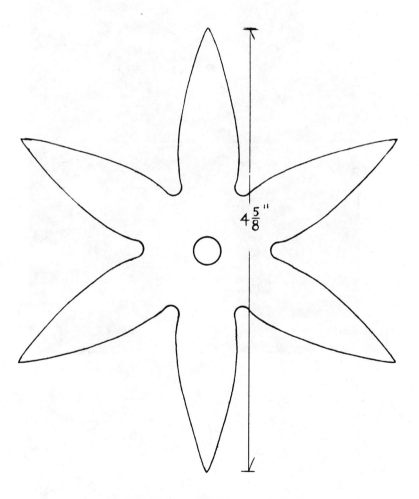

$4\frac{5}{8}$"

PRIVATE COLLECTION

263

G. Simpson

Ejner Handberg

ABOUT THE AUTHOR

Ejner Handberg is a cabinetmaker of some 50 years expe-
rience. He was born in Denmark and came to the United States
when he was 17 years old. He learned his craft from oldtime
19th century cabinetmakers who insisted upon precision and
accuracy.

A number of years ago he first became acquainted with the
simplicity and dignity of Shaker furniture as a result of
restoring and repairing many original pieces. His reputation
in this field grew and the early collectors soon learned of
his skill in such restorative work.

At this time, Mr. Handberg began to prepare meticulously
perfect measured drawings of these original Shaker pieces
for the purpose of reproducing them in his own shop one at
a time. He made careful notes about the different types of
wood used in the originals, and the unique methods of join-
ing. He felt drawn to the basic Shaker designs that were
charecterized by the abolishment of non-essential ornamen-
tations. He followed, as closely as possible, the reverence
that these unusual people had for wood and the purely func-
tional purpose in furniture.

The first part of this book, containing 160 of Mr. Hand-
berg's carefully prepared scale drawings, represent much of
his life's work. It includes drawings of Shaker chairs, ta-
bles, stands, sewing boxes, cupboards, a bed, trestle tables
and many other pieces.

The informed amateur worker in wood, as well as the pro-
fessional cabinetmaker, will find Mr. Handberg's book a val-
uable addition to the perpetuation of Shaker qualities.

Although not a tinsmith or metal worker himself, Mr. Hand-
berg's interest in Shaker products and design grew to include
the items made of iron and tin. The third part of this volume
of his drawings includes 75 meticulously detailed scale draw-
ings of Shaker iron and tinware. In addition, there are sev-
eral pages of photographs of fine examples of Shaker crafts-
manship in metals.

INDEX

Asterisks after plate numbers refer to drawings made from pieces in the collection of Dr. and Mrs. Edward Deming Andrews.

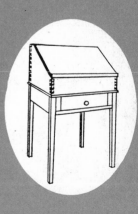